ANALYSING POPULAR MUSIC

ANALYSING POPULAR MUSIC

image, sound, text

DAVID MACHIN

SAGE

Los Angeles | London | New Delhi
Singapore | Washington DC

SAGE Publications Ltd
1 Oliver's Yard
55 City Road
London EC1Y 1SP

SAGE Publications Inc.
2455 Teller Road
Thousand Oaks, California 91320

SAGE Publications India Pvt Ltd
B 1/I 1 Mohan Cooperative Industrial Area
Mathura Road
New Delhi 110 044

SAGE Publications Asia-Pacific Pte Ltd
33 Pekin Street #02-01
Far East Square
Singapore 048763

Library of Congress Control Number: 2009932887

British Library Cataloguing in Publication data

A catalogue record for this book is available from the British Library

ISBN 978-1-84860-022-5
ISBN 978-1-84860-023-2 (pbk)

Typeset by C&M Digitals (P) Ltd, Chennai, India
Printed by MPG Books Group, Bodmin, Cornwall
Printed on paper from sustainable resources

Mixed Sources
Product group from well-managed
forests and other controlled sources
www.fsc.org Cert no. SA-COC-1565
© 1996 Forest Stewardship Council

Contents

Acknowledgements

Thanks in the first place to Theo Van Leeuwen whose ideas expressed through his written work, in conversations in the pub and through his music during a winter of regular gigging, provided me with much of the content and motivation to do this book. Thanks also to Anna Claydon for her bravery in teaching techniques that got me started with this, to Malika Kraamer for the conversations and to Sharon Magill for having the enthusiasm to show me how to realise many of these ideas practically in teaching, using sound editing software. Further, thanks to the professional excellence of the staff at Sage.

Introduction

You switch on the TV. It is a music show. A band is introduced as the latest thing on the indie scene. Yet when the camera cuts to them you see two middle-aged women playing acoustic guitars. Strumming gently they start to sing about lost summer's days and world peace. This must be a joke. This is not indie music. The look, the instruments, the sound and the words are not how they should be. An indie band should not look like this. Their music should be more 'raw', 'darker' and troubled, as should their lyrics. In terms of attitude they should be more intense and yet indifferent at the same time, but certainly not brightly warm and eager. The next act to be introduced is billed as the latest boy band. They are introduced as producing their special brand of 'music from the soul'. Again this must be a joke. Boy bands don't play music from the soul.

You switch channels. There is a movie showing. It is a scene of suspense. You have no idea what is going on but you can tell because of the music. Then the mood changes, as indicated by the music, to suggest a happy moment. But how can we so easily understand this meaning? It seems that we do so with no effort whatsoever.

We often hear music referred to in terms of **creativity**, of self- expression, as ground-breaking. In record reviews classical composers and jazz musicians are often credited with producing music from the soul. Singer-songwriters are depicted as almost being slaves to their innate talent. These artists are often contrasted with those that are more manufactured, such as a boy band. The latest bands on the music scene are talked about in terms of their originality and their 'new sound'. Yet the example of the indie band and the film music suggest that there are patterns and conventions in music. Yet these are seldom discussed.

For a band to be recognised as 'indie' certain boxes have to be ticked – a particular look, a sound, an attitude. We are familiar with talking about such bands in terms of **genre**, but less so in terms of the precise details of sounds and look that qualify such categories.

We can quickly recognise when a band does not sound like a particular genre of music but we lack a language to describe just why this is so apart from using adjectives such as 'mellow', 'raw', 'rhythmic'. The fact that we can recognise moods connoted by music in a film suggests that we have some kind of repertoire of sound meanings or associations in our heads. Yet we are for the most part not familiar with trying to describe what these are.

This lack of a language to describe these sound and music details is not the same as lacking theoretical musical knowledge, although this of course can be true on one level. Often when a contemporary artist makes a cover version of a song previously released by another artist the music in many ways stays the same. The melody notes remain the same, as do the chords that provide the backing. What changes are the sound qualities on the instruments, the timbre of the voice, the **rhythm** and the instrumental **arrangement**. So a band like the Sex Pistols can transform Frank Sinatra's 'My Way' into something that expresses pure contempt. In this book it is this level of musical language that is of primary interest. The aim is to provide a toolkit through which we can describe the changes, the meanings of sounds, at this level.

Of course we might simply want to believe that music really does communicate with the soul, that when we hear music it does touch something deeper in us. In fact historically some musicologists have thought that music did just this, that it came from a different plane, that it was the sound of God or Heaven. And there are very good reasons why many of us still wish to believe that music is indeed about higher meaning and the expression of the individual. We will come to these in Chapter 1.

This is not the approach taken in this book. From the 1970s sociologists such as Becker (1974, 1976) have shown that what we call art, including music, is not so much about creativity but the result of shared conventions and shared definitions as people come to inhabit cultural spaces. Music too is about cultural definitions as people come to create meaningful worlds in which to live. This book deals with music as part of the way in which through culture we come to give meanings to what are after all just noises (Levitin, 2006). Why does a distorted electric guitar sound meaner than an acoustic guitar? Why do punk vocalists use tense throats and seem to sing through their noses, whereas some singer-songwriters use more breathy sounds? Why do we think of conga drums as creating a beat which connects to our bodies whereas the rhythm of a clock does not? This book is about describing and analysing the shared conventions and associations that allow music and sound to have meaning for us.

For the most part music itself is highly formulaic and predictable. Some even think of it as having much in common with language (Cooke, 1959; van Leeuwen, 1999), even that music is a sort

of by-product of the centrality of language to human evolution and the kinds of development in our auditory cortex this has involved (Pinker, 1997). When we talk we draw on a repertoire of word choices. These words are designed to fit in a grammatical structure. So to some extent what we can say and how we can say it is predictable and takes predictable forms, or genre. This has to be the case to make communication possible. A more careful look at music reveals similar kinds of repertoires, patterns and structures. What sounds 'happy' has particular features, as does what sounds emotionally expressive, or emotionally contained. How these sounds are built up with others into arrangements itself follows a formula and can itself influence the meaning of individual sound choices. As listeners we tend not to think about music in this way, yet an indie band or a folk band will draw upon particular musical language in order to communicate particular associations. They will use a particular range of sound types, melody types and instruments in the way that a speaker will use certain words and grammatical features in order to make meaning through language.

There is a visual language of music too. Bands must wear the right gear and have the right haircuts. The right mood must be created through publicity shots and record sleeves. So in theory we should be able to describe the available repertoire for creating musical moods and looks.

Lyrics themselves can communicate something about a band that can be analysed. Heavy-metal songs tend to contain different lyrics than rap, folk or country music. And lyrics that deal with the same topics over time take very different approaches to them. We are more familiar with assessing song lyrics in terms of the story they tell, how much they contain feeling, what message they have. But when we look more carefully we find much deeper meanings that tie them to particular times, places and ideas.

This is the aim of this book. In the way that a linguist might document the linguistic resources and structures available to create meaning in linguistic communication, we look for the kinds of semiotic resources and patterns available for communication in the sounds, images and worlds of popular music.

To some this kind of approach might sound like music is being reduced to its nuts and bolts and therefore removing the way that it affects them, the way it moves them. This is partly because in our society we understand what we call art, including music, in terms of the 18th- and early 19th-century Romantic tradition. We have inherited a sense that artistic creativity comes from within. This is why in popular music the singer-songwriter is so important. Their music is the outpourings of their soul. As Raymond Williams describes, in this tradition, the artist – whether musician, painter or poet – has the business to

read the open secrets of the universe (...) the artist perceives the Essential Reality, and he does so by virtue of his master faculty: Imagination. (1961: 56)

At the heart of this view is the idea of the artist as genius and art as in touch with a greater reality or a greater truth. To suggest that there are patterns and conventions in this process is therefore to challenge the very idea of music being almost spiritual, affecting us in a deeper, unfathomable way. While such ideas are not necessarily made explicit in the 21st century they nevertheless still have a huge influence over what we think music is.

The problem is that this Romantic idea treats creativity as mystical (Toynbee, 2003: 104). Drawing on the social psychologist Bakhtin (1981), Toynbee sees all communicative acts as to some extent ventriloquated from previous ones. In other words, when we speak we draw on what has been said before. This existing repertoire is what we can think of as culture. Music can be thought of in the same way in that it draws on what has been heard before. All aspects of musical styles can be understood as being part of cultures at particular moments, although of course how we understand and hear them – the meaning they have for us – may be different than for audiences at the time of production. Toynbee argues that far from being an outpouring of the soul 'Creativity is thus manifestly a cultural process' (2003: 111). Yet we still hold on to the myth of the individual creator as we enjoy the idea of individualism, and it makes us feel special when we feel we can recognise talent.

How we talk about music has itself has been shown to be very important in the study of popular music (Frith, 1996). This talk is part of the way that we come to know how to understand music, to have a relationship with it. We also use music to talk about ourselves, and this is another reason that the dissection of music into established codes and conventions seems to take away its essence. This demystifies the self, placing us as members of a wider culture rather than as special individuals.

McClary and Walser (1990) have said that to dissect music 'is to compartmentalise it into atomic bits that no longer seem related to the entity that was able to seduce and move audiences. It is cut off from its power source' (p. 286). But we can still learn about the way music works without removing the importance of its affect. When linguists describe grammar and the way that lexical and grammatical choices can signify particular broader meanings, we do not see that this somehow reduces what language is or therefore diminishes the way that it has an emotional effect on us. We do not consider that to analyse the language of poetry or novels is to somehow take away something of the way that they can inspire us. The affect music creates for us cannot be denied, but how we hear something, how

we talk about it, and the meaning it has for us, must be understood sociologically rather than as being something in the music.

Without accepting the fact that there are conventions and a repertoire of cultural meanings we cannot explain why a band must behave in a particular way on stage depending on genre. What if a female singer-songwriter tore up her ethnic jewellery and smashed her violin at the end of her set? Why do we sit in still silence to listen to classical music, yet are obliged to move around for rock? When we look at record sleeves we can easily anticipate the kind of sounds that are found on the record itself. These are all sets of established conventions that can be seen as communicative resources. Frith (1996: 91) said that, in order to be recognised as punk or country,

> a piece of music has to have certain aural characteristics which include playing conventions – what skills the musicians must have; what instruments are used, how they are played, whether they are amplified or acoustic; rhythmic rules; melodic rules; the studio sound quality; the relation of voice to instruments.

Frith argues that while sound is organised according to formal rules so is the behaviour of the artists both on and off stage. Of course there are really no fixed genre boundaries, and we cannot exactly describe the rules for genre, but what we can do is look at the kinds of semiotic resources being used in particular cases – visual, lyrical and musical – and what these are used to communicate.

Music as discourse

Wall (2003) has suggested that rather than thinking about the way bands have musical influences we should consider the idea of 'music culture discourses' (p. 21). He says: 'Music sounds are part of the wider cultural practices, which collectively constitute our knowledge of popular music'. These influences, which he refers to as **discourses**, Ⓖ constitute whole ways of playing, listening, moving to, talking and thinking about music. In Wall's terms we have broadly shared discourses about what music is, how it should be made, how it should be listened to (people get offended on hearing Mozart or a favourite pop song piped through the phone while on hold, or used for an advert) and also for explaining why music is good and bad.

Walser (1993: 28–9) has suggested that music can be thought of as functioning much like verbal discourse. He says that,

> by approaching musical genres as discourses it is possible to specify not only certain formal characteristics of genres but also a range of understandings shared among musicians and fans concerning the interpretation of those characteristics.

Hibbett (2005) used this idea to study the discourses used by fans to talk a particular genre of music, indie, showing how they used terms such as '**authenticity**' and valued certain kinds of 'raw' sounds through which these are signified. In this study there is a clear sense that these discourses not only allow the fans to know about and share the music but also to go on to constitute what the music can be, how it should sound and what look acts should have.

While these writers make important points for the approach taken in this book, as is common in media and cultural studies, none offers any clear definition of what they mean by discourse, nor say systematically how it should be studied. Since the concept is a core tool in this book, however, there is the need to be more specific. The concepts of discourse used in this book is as generally found in Critical Discourse Analysis (CDA), and it is one useful way to analyse the ways that sounds, images and words can have particular meanings and sum up to a broader picture or message. And there are more recent developments in CDA that allow us to assess visual and sound semiotic resources too.

In CDA the broader ideas communicated by a text are referred to as discourses (van Dijk, 1991; Fairclough, 2000). Individual lexical and grammatical choices in texts are examined to show the kinds of discourse that they signify. These discourses can be thought of as models of the world, in the sense described by Foucault (1978), which can include kinds of participants, behaviours, goals and locations (van Leeuwen and Wodak, 1999).

In traditional semiotics it has been common to talk about the way that signs can connote meanings. For example, a flag can connote meanings about nationalism. So it can connote, to some, national glories and pride of a people. To others it might connote inward looking, narrow mindedness. So in each case the flag can connote a particular set of circumstances, identities, values and sequences of events. These are what we refer to as discourses. So if we saw a national flag flying outside someone's house it might connote a kind of identity such as a person who was not open to multiculturalism. This would suggest a set of values such as racism or xenophobia and a sequence of events such as might result from intolerance and exclusion of 'othered' groups.

More recently in CDA there has been a visual turn, inspired mainly through the work of Kress and van Leeuwen (1996, 2001). Prior to this discourse, analysts had focused on the way that discourses, were realised through the linguistic mode. But Kress and van Leeuwen showed how we could systematically analyse how this happens visually through photographs, pictures and visual designs. Out of a concern to include much of the visual meanings that had been missed in linguistic-oriented CDA, Kress and van Leeuwen argued that much

communication is '**multimodal**' rather than 'monomodal'. Therefore, ⓖ
discourses, along with their values, participants, actions settings, etc.,
can be connoted by both linguistic and visual choices. They revealed
that just as we can study lexical choices in language to reveal dis-
courses so we can study choices of visual semiotic resources.

In this book we are interested in the way that visuals, sounds and
lyrics are all able to communicate discourses multimodally. In other
words, on a record sleeve, the contents and style, the poses of the art-
ists, the kinds of melodies and sounds they produce, the words they
choose for their lyrics all connote discourses. The importance of this
will become clear in Chapter 1, where we find that there are certain
discourses that tend to dominate popular music and it is often in the
interests of artists to be able to signify these.

Multimodal semiotics

While traditional semiotic approaches address the way that indi-
vidual signs connote or symbolise as we saw in the example of the
flag, the multimodal approach used in this book is concerned with
the choices of signs available to communicators and the way that
the meaning of individual signs changes when used in combination
with others. In this approach it is important to first describe and
document the range of possible choices available to communicators.
This *social semiotic* approach draws on the Systemic Function Lin-
guistics of Halliday (1978). This is based around the principle that
language is comprised of a shared set of lexical and grammatical
options that can be used to build meanings. When we speak we can
choose between words such as 'big' or 'small' to convey meaning. We
can use modal verbs such as 'possible' or 'certain' to convey levels of
commitment to truth. Halliday was able to create exhaustive inven-
tories of the kinds of choices available that were displayed as *system
networks*. This means that if a speaker makes one particular choice
then they eliminate one possible pathway of other word choices and
move onto others. These networks of choices can be represented
diagrammatically.

Kress and van Leeuwen (1996) argued that the same process of
analysis could be applied to account for the options available in visual
communication. In traditional semiotics it was usual to describe the
way that a colour (such as red) connotes sensuality through its asso-
ciation with flushed lips. But when a designer chooses a particular
shade of red they do so rather than other possibilities such as cooler
blues associated with rationality or brown colours associated with
earth and organics. They also make a choice to use a saturated or
more muted red, a pure red or an impure red. All of these involve

choices from options that can be used to create specific meanings. National flags, for example, will use saturated, pure colours to indicate certainty and emotional vibrance rather than muted impure colours that would connote moderation and uncertainty.

Halliday (1978) explained that the signs from which we are able to choose to create combinations do not have fixed meanings, but have 'meaning potential'. To continue with our example of colour, a saturated red might alone be used to communicate sensuality. But if we combine that red on a design alongside three other highly saturated colours – yellow, blue and black – its meaning changes. Such a use of colours, a loud, varied colour palette, is often used to communicate vibrancy and fun, or could connote garishness and lack of taste, for example. Clearly in such a case it is not just the hue that has meaning potential but the degree of saturation. This meaning would have been different had the colours been all dilute as opposed to saturated.

The point is that we need first to be able to describe the available repertoire. We must then treat this as an inventory of potential meanings. In our analyses we first describe the semiotic choices found in a text or visual composition and, second, describe the way that meaning potentials are activated.

Just as words and visual elements and features involve choices from an available repertoire of meaning potentials so we can think about sounds in the same way. At the start of this chapter we thought about the way we can grasp the meaning of a movie simply from what we hear on the soundtrack. Just as we can tell much about the meaning of a magazine cover from the uses of colour hue and its level of saturation and purity, so there are features and qualities of music that can be inventorised and which can be thought of as having meaning potential. As with language and visual communication, these are comprised of a repertoire of associations built up in our particular culture and also through the relationships of sound to qualities to our basic physical experience of living in the world. So when we see a scene in a film we can ask: What is the meaning potential of a deep sound compared to a high-pitched one, a rasping sound as opposed to a smooth one? What if there are many rapid accented notes as opposed to several longer, more softly articulated notes? And what are the iconic meanings of particular recognisable sounds, a petrol motor as opposed to an electrical engine, a clanging machine as opposed to the clicking of a computer? In all these cases we can ask what kinds of broader discourses each of these choices connotes.

We can ask the same kinds of questions about popular music. Do vocalists use large or small **pitch ranges?** Do musicians play in **unison** or as individuals? Do they use **vibrato** or not, and if so is it highly regulated? All of these involve choices from repertoires of meaning potentials that are realised through use in combination with other

sound choices. But importantly we need to avoid simply randomly choosing sounds and sound qualities to show what they signify, in the manner of traditional semiotics, and take care first to show the available choices. The following chapters deal with inventories for different semiotic modes in popular music: image, sound and word. Chapters 2 to 5 show how we can systematically analyse the ways that pop musicians communicate about themselves through these different modes. Through each they are able to draw on repertoires of meaning potentials.

This book is titled *Analysing Popular Music: Image, Sound and Text*. What is meant by the last part of the title has been clarified. But what is meant by 'popular music' here requires a few words. Much of the music and the artists analysed in this book are from contemporary music from the 1960s onwards. But there is also reference to classical music, jazz and blues. Contemporary pop music cannot be understood without drawing connections and differences. But for the most part 'popular music' in this book refers to the music that surrounds us in everyday life. We continually hear adverts that contain music. We hear movies and film drama, music in supermarkets and while we are put on hold at call centres. This music is used as entertainment, to provide background mood, to give things salience, to fill spaces, to create meanings to settings, people and events. While the main aim of the book is to provide a way to analyse what we would normally think of as 'pop music', this is best done though an analysis of the different ways music is used.

It is also important here to say something about the context of listening. To some extent the analyses provided in this book are 'disembodied'. This means that they are removed from the actual everyday way that we normally listen to music. As we will argue in the next chapter, there is in fact no 'neutral' or 'natural' way to listen to music. But it has become common in media and cultural studies to point out that how people interpret media will depend on many individual, cultural and contextual factors. What a television programme or magazine will mean therefore is in no way fixed but depends much on the viewer themselves, and on how and where they watch. We can argue that the same goes for music. The songs and sounds we analyse throughout this book may be listened to and enjoyed by people generally in their car, while they share food with people, while in a sweaty gig. The actual meaning of a song or set of sounds can change for us over time. A really great record that made us want to jump around might later depress us as we associated it with a break-up with a partner, for example. This issue of context should be borne in mind throughout the book. But in the tradition of linguistic analysis that this book takes as inspiration, it has been shown to be highly productive to identify some of the repertoires of meaning potential

that can be found in music and sound. And while there have been many studies of audience uses of popular music there have been few that have explored the way that its sounds can be analysed.

The toolkit provided in this book is aimed at those with no prior musical knowledge. Even where, for example in Chapter 5, there is discussion of the meaning of the different notes in a musical scale this is translated into a kind of analysis that can be easily carried out by a non-musician – although the kind of analysis that takes place throughout this book gets easier with practice. Sections and chapters contain activities to help develop such familiarity.

The book's contents

Chapter 1 introduces some of the discourses we have for thinking about music drawing on sociological work done on music. The aim of this chapter is to explore the main discourses of music that we find communicated through the images, music and text produced by different artists. Theorists have pointed to the centrality of the concept of authenticity, of music being from the soul, where only certain kinds of artists can lay claim to this ability. The origins and uses of this concept are explored. This takes us on to consider the way that some music is associated with the body and other music with the mind and why 'black' music is associated with the body and with movement. It is revealing to consider why there seem to be rules for expressing how we enjoy certain genres of music. Some writers have dealt with the way we talk about music that has certain predictable patterns, asking why we believe that our ability to appreciate certain sounds says something about us as people. We explore these patterns. The chapter then moves on to look at two areas that have been central to the study of popular music. One is the idea of music being part of **subcultures**, asking whether this is indeed the case. The second is the idea of creativity versus corporate control, itself a largely invented distinction but nevertheless important in the way we like to think about music.

Chapter 2 is the first of two chapters that deal with the analysis of the realisation of the discourses dealt with in Chapter 1 through visual semiotic resources. The chapter begins with an analysis of the **iconography** we find on record sleeves of different artists, looking at settings, poses and objects. It then moves on to **modality**. This is one way to analyse what is real, more real or less than real in images. This is one important way that discourses can be managed and comes from analysis of truth claims in linguistics (Hodge and Kress, 1989). While we use record sleeves as examples for analysis the toolkit can be equally applied to webpage, magazine features and other kinds of publicity material.

Chapter 3 continues the analysis of visual resources, moving on to typography and colour. Van Leeuwen (2005) and Kress and van Leeuwen (2002), using their social semiotic approach based on the functional linguistics of Halliday (1978), showed that it is possible to look for the ways that qualities of typeface and colour can be used to communicate ideas and moods, and create coherence across images. On any composition these can be described precisely in the manner of doing a lexical and grammatical analysis of written texts. We can then consider what discourses are being communicated. Why, for example, do some artists use curved rather than angular fonts? Why do they use letters that are spaced out rather than close together? As regards colour, why might some record sleeves contain saturated colours and others more muted colours and a more limited colour palette? As we show, such semiotic choices are fundamental to the way that artists communicate about themselves.

Chapter 4 moves on to the analysis of lyrics. Many dismiss lyrics in pop music as fairly trivial, especially since most of them seem to be about falling in love or breaking up. But some analysts have shown that even love songs have changed dramatically over the years and reflect broader cultural changes. What men and women look for in relationships, what problems they have with each other and how they deal with break-up have changed reflecting changing gender roles and notions of sexuality and individualism. In this chapter we show that bands can communicate broader discourses about themselves even through lyrics that at first listening seem quite abstract or mundane. We begin by looking at the underlying activity scheme in lyrics. This allows us to reveal the underlying cultural values expressed by bringing out the core sequences of activity in the song. We then look at how to analyse participants and action. In the first case we think about the 'who' of the song. Are these named? Do they perform roles? Are they 'babes', 'American idiots', 'anarchists', 'the people'? In the second case we consider who has agency in the song. Drawing on Halliday's (1985) account of linguistic categories of action we show who considering who does what is revealing of the social world connoted in lyrics.

Chapter 5 is the first of two chapters that present a toolkit for analysing the music itself. In these two chapters we are interested in the way that choices of semiotic resources in sound can connote discourses. This chapter deals with the meaning of **pitch** and melody. Why is it usual for some folk singers, such as Bob Dylan, to use a very limited pitch range, while in soul music we might find very large pitch ranges? In punk we even find whole songs where the singer hardly deviates from a single note, therefore using an extremely restricted pitch range. And why does much folk music use melodic phrases that descend in pitch, whereas much pop uses rising melodies? All of this, we show, is connected to giving out of emotions and emotional containment.

Chapter 6 is the second of our chapters that deal with semiotic choices in sound. This chapter deals with the meanings of arrangement, sound qualities and rhythm. Here we are interested in the actual kinds of sounds used by different artists, a 'raw' sound compared with a 'melodic' or 'soulful' sound. What are the semiotic resources used to create these and how does arrangement affect the way these create meaning?

Chapter 7 assesses the extent that one genre of music shares musical and sound quality features. A number of theorists have argued that genres of music are associated with particular discourses, for example that indie music is authentic and anti-mainstream. But there has been no analysis of the way that such discourses are communicated through sounds. Using mainly the concepts from Chapter 5 but also drawing on those from the preceding chapters on image and lyrics the chapter analyses the music of three British pop songs.

Chapter 8 offers a number of ways to analyse the music and sound effects in movies. In film studies there has been work explaining *what* music does in film but none that has dedicated itself to showing specifically *how* it does this. In the first part of the chapter we look at how music creates setting, character and action. In the second part we start to explore the way that music combines with sound effects. In Chapter 2 we show that images, like language, can be judged in terms of modality. This is to do with how elements and features appear as they would were we to see them in real life. Are they less than real or more than real (have certain details/qualities been enhanced)? Here we look at the way that sounds in movies can be realistic, or can be changed in a number of ways, or even symbolised, in order to communicate particular meanings. We look at a systematic way to analyse these changes.

Chapter 9 expands our assessment of modality of sounds in video. But in the first place the aim of this chapter is to show how we can analyse the way that video and music work together to create meaning drawing Halliday's (1978) account of clause relations in language that has been used subsequently by a number of authors to think about film editing (Iedema, 2001; Baldry and Thibault, 2006). The chapter begins by comparing two pop videos from Coldplay and The Clash showing how sound, image and editing style can work together to communicate discourses, and can also elaborate and extend the discourses created by each other in mode-specific ways. The chapter then moves onto compare the use of music and sound effects in two pieces of television drama, *ER* and *Sex and the City*. Again we are interested in the way that the different modes work together, including at the level of modality.

Discourses
of Popular Music

A number of discourses dominate the way we think and talk about popular music. They shape how we assess what is good and bad music and what is meaningful and trivial music. They influence the way we think about our own musical tastes and knowledge and lead us to believe that these tell us something about ourselves and in turn that the tastes of others tell us something about them.

It is these discourses that tell us that a boy band does not produce music from the heart, whereas a blues artist does. In fact what we actually mean by such an evaluation is never clearly articulated. But nevertheless it can lead us to be less forthcoming in expressing our enjoyment of one of their songs and may even prevent us from enjoying it at all. In a discussion about music in a lecture theatre a student who confesses to liking a boy band will most likely be mocked by their classmates. I have seen it happen often. But if it is good pop music why should it matter? We are not laughed at for our tastes in food or because we prefer to take our shower really hot rather than cold. Both these are sensory experiences, as is listening to music. Nor are we evaluated for the kinds of paintings we prefer. We might consider that someone has bad taste but this is different to the way our musical preferences position us. Such notions might sound trivial, but unpicking them to clearly describe the discourses that underpin them provides a valuable resource for the analyses in subsequent chapters.

In this chapter we explore the idea that the meaning of any piece of music is not so much in the sounds themselves but in the discourses we have for understanding them. In other words, we put the meanings there. Frith (1996) has said of music that 'to understand cultural value judgements we must look at the social contexts in which they are made, at the social reasons why some aspects of a sound or spectacle are valued over others' (p. 22). In subsequent chapters of this book we present a set of methods for exploring how artists communicate such cultural value judgements, what we here refer to

as discourses, through look, sounds, voices and lyrics. Here we start to think about what these discourses are.

Authenticity

The discourse of authenticity is at the heart of the way that we think about music and can be seen signified in the different semiotic modes through which artists communicate, through their sound, look, lyrics and what they say in interviews. This idea of authenticity can be illustrated by the different way we evaluate an indie band as compared to a boy band. We might accept that the indie band is authentic but a boy band is certainly not. What is important here is why this is the case and what underlying social values are in operation to bring this evaluation about. Authenticity is something we take for granted but seldom try to define systematically.

To help illustrate the different ways we think about these two kinds of music Cook (1998: 9) gives an example from the *Muppet Show*. There is a scene where one of the puppets plays the part of a classical musician who has the opportunity to play a duet with guest blues guitarist Ry Cooder. The puppet is terrified as he cannot play music without a written score. Ry Cooder gives him a lesson in playing music from the heart, 'letting it come naturally'. In other words, natural music, the blues, is contrasted to music of artifice, classical music. When the puppet does this, letting go and playing naturally, it sounds just like the blues. So the blues is not simply music but natural sounds that come from within. Therefore it is about self-expression as opposed to the structured classical music, which is not. Classical music is part of a literate tradition where music is written down, where there are formal rules as to how it should be played, where institutions school performers as to how this should be done properly. This idea of nature versus artifice underpins much of how we assess music and there is an established range of conventions for it to be communicated. What exactly these are in terms of sounds and performance will be explained in later chapters.

Since the blues is viewed as an authentic expression of an oppressed race – music from the heart – in contrast to the formality of the classical tradition of concert music from Europe, it is considered to be the archetype of music that genuinely expresses true emotion and feeling. In the case of the boy band there is clearly an association of lack of this deeper expression of feeling. To say a boy band produced music from the soul would seem inappropriate.

This idea of authenticity has its origins partly in the Romantic tradition where it was considered that artistic creativity comes from within the soul and is somehow connected to God. Writers such as Goehr (2007), who have written extensively on the history of music and

composition, show how this is connected to the emergence of the notion of individual works of art, of creativity being an individual process rather than something that emerges out of society, out of wider shared cultural practices. Authenticity suggests the opposite, that creativity is individual where there should be an absence of artifice or culture.

This view of the meaning of music emerged in the 19th century. Before this time very different views were held. In 17th-century Europe it was thought that people of certain temperaments would be affected by different kinds of music (Cook, 1998). Lang (1972) cites a theorist from the time who writes: 'martially inclined men are partial to trumpets and drums, and they reject all delicate and pure music' (Kircher, 0000: 544). The idea was that temperaments would respond naturally to particular musical characteristics. In this way music was seen to represent nature itself, into which human character was also tied.

By the 18th century this idea that music represented nature was altered by the idea of 'affects'. Here, due to its connection to the soul, music could convey feelings such as anger, love and pain. This can be heard in opera. Music could speak of the torments and joys of the heart and soul in a way that words could not.

In the 19th century musicologists such as Schenker (1979) argued that music was some higher form of reality entering into our own. This was a view of music that had been around since the time of Pythagoras who had hypothesised that the universe was organised around the same structures as those found in music. The music we hear therefore is the sound of the force of the existence of the universe. Schenker thought music used genius composers as a kind of medium to communicate this higher reality with ordinary people. Music is therefore a window to a different world. During this period, as science was replacing religion as the dominant belief system, music 'provided an alternative route to spiritual consolation' (Cook, 1998: 38). From this lies the logical association with musicianship and ethical qualities, being true to oneself, being sincere – qualities we might group as part of authenticity.

When we assess artists this is often in terms of whether or not they produce music from the heart and whether their performance has some kind of sincerity or whether it is contrived. In the case of a boy band we perceive a look and music designed for specific markets; in other words, something that is produced, contrived, of culture rather than of the soul. We feel, therefore, that there can be no authentic expression either in sounds, looks or lyrics. This means that such acts, however catchy their tunes, however innovative they might in fact be, however finely crafted their songs, will not be taken seriously as evidence of true musical expression. In fact this is odd considering the huge amount of marketing and promotional work that goes into

most acts. Frith (1996) explains that importantly authenticity is not something thought through when people use it and only relates to some kind of sincerity or commitment.

Even music that is clearly predictable can be thought of as being from the heart if it is the right genre. I have sat in blues bars where the musicians looked and sounded like a cliché of blues. Yet from the facial expressions, movements and responses of the punters it was clear that they were witnessing music from the heart and certainly nothing contrived.

One of the reasons that folk music manages to maintain its authenticity, no matter how predictable it might be in terms of sounds, looks and lyrics, is that it is associated with tradition and an older form of social organisation. It is the authentic sound of the past unpolluted by artifice. This is why it is important to play acoustic instruments or 'traditional' instruments. It is a music unspoiled by urban and technological contamination.

Chapman (1996) shows that the idea of folk being an authentic roots music is simply not correct. Much of what is known as 'Celtic' music, for example, has nothing to do with any concrete relationship to any kind of place or time. Nor, he argues, are the instruments traditionally Celtic. This is, he says, is about 'nostalgia for (...) the traditional past, and perhaps a good deal of naivety about the nature of that past' (p. 31). He points out that the idea of a separate Celtic music ignores the fact that if there ever were a Celtic people then they, for as long as we have records, have been involved in **mainstream** European events. Also the idea of 'traditional' Celtic instruments is equally fictitious. The three-drone bagpipe is a relatively new invention yet it is now internationally accepted as an authentic Celtic sound that speaks of ancient times and people of the land (p. 37).

The musicologist Cook (1990) was interested in the way that we have assumptions about how older forms of music should sound even though we have no recordings of original performances nor accurate transcriptions. For example, we have no idea what medieval music sounded like yet we attend a themed banquet where there are period musicians, and they sound just as we expected (p. 56). Musicologists have demonstrated that we have no real basis on which to make this assumption and that such music may have sounded completely different. Taruskin (1995: 164) states that:

> absolutely no one performs pre-twentieth-century music as it would have been performed when new. This may be so easily verified that it is a wonder anyone still believes the contrary.

He gives the example of the music of Beethoven where eyewitness accounts from original performances speak of the way composers would themselves ignore and play around with embellishments and

Analysing Popular Music

16

tempos when performing their own pieces or conducting. Beethoven himself wrote 'Tempo of feeling' on his scores; in other words, 'play as you feel fit'. Taruskin suggests that such issues are now glossed over in performances. He believes that Mozart and Beethoven would listen to contemporary CD recordings of their music with 'utter discomfort and bewilderment' (p. 168). He notes that even early 20th-century recordings of classical pieces sound odd to us now such have ideas of authentic sound been merged with current requirements for how the past sounded.

Goehr (2007) points out that the way we now think about classical works is mistaken. Composers such as Mozart wrote music that they expected to be disassembled and played according to the needs and mood of settings. Often what we now know as individual works were never meant to be so.

I once heard an American colleague who had Welsh ancestors say that when they heard Celtic music, which included bagpipes, for the first time at a Welsh cultural festival they felt that somewhere deep inside they recognised the music, suggesting that the music touched them in a special way as it chimed with their own spiritual connection to the land. Of course this is not to take away the pleasure involved in such imaginings, but it reveals something of the discourses through which we understand sounds and that this influences the way that we hear them. These 'Celtic' sounds not only represent a former time but are literally tied in with the very mists of the ancient lands and peoples we associate with them. Of course the colleague would not have wanted to take the point this far and had made the comment flippantly in a wistful moment over a beer. And I would be the last person to want to take away the pleasure that such a feeling brought to him. But it was based on certain cultural assumptions that allowed him to put these meanings into the sounds and not on anything to be found in the sounds themselves. Cook (1998) concludes that it is the stories we tell about music that help to determine what it is. He puts it thus: 'The values wrapped up in the idea of authenticity, for example, are not simply there in the music; they are there because the way we think about music puts them there' (p. 14).

In subsequent chapters in this book we will be looking at way that artists are able to connote authenticity through certain sounds, looks and lyrics. Authenticity is itself a discourse that can be realised through a range of semiotic resources.

To raise one final point on authenticity, another reason that a boy band is not authentic is that they are not the creators of the music but performers. Performers do not have so much status, unless they establish a status as an original interpreter, such as Billie Holiday. This is slightly different in the case of classical music where certain

virtuoso musicians are considered to be geniuses and in touch with some kind of divine force.

Taruskin (1995) suggests that classical music reveals a particular contradiction in our idea of authenticity. On the one hand, authenticity is about conviction and expression of emotion. But, on the other hand, we also like to think about authentic works. So how does a classical performer remain faithful to the original and convey authenticity through the expression of emotion? Cook (1998) explains that it is odd that such musicians are credited with providing unique interpretations of compositions yet no one ever discusses where the boundaries of interpretation and improvisation meet. Therefore, what interpretation means is never articulated. Yet it becomes a discourse for talking about music and again can be understood as a culturally based way that it has meaning for us.

Body and mind split

I was at a gig enjoying the music of one of my favourite musicians. The audience had all remained seated for most of the performance but during the encores began to leave their seats to dance in the aisles or just to stand where they were and sway and wave their arms about. I didn't have the urge to do this and simply sat watching and listening carefully. After the gig some friends asked if I hadn't enjoyed it, that I didn't appear to get into the music. In fact I had been enraptured. Here we have another discourse about the meaning of music: how it relates to our body and mind and how we can use music to express ourselves. It also shows how people are convinced that there are correct and incorrect ways to express enjoyment of music. Clearly in the case of this gig I had not done so in the right way. I was too busy listening and watching.

For a time I played regular weekly slots in a jazz basement. When I was playing solos audience members would sit smoking and sipping drinks thoughtfully and then clap lightly when I had finished or maybe even just nod a few times or tap the side of their glass with their finger. Occasionally someone might exclaim 'Yes!' as I finished the solo. But there was certainly no raising of arms, leaping around, nor smiling. During the same period I played regular gigs in a blues band. Here people would whoop during solos, shout 'Yeah', would dance in a walking type of motion and occasionally shake their heads as if trying to shake water from their hair. But there would be no leaping around. Earlier in my musical career I performed in orchestras where the audience would sit completely still in silence and then applaud rapturously when they were sure the piece was finished, with of course a few minor ripples, quickly and shyly withdrawn, in some of

the pauses. There were even different facial expressions commonly seen at the different performances. At the blues gig punters would screw up their faces; in the jazz basement you would tend to see furrowed brows, head slightly to one side, suggesting concentration. At the classical concert faces would be open, with the occasional smile.

There are clearly kinds of behaviour appropriate to watching and listening to different kinds of performance and for expressing our appreciation of the music. Frith (1996) has discussed the way we have developed an association of fun with the body and seriousness with the mind. This also helps to explain how what we think of as 'African music' or blues has become associated with the body and movement and classical music has become associated with the soul, intellect and quiet contemplation.

Frith (1996: 124) explains that these associations have their origins in Europe and the USA in the 19th century. We must be still and silent during a classical concert or a jazz session as there is something intellectual going on. Serious music needs to be contemplated carefully. But at a rock concert such behaviour is seen as silly, repressed or as missing the point. This is the difference between listening with the mind and listening with the body, which has its origins in the Romantic dichotomy between nature and culture and their corresponding associations with feeling and reason. Feelings were therefore associated with the body as opposed to the intellect. For this reason pop music is often seen as simplistic and not requiring intellect. It is not listened to intellectually but physically.

Frith (1996) argues that it is this association with the body and the natural as opposed to the mind and culture that has allowed pop music to come to be seen as a way of casting off bourgeois inhibitions. The distinction between the body, instinct and feeling as opposed to the mind, intellect and reason sets up the idea that music of the body is free from restriction of the intellect and of high culture. So artists, simply through using certain sounds and visual references that connote this discourse, can indicate that they are of the body, the low brow and not of the bourgeoisie repressed social condition. Of course pop musicians can use this to indicate that they are anti-respectable to give a sense of challenging social convention, when in fact they do nothing of the kind. This is convenient for listeners who can align themselves alongside a spirit of anti-establishment simply by buying and enjoying a particular kind of music.

Black culture and music is generally viewed as the paradigmatic music of the body in opposition to the bourgeoisie intellect. Frith explains this in the context of the Romantic tradition where black people were seen as primitive innocent people, 'uncorrupted by culture, still close to a human "essence" ' (p. 127). The argument goes therefore that African music is more sexual and physical since

Africans are more in touch with the body and are associated with unmediated sensual states.

Frith's points help us to understand our earlier example from the *Muppet Show*, where black music is intuitive, instinctive and unmediated sensual expression compared to the formal intellectualisation of classical music. Therefore, the blues itself can free us from the strictures of culture. These points can also help us to understand the difference between the blues and a boy band. The boy band is not an unmediated expression of intuitive feeling as they have been contrived to address a particular audience. Even though the blues band may also have been designed for a market, both by the artists themselves and by a record company, they carry more associations of instinct.

One thing we often take for granted in the context of the body and music is that rhythm and beat are somehow some kind of rhythm of the body, a pulse or heart beat. Frith (1996) suggests that there is something odd about this. He asks why beat is never compared to machines, to clockwork and therefore why these kinds of rhythms are never thought to affect us in this primitive way (p. 133). As with authenticity this kind of discourse is not clearly thought through and appears simply as a natural way to think about music. Using a machine to talk about an effect on the body appears as contrary to the idea of the soul, the spirit and expression from the heart, and to the romantic notion that music connects us to some higher plane. Rap music is able to use the sound of the drum machine to a different effect. But rap, of course, has a number of other important indicators of authenticity. We will be analysing these in later chapters.

As well as being the paradigmatic case of authentic, unmediated music of the body, African or black music is often distinguished in terms of the centrality of beat. But a number of writers have challenged the very idea of an 'African' or 'black' music being one category of music at all. Negus (1996) suggests that the very idea of African music is absurd. Africa is the largest of all continents with massive genetic, cultural and linguistic variation that is more distinct than across the whole of Europe and between some European and African areas. Yet it is common to call music 'African' or 'black'. Gilroy (1994) has discussed the oddness of this particular role given to black and African music. He describes this as the 'place prepared for black cultural expression in the hierarchy of creativity generated by the pernicious metaphysical dualism that identifies blacks with the body and whites with the mind' (p. 97).

The question is to what extent can we indeed find any evidence for this 'bodyness' in black music? I personally have heard white musicians saying that they could only ever copy a black musician, but never really play like them, unless they were themselves black, meaning of course that black people are more in touch with a bodily

kind of expression. Such white musicians would consider this as a non-racist statement, as showing respect and reverence for black musicians. But is there evidence for these things in black music?

Tagg (1989) has argued that all of the features often ascribed to black music – i.e. African-American music – can be shown to be characteristic of much music played by people around the world and through history. For example, the blue notes that give blues its sound can be found in most European folk music. Further, he argues, that what is generally referred to as European music in contrast to African-American music is highly selective and elitist. Tagg concludes that there are no intrinsic musical styles that are essential to black music.

Negus (1996) explains that there are hundreds of European musical traditions, many of which contain all the ingredients often attributed to black music – blue notes, syncopation and improvisation (p. 104). But this is the kind of music that black people have been allowed, or encouraged to do, which has then become what they do produce. Artists such as Scott Joplin had their operas ignored while their ragtime was celebrated. Also the technical aspects of what we think of as black music tend to be ignored. Kofsky (1970) points out, for example, that the jazz of Charlie Parker was highly technical yet is mainly associated with feeling. Much of John Coltrane's saxophone soloing is highly mathematical and of incredibly high technical rigour. Yet this is not talked about in this way but rather in terms of its spirituality. One result of all this according to Gilroy (1994) is that black people can end up using this kind of romantic reference to define themselves. The problem, he suggests, is when it is treated as essentialist, black identity is treated as unchanging, monolithic, a kind of ethnic absolutism. What being black is can be constructed through these categories even though this lumps together massive racial and cultural variations.

Hutnyk (2000) has commented on the way that this essentialist view of black identity has been a central feature of its commodification. What we think of as black music works through a racialisation that has been a central part of the marketing of this music to both Euro-American audiences and to black audiences themselves. In agreement with Gilroy, he suggests that this has also served as a means of 'presenting identities for self confirmation and internalisation to black communities themselves' (p. 20). This racialisation leads to a perception that music can simply represent monolithic ethnic groups, where black musicians represent music from the body. At music festivals such as Womad, he points out, African and Caribbean musicians offer multicultural music based on ethnic marketing categories.

From this discussion about authenticity and the body notions of musical affect we can begin to see why we talk about music in terms

of the way it says something of our character, why we feel that music comes from a realm other than culture, that it is associated with the soul, and that it is connected to nature, and why it can allow us to challenge bourgeois culture. Of course we rarely find such discourses articulated directly, nor do we find people struggling with the contradictions between them. Taruskin (1995) suggests that these kinds of discourses have become the 'moral slang' of our age. In other words, we use them to give meaning to our experiences though they are by no means concrete terms.

How we talk about music

In the introduction I suggested that just as when the linguist analyses grammar and patterns in the use of language in literature and poetry that this takes nothing away from the pleasures that they can bring, so there is no reason to suggest that a semiotics of music takes anything away from the way it affects us. However, there is an argument that when we listen to music for leisure we do not attend to the same features and qualities as we do when we approach it for purposes of analysis. It is akin to analysing a fine painting in terms of the kinds of brushstrokes and use of perspective. This is not how most of us enjoy such works and not why they move us. But there is a problem with this view of listening as it implies that there is a way to do it neutrally and completely unmotivated. Again here we see the influence of Romanticism where it is assumed that there is a kind of listening where we simply connect spiritually or bodily with the music. But how we talk about the way that music affects is a valuable resource that can give us further access to the discourses we have for understanding it.

Frith (1996) gives much thought to what we actually think listening to music is since this can tell us something about what we believe music to be. The music reviews we find in the music press are one source of such views. Here is an example of how critics write in a BBC review of an album by Willie Nelson and Wynton Marsalis called 'Two Men with the Blues':

> Nelson's vocals on Stardust are a touch brighter than Hoagy Carmichael may have intended but the effect is leavened by a smokey, gently twisting trumpet line full of yearning beauty courtesy of Marsalis. Another Nelson standard, Georgia On My Mind, has a sweet, subdued but compelling intimacy and could legitimately lay claim to the title of ultimate standout track on an album of standout tracks. (www.bbc.co.uk/music/release/3brg/)

We find a number of terms to describe the trumpet sound: 'smokey', 'twisting' and 'yearning'. Frith says that such descriptions may indeed appear as elegant ways of describing the work of a musician. But in

other ways he feels they say more about pop history and culture and what we have come to believe of music (1996: 68). These are clues to what we think music is and how it should affect us. If we were to comment to a friend about a boy band song heard casually on a radio playing in a café that we thought the trumpet was 'smokey' and 'yearning' they would think we were mad. And indeed in reviews for the records of boy bands such things are never mentioned. 'Smokey' here conveys something of the jazz basement and 'yearning' of bodily feelings. Such terms are not fitting for the music of a boy band. Reviews for John Coltrane records say little about his technical abilities and the arrangements but much about the 'soulfulness', 'longing' and spiritual journey of his music. Clearly the adjectives chosen, as Frith suggests, speak not so much about the music but about pop history and discourses of music. In fact boy bands are often assessed in terms of which other artists they sound like, or, if it is a second album, whether they can be taken seriously as musicians, whether they can mature.

Some have argued that since music can only ever connote and never denote it is impossible to describe. Ethnomusicologists such as Charles Seeger (1977) have questioned the degree that words can express musical experiences. Roland Barthes (1977) made the point that music in language is 'only ever translated into the poorest of linguistic categories: the adjective' (p. 291). But these comments suggest that there might possibly be a neutral language for describing music or that somehow there are affects that are free of the discourses we have for talking about them. As Frith suggests, these provide clues as to what we think music is.

So what is music? For Cook (1990) it is not possible to answer this question in terms of anything to do with sounds themselves. Some theorists such as Hanslick (1957) have argued that music can be distinguished from nine musical sounds as they involve the use of fixed pitches, where as all naturally occurring sounds generally do not. For Cook (1990) this creates problems. Much music does not involve fixed pitches, such as Japanese *shakuhachi* music. Morse code has fixed pitches but we wouldn't call that music. We might hear workers on a nearby building site bashing out melodies accidentally as they hit metal and saw wood. For Cook:

> it is not possible to arrive at a satisfactory definition of music simply in terms of sound (...) because of the essential role that the listener, and more generally the environment in which the sound is heard, plays in the constitution of any event as a musical one. (p. 11)

Cook gives the example of John Cage's 4' 33" for piano. This is an entirely silent piece. A pianist arrives on stage, opens the keyboard and sits motionless for the duration of the piece. What happens is that people in the audience become hugely aware of the sounds

around them. Cage's point was that anything can be heard as music. He went on to compose silent pieces to be performed in all sorts of contexts. For Cook this shows that composing music is not so much about making musically interesting or appropriate sounds as it is of creating contexts in which those sounds will be perceived as musically interesting (p. 12). We can argue that this is what pop musicians partly do. They work to make contexts (image, look) that help to make the sounds they make relevant and more interesting to people. Making them relevant and interesting, as we have already shown, may mean creating the right conditions for listeners to put meanings into the music. So the right look, sound quality or lyric, the right behaviour off stage, helps the listener to realise particular discourses, such as authenticity, for example.

We can do courses in musical appreciation, read books, or read critics in the music press, that teach us to link what we hear in the music to biographical facts about the composer and historical information about the musical style. Jazz lovers may know lots about a performer and their music and particular narratives will become established about these performers. But this is not the case for all kinds of music. Only authentic artists, or those who exhibit genius, are to be discussed in terms of biography and influences.

There is also a resistance to being told by experts about what we should listen to in music or how we should listen. We feel we have the right to have our own emotional responses to music. Cook (1998) points out that in concert notes about classical music or about jazz musicians at a performance we may have no idea about what is described in terms of things like 'large scale tonal structures' or 'modal blues'. But we enjoy the music nevertheless and may wish to vehemently point this out. It feels rather like being told exactly how to enjoy other sensory experiences such as taking a hot shower or eating our favourite meal. But as we have seen throughout this chapter both what experts say about music and the very fact that listeners claim to have a natural way of listening free of technical knowledge both offer evidence of the way that culture shapes what we think music is shaping our listening and participation.

The fact that there are experts in music and that enjoying some kinds of music is believed to be enhanced by expert knowledge does have another effect: it drives a high–low culture distinction. Some have the power to define what is good music and what is trivial or no more than simple entertainment. This expertise and authority of aesthetic sanction brings power. We see this at the level of musicology, rock criticism and even where a group of dedicated indie fans, as in Hibbett's (2004) case, pride themselves in having knowledge about musical tradition and origins, therefore excluding those who are not real fans. Frith (1996) has thought about this in terms of the

way that we can establish a sense of identity and difference through this process of displaying the ability to discriminate good, bad and important music (p. 18). He draws on Bourdieu to argue that

> the aesthetic interpretation of high art is, in fact, functional: it enables asthetes to display their social superiority. (p. 18)

So the very fact that we pride ourselves on recognising talent and good music is part of perpetuating such distinctions. The audience at the jazz basement who said 'yes' at the end of a saxophone solo are displaying their aesthetic appreciation and therefore alignment with jazz heritage. So to understand any kind of value judgement made about music we must look first at the social contexts in which we find them made. Then we must ask why a kind of music, a sound, a look, a particular of performance is valued over others. This process means looking at the way that the kinds of discourses we have been looking at in this chapter are used as taken-for-granted measures of what music is. But, crucially for the purposes of this book, it means that we can establish and inventorise the way that certain kinds of sounds, words and arrangements become associated with notions like talent and creativity and others not.

Music reflects subcultures

A further way that we talk about music is through its association with 'subcultures'. We often hear people talk of things like 'indie culture' or the 'indie scene'. In Cardiff where I live there is a music venue which attracts acts from a range of genres. When there is a gig queues stretch out along the street. It is a simple matter to identify the genre of music by clothing, haircuts and poses. We have already dealt with the way that being a fan of a particular music can bring a sense of expertise or can indicate our alignment with authenticity and anti-bourgeois sentiments. But why the need to dress the same? Can we indeed think about these groups of genre fans as a kind of subculture or scene?

I have a friend whose highlight of the year is the folk music festival Womad, from where she usually returns with a range of 'ethnic' music and jewellery. This friend is marginally active in Amnesty International and is always proud to take part in peace and anti-war demonstrations. When she last returned from Womad she showed photographs of herself with a fire-juggler, of her participating in 'African' dancing, eating exotic foods, and sitting listening to indigenous 'Latin American' poetry. These things form a familiar collection of cultural practices and artefacts. When I have been to this friend's house for dinner I have met more of her friends with whom she attends festivals who share the same set of interests and aesthetic

pleasures. But to what extent do they form some kind of identifiable culture? It is clear, for example, that we will not tend to get the African dancing, juggling and ethnic jewellery at an indie or rap gig.

At the end of the 1970s Dick Hebdige, in his book *Subculture: The Meaning of Style*, discussed what he called 'style' in order to explain the way that subcultures combined elements to communicate a way of life. He gave the example of punk music that used visuals of torn clothes, swastikas, spiky brightly-dyed hair and swearing to point to their dissatisfaction with society. Of course punks had no coherent criticism of society, nor did they offer any solutions, but they were able to show their disillusionment through how they looked and spoke, and also through the **distortion** and directness of their music. I recently saw a photograph of a colleague in his punk gear in 1980. On his jacket was written the word 'destroy'. This was about indicating a lack of alignment with consensus culture rather than with physical destruction itself.

Hebdige thought that punk was basically about challenging the mainstream culture done through appropriation of things from that culture. All this came from working-class young men who, disillusioned with much in their lives, found alternative ways to create meaning. In the case of punk and other subgroups, such as the mods and rockers of the 1960s, their existence could be seen to be as a response to specific circumstances. And given our discussion of the way that music can be an authentic expression of the soul and also indicate certain individual dispositions, it is not surprising that people might see it as being part of the core of their identity.

Clarke (1990), however, was critical of this view of an active subculture challenging a passive mainstream. Many people who became punks were not part of any hardcore subcultures but simply had a particular haircut, wore a few of the clothes for a while, or liked some of the music. The colleague in the photograph, for example, went to university, became an academic and has shares in public services that were sold off in the 1980s. But when he had his spiky hair and carried the words 'destroy' and 'anarchy' on his jacket he felt good through his disrespect and difference.

Thornton (1995) thought it useful to think about such subcultures using Bourdieu's (1986) concept of cultural capital. Here young people use subcultural capital as a way of distinguishing themselves from others. For young teenagers there might be important cultural capital in wearing a particular kind of clothing for a while, or being able to connote the values of being anti-mainstream. So music and clothes can be seen as markers of distinction and status. Of course this can involve an extremely conformist seeking of acceptance and status, realised in the first place though acts of consumption. The

question can be posed therefore as to how can this be any challenge to the mainstream?

Laing (1985) was critical of the view that subcultures of this kind did ever really offer any kind of challenge. After all, the kinds of punk bands discussed by Hebdige made a fortune in sales, becoming mainstream themselves. The friend who goes to Womad considers herself as against the mainstream. Yet she lives in a large 19th-century house in an opulent area of town, owns several other properties which she rents out and likes expensive furniture. We could argue, using Chaney's (1996) account of lifestyle society that music cultures can be taken on in the same way that we take on other signifiers of lifestyle identity in consumer society such as the car we drive, the furniture we put in our house or the newspaper we read. Being into indie music or Womad's world music could be thought about as lifestyle choices. This is not to say that when we listen to this music that it will not affect us emotionally, but that the meanings are part of the lifestyles that we construct.

Kruse (1993) suggests rather that we use distinctions like 'mainstream' and 'alternative music' in order to differentiate ourselves from an imagined other. After all, she reminds us, 'Senses of shared identity are alliances formed out of oppositional stances' (p. 34).

For Thornton (1995) the very idea of a mainstream is itself problematic. It is often something proposed by people in order to authenticate their own likes and styles. What we call subcultures cannot be understood independently from the role of the media and commercial interests. This is all the more the case when we think about the signifiers of subcultures in terms of lifestyle society where we are able to indicate the kinds of person we are through consumer choices (Chaney, 1996). Negus (1996) makes the observation that much of what we think about as rebelliousness in pop music cultures is in fact pretty harmless. As we considered earlier, much of the challenge produced by pop music can be due to the way it is able to signify a rejection of bourgeoisie intellectual culture. In later chapters we will be looking at how this rebelliousness is connoted in sounds, looks and lyrics.

Negus (1996) asks a further interesting question about the nature of subcultures. What happens when they become internationalised, when we see punk in Tokyo, or a rap act in Turkey? A search on the Web reveals that many countries around the world have rap artists, who follow a very similar iconography and sing similar kinds of 'protest' songs. All wear very similar clothing and strike the same poses on their promotional material. Is it productive to think about this as a subculture or music scene? Negus asks whether what we are seeing involves simply imitation and commercial exploitations (p. 24). Again this brings us back to the idea of lifestyle. Challenges to the

social order through music genre such as rap are not systematically argued nor carried out but are connoted through aligning oneself alongside an unformulated idea of rebellion though striking certain poses, wearing clothes and making or listening to particular kinds of sounds. Rap is able to connote an authenticity of inner-city oppression, and also of macho aggression and pride, all realised closely to consumerism.

Creativity versus the music corporation

While the following chapters in this book will be looking specifically at how bands use semiotic resources – sounds, image and word – to communicate about themselves, it is important that we are mindful of the way that record companies are also active in this process, taking an important role in shaping the image of artists, in seeking market position and addressing audiences. Negus, writing in the mid-1990s, points out:

> Since the beginning of the 1990s, six major recording companies have controlled the means by which approximately 80 to 85 per cent of recordings sold in the world are produced, manufactured and distributed. These companies are Sony Music Entertainment, Electrical and Musical Industries (EMI), the Music Corporation of America (MCA), Polygram Music Entertainment, the Bertelsmann Music Group (BMG) and Warner Music International. (1996: 51)

Musical and visual language of music comes to our attention generally through large corporations. Even bands which are sold as 'edgy', 'indie', or 'anti-mainstream', have often been carefully marketed as such. In this book we will not be dealing with marketing or record companies (see Middleton, 1984, 1990). But there are a number of discourses about the role of corporations and the way that they are seen to interfere with and be opposed to creativity that are important to how we evaluate bands themselves that relate to music's or artists' authenticity, creativity and social relevance. These crop up in the discourse connoted by the semiotic resources used by bands.

Stemming from Adorno (Adorno and Horkheimer, 1979) many commentators have discussed standardisation in the music industry, where large corporations treat music like any other goods in order to maximise profits (Chapple and Garofalo, 1977). This can mean that even if an artist wishes to use their music to challenge capitalism or wider society this will become watered down through the way it is processed by corporations (Harker, 1980; George, 1988). Other writers (e.g., Negus, 1992) have pointed to a number of problems with

such views. It is not so much that corporations have no effects at all on music but that this view involves a romanticisation and simplification of their relationship to creativity.

From what has been discussed throughout this chapter it is clear that commercial activity sits in conflict with our idea of the creative artist who communicates something of the soul through their god-given raw talent. The big record companies are interested in profit maximisation. There is in principle, therefore, a difference of interest. Artists might be manipulated by their record label, become seduced by monetary gain and therefore 'sell out'. Worst of all, some bands become the product of a label, deliberately designed and marketed to appeal to particular listeners. We can accept that some artists do become very rich, and this is permitted so long as it as a reward for talent and not as an end in itself.

In the romantic tradition we also tend to resist the idea that creativity can be a large-scale collective act. We can see this, to step outside of the field of music for a moment, in the way movies can be thought of as art only where they are the product of a single director. In art house cinemas it is the movies of single-named directors that are shown and celebrated. Such movies sit more easily with our idea of authorship than studio-produced movies where huge production teams collaborate to make blockbusters. This is even where such works produce incredible cinematic experiences. In such cases we even seek out to name individual talents who make particular contributions, but not think of the whole as art. There is a similar thing happening in music where it is not acceptable that a musician, or at least our experience of them, could be improved by the involvement of the music industry itself. It should be the artists who design their own sound, look and image. Musicians who, we feel, have become too processed are thought to have sold out and lost their artistic integrity in order to sell records. But this will be judged through discourses of authenticity and not through any actual concrete facts.

There is also the idea that independent labels break new and exciting bands that would have been excluded by the majors, that the indie labels are much more able to provide room for true creativity. Negus (1992) believes that there is some evidence that such labels have made significant contributions but that such companies also have financial concerns as priority (p. 43). Therefore they have an investment in the same system. In a similar vein, Lee (1995), after researching independent labels, concluded that they still operate in the same capitalist system as the majors and that while they may make music for niche groups they do not provide any challenge to the nature of the market itself. He suggests that as they become more successful they are likely to move away from any sense of challenging the system. For Negus (1992) we should not make the

mistake of seeing indies and majors as some kind of opposition. They are connected by 'complex patterns of ownership, investment, licensing, formal and informal and sometimes deliberately obscured relationships' (1991: 18).

Frith (1983) suggests that the best way to think about such labels is as talent spotters, reminding us that many are often arms of majors. Being on an indie label can bring extra kudos, which is important in the way that artists need to be seen to be authentic. For example, Blur were on the Food Label which was part of Parlophone records, which in turn was part of EMI. But this allowed them, for some of their fans, to be an 'indie' band.

But Frith (1987) makes a more important point. He argues that what we know of as pop music, even that which we have thought of as most creative as most anti-mainstream, has come to exist not in spite of commerce, but in harmony with it. It was the music industry, the commercialisation of music, that allowed pop to happen in the first place. Pop music, as we know it, is not something that is apart from the process of the commercialisation of music, of it becoming an industry. Rock and roll did not emerge from outside of the system of capitalist production but is a product of the fusing of creativity and commerce.

For record corporations a new sound, or creativity, is part of the way they can make money. On the one hand, this important for what the public wants. But on the other, Negus observes, while record companies must be profitable their acts are also assessed in terms of creativity by DJs, journalists, fans etc., which means that to some extent they must attend to these things. Of course this means that commercial decisions, such as which bands to promote, can be about a commercial/creative set of predictions, meaning that at a certain time particular kinds of music might be preferred by record companies. But this can mean that at one time it is a new kind of sound that they are promoting. For Negus (1996) it is important to remember that what becomes commercially successful is not about the market deciding, yet nor is it a matter of the public getting what it wants (p. 50).

Much music, of course, gets made outside of the controls of record companies. We can see gigs in a local pub, create our own music on sound-editing software on our own computers and busk on street corners. But does this really mean that this music is beyond the influence of the big labels? After all, Negus (1996) argues, record labels have been powerful in defining what the canons are, what we get to listen to more broadly, how artists sound, play and look, and the attitudes that they should have. When I played saxophone in blues bands the punters knew what we should sound like as they had heard blues on records, on the radio, all distributed by corporations.

In this chapter we have begun to look at the discourses that shape the way that we think about popular music. In the following chapters the aim is to provide a toolkit for analysing the way these discourses are realised through the designs of record sleeves, promotional photography, music videos, lyrics and the music itself. In later chapters we therefore explore how artists are able to help listeners put meanings into their music.

1 Look at a list of chart music or musicians listed as nominated at an awards ceremony. Rate them in terms of authenticity and explain your choices in the context of what we have discussed in this chapter.

2 Access around six reviews of different genres of records. There is an abundance of these on the Web. Consider the following issues:

- What kinds of things in the music do the reviewers describe?
- What do they tell us about how we should listen to music?
- What makes good and bad music?
- What kinds of adjectives are used to describe the sounds?
- Is there a difference in which bands are described in terms of their musical influences?

Use your answers to these questions to say what kinds of discourses dominate about music.

3 Interview people who have different musical tastes. Ask them to talk about a particular song that they like. Note what kinds of discourses they use to talk about the music:

- How do they use the music to talk about themselves and others?
- Do they use a sense of the mainstream and counter-culture?
- How do they talk about the way that music affects them?
- How do they think music affects people who listen to mainstream music?

2
Album Iconography:
Postures, Objects, Settings

Artists need to tell us about themselves, about who they are, their meaning as an act and how to understand their music, not just through the kinds of sounds they make, but also through the way they look and move, through the photographs in which we see them and the art work they use on record sleeves. We are generally able to hazard a guess at what a band will sound like, through a record sleeve, or a publicity shot. In the last chapter we looked at our repertoire of discourses about what we think music is and the way that the meaning it has for us is not so much about the sounds themselves but the cultural meanings that these sounds have come to have for us. In this chapter we provide the first part of a toolkit for systematically describing and analysing the visual language of pop music which is one important part of the way that artists communicate these meanings. In this chapter we are interested in the ways that artists tell us about things like their authenticity, their anti-mainstream credentials etc., through visual semiotic resources.

When we analyse visual communication, such as a record sleeve, we generally jump immediately to 'affects' in the form of adjectives, rather than carefully first describing what we see. We might say it is 'arty', 'classic', 'edgy', or use terms like 'playful', 'sexy', 'modern'. But this means that, for the most part, we miss much of what is actually contained in the image. A linguist can show us how a sentence creates meaning in a way that we might not be casually aware of, by looking at the particular uses of linguistic semiotic resources; in other words, at individual word and grammatical choices. This means that the conclusions at which they arrive are based on careful and systematic observations and description. In this chapter and the next it is shown that our visual semiotic analysis likewise should in the first place be based on careful description. Traditional semiotics was based around the way that visual elements 'symbolise' or 'connote'. The *multimodal* discourse approach we take here involves a more careful description of the nature of those elements in order to build up a more accurate picture of how they are being used.

Figure 2.1 Clannad 'Legend' record sleeve

Figure 2.2 Iron Maiden: 'Seventh Son of a Seventh Son' record sleeve

In Figures 2.1 and 2.2 there are two record sleeves that deal in what for the moment we can call 'fantasy' rather than realism, although this is done in very different ways. One uses a cartoon/comic art

Figure 2.3 The Clash record sleeve

style and the other is a stylised photograph of a distant ancient land, presumably associated with legends, as in the title. In neither case do we see the musicians/artists themselves. In contrast, in Figure 2.3 the artists are represented and in a real setting, although the photographic style lends scruffiness and lack of clarity. What is of interest to us in this chapter is how these covers help to communicate certain discourses, values, identities, etc.

There is also a difference in the sleeves as regards the typefaces used for the artist names. These too communicate ideas and attitudes. How the shape and form of the 'Clannad' lettering is written to suggest something of the meaning of the band, as does the way 'Iron Maiden' and 'The Clash' are written. The Iron Maiden font suggests something more about strength compared to the Clannad font which is much more wistful and The Clash font which is untidy.

These are all ways that meaning about the band is signified for us, through a language that we are more or less able to read. But how we have so far described these visual cues is in terms of 'affect', through adjectives. So we have described a photographic style in terms of 'scruffiness', 'realism', a font in terms of 'strength' and 'wistful'. But jumping immediately to such descriptions of affect means that we miss out on precision in our observations. And such an approach to analysis is basically ad hoc. In other words, we make our interpretations as we go along. So, on the one hand we need to provide a way

of being more careful in our observations, and on the other provide a form of analysis that is to some degree predictive. To do this we need to take some steps in providing an inventory of choices available to designers, seeing them as lists of meaning potentials. This can then be followed by a careful description of what is found in designs.

The next chapter provides inventories of meaning potential for typography and colour. This chapter deals with the iconography of visual designs, the salience of elements, the way viewers are aligned to the people in images and levels of visual modality. Iconographic analysis draws on the traditional semiotics of Roland Barthes and involves focusing on the way that objects, persons, settings and poses are able to connote meanings. Salience refers to a set of basic principles whereby we identify which elements and features are the most important carriers of meaning. Modality, drawing on the work of Hodge and Kress (1989) and Kress and van Leeuwen (1996) is the analysis of the extent to which images or the elements in them resemble or are different to naturalistic truth. Modality has been shown to be important in the way that discourses can be assembled by conveniently concealing certain features and highlighting others (Machin and Thornborrow, 2003). We also introduce the notion of **metaphorical association** in visual communication which is to do Ⓖ with the way that visual elements can have meaning through the way they resemble things, or certain qualities of things in the real world.

Together these levels of analysis provide a set of tools that allow us to carefully build up our sense of how whole compositions create meaning, how different elements and features work together, in the manner that a linguist might build up their analysis of a text.

Iconography

We begin with the widely known semiotic theory of Barthes (1973, 1977) and his account of how images can denote and connote. But here the emphasis normally given to the two levels of analysis is switched.

On one level images can be said to document. In other words, they show *particular* events, *particular* people, places and things. Or in semiotic terminology, they *denote*. So asking what an image denotes is asking: Who and/or what is depicted here? So a picture of a house denotes a house.

Other images will still depict particular people, places, things and events, but 'denotation' is not their primary or only purpose. They depict concrete people, places, things and events to get general or abstract *ideas* across. They use them to *connote* ideas and concepts. So asking what an image connotes is asking: What ideas and values

are communicated through what is represented, and through the way in which it is represented? Or, from the point of view of the image maker: How do I get general or abstract ideas across? How do I get across what events, places and things *mean*? What concrete signifier can I use to get a particular abstract idea across? We can see how this is relevant for the designer of a record sleeve who wishes to think about how they can connote a particular set of meanings about the music that will shape how an artist is experienced. A designer may use a particular feature or element to connote a particular discourse which communicates about kinds of persons, attitudes, values and actions. So we can think about what discourse is connoted through the use of a cloudy lake scene, as on the Clannad sleeve.

Of course we could argue that there is no neutral denotation, and that all images connote something for us. For example, an image of a large house can connote wealth and excess. But considering what is denoted, arguably, is what is often undervalued in semiotic analysis. Students often look at an advertisement for a car, for example, and immediately speak of what is connoted in terms of 'energy', 'style' and 'modernity'. But here they are jumping a step. They are saying *what* is connoted but not exactly *how* it is connoted. When we listen to a political speech we might be aware that the speaker has managed to give a particular spin on a set of events, but it may take a linguist with their careful attention to the detail of the way that language is used to show exactly how they have done this. This is why we need to be attentive to denotation.

There are a few other points of relation between denotation and connotation that we also need to make. Again the importance of these will become clearer shortly. Firstly, the more abstract the image, the more overt and foregrounded its connotative communicative purpose. On The Clash sleeve the photograph of the band has a level of abstraction where the articulation of detail of what we can see has been reduced. This means that there is a reduced likelihood that this image was intended to show us something about a particular place at a particular time, but rather it has a symbolic value.

Secondly, whether the communicative purpose of an image is primarily denotative or connotative depends to some extent on the context in which the image is used. The photograph on The Clash sleeve could be used to show something of what life was like at the time of punk. Or it could be used to communicate something more symbolic about the identity of the band.

Thirdly, what an image connotes may, in some contexts, be a matter of free association. But where image makers need to get a specific idea across, they will rely on established *connotators*, carriers of connotations, which they feel confident their target audiences will understand (whether consciously or not).

While the concept of connotation is one we use in our analysis we also use the term 'meaning potential' as defined in the introductory chapter. In language we have a range of communicative resources that we can use in contexts to communicate. For example, we might choose one word over another, say hot, rather than cold. So we have a range of choices that we can use to create particular meanings. However, these meanings can change depending on the context in which they are used. For example, if we put the words, 'You must' at the start of sentence in place of 'Can you' it changes the meaning of the sentence from imperative to interrogative; in other words, a demand rather than a question. The words that follow therefore are part of a different meaning. So words have meaning potential that can be realised in different contexts and which is sensitive to that context. Visual semiotic resources also have the potential to mean that is realised in specific contexts. The term 'meaning potential' has the advantage over 'connote', as it suggests not something fixed but a potential, and it encourages us to consider specifically how any visual element or feature is connected to and used with other visual elements, which may serve to modify its meaning. Why this is important will become increasingly clear through the current and following chapter.

Barthes listed a number of important connotators of meaning which we will consider here. The first is 'poses', to which we add two other levels of analysis: 'gaze' and 'social distance'.

Poses

A band photographer who specialised in taking publicity shots of bands for record companies interviewed by the author said that postures must suggest something about the band, whether they are approachable, independent or moody, whether they are to be thought of as a unit or as individuals. She said she would photograph a boy band being playful and cheeky. This would mean they would be moving, perhaps jumping around, be touching each other and would smile, look romantic or even 'gurn' a little if they have a less formal image. In contrast she would show an indie band as not giving out energy, as disengaged from the viewer, certainly not touching and would find a way to distinguish the members to emphasise that they were individuals.

In the case of McFly in Figure 2.4 we can see some of these principles. They are expending energy and connote 'fun'. They all strike 'fun' poses and stand on the posts. There is a tradition in music promotion for boy bands, from The Beatles and The Monkees, to depict band members larking about. McFly strike slightly different

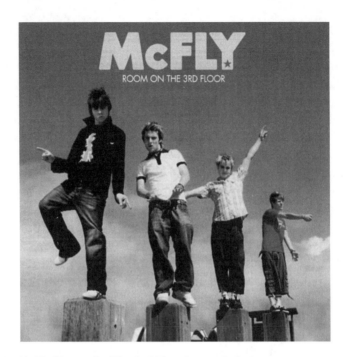

Figure 2.4 McFly 'Room On The 3rd Floor' record sleeve

poses suggesting some individual character for the members, but nevertheless there is strong cohesion and similarity between them. This would not be suitable for The Clash who are not performing for the viewer but rather look directly at the viewer taking up physical space with their stance.

The photographer told us that even for an indie band there would be need to show some cohesion. They might wear the same black clothing, but then she might depict them as different and individual in other ways; for example, they might stand further apart and look away from each other. They might also stand in odd postures but these would be much calmer and suggest inner absorption rather than outward playfulness.

On the Girls Aloud sleeve (Figure 2.5), the band strike identical poses. They also stand with legs spread, taking up space but at the same time emphasising the curves of their body. They stand in a row and overlap making them into one visual grouping, and they all look directly at the viewer. Some of the girls strike an 'attitude' pose, as the photographer called it, with head slightly to one side. They are also clearly performing in a choreographed manner. Other factors add to the meaning of this image, but here we are concerned only to introduce the way we can describe the meaning of poses. In this case, it is communicated that Girls Aloud are feminine, sexual and attractive yet also confident with just a little bit of 'attitude'. But there is no

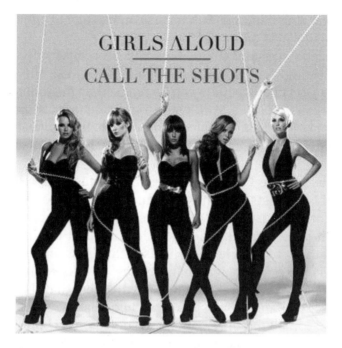

Figure 2.5 Girls Aloud 'Call the Shots' record sleeve

doubt that this attitude is not of the same nature as expressed by The Clash due to the sense of performance and glamour.

In terms of pose we can ask the following questions:

- To what extent do artists take up space or not?
- Do they perform for the viewer or are they self-contained?
- Is there an emphasis on relaxation or intensity?
- To what extent do band members mirror each other or appear as individuals?
- Are they depicted as being intimate, standing in close proximity or is there some indication of distance?

Gaze

An important part of poses is the gaze of the artist, whether or not they look out at the viewer, whether they look downwards or upwards. Kress and van Leeuwen (1996) were interested in the way that images can be thought of as fulfilling the speech acts as described for language by Halliday (1985). When we speak, Halliday argued, we can do one of four basic things: offer information; offer services or goods; demand information; demand goods and services. In each case there is an expected or alternative response possible. Kress and van Leeuwen (1996) thought images could fulfil two of

these: 'offer' and 'demand'. So images can be seen by viewers as referencing actual acts of interaction in talk.

Both speech acts and image acts can be realised by 'mood systems'. For example, in speech, demands can realise the imperative mood as in 'Don't do it!' Offers can be realised by the indicative mood as in 'You won't like this'. And we can indicate our attitude through other cues such as tone of voice and posture. In images we can find both demands and offers realised visually along with the form of address.

In the case of the Girls Aloud sleeve the viewer is addressed by the gaze of the artists. This has two functions. On the one hand, this creates a form of visual address – the viewer is acknowledged. On the other, it produces an image act meaning that the image is used to do something to the viewer. This is what Kress and van Leeuwen (1996: 124) describe as a 'demand image'. It asks something of the viewer in an imaginary relationship, so they feel that their presence is acknowledged and, just as when someone addresses us in social interaction, some kind of response is required. The kind of demand, the mood of the address, is then influenced by other factors. There might be a slight frown, as in The Clash example, that is unwelcoming and maintains a social distance. In this case we might relate to the band as them being superior to us or even a danger, particularly as they stand in this fashion occupying the width of the narrow street. There might be a pout, as in the Girls Aloud case, where we are only invited to look on at the display. We might find postures that are welcoming, through open arms or some kind of activity being undertaken in which we appear welcome or not. The members of McFly look at the viewer but appear open and welcoming.

In real life we know how we should respond when someone smiles at us. We must smile back or offend. In the case of images while we know that there will not be the same kind of consequences if we don't respond appropriately, we still recognise the demand.

Where the artists do not look out at the view there is a different kind of effect. Here there is no demand made on the viewer. No response is expected. This is what Kress and van Leeuwen (1996: 124) call an 'offer image'. Here the viewer is offered the image as information available for scrutiny and consideration. Had The Clash members not been looking at us, how would this have changed the effect in the viewer? We can see that the fourth member of McFly looks away from the viewer. So we are invited to simply observe what he does without any required response. We can see this in the example of the Oasis sleeve below in Figure 2.8. Often the Gallagher brothers appear in demand images where they scowl out defiantly at the viewer. But in this case we are invited to consider the scene, where they are, as an observer, invited as voyeur into their fairly bohemian room. In this

Figure 2.6 Bob Dylan 'Blonde on Blonde' record sleeve

case we are invited to create meaning from the setting, the poses, the objects etc., rather than through the arrogance and confidence, the attitude, of the band themselves.

Looking off frame also has meaning potential. When we see a person in an image looking off frame rather than at an object in the image, as in the Oasis sleeve, we are invited to imagine what they are thinking. We can see this in the case of the Bob Dylan sleeve (See Figure 2.6). We often find this technique used for folk singers to connote melancholy or reflection. And it is often used by pop singers who wish to reinvent themselves as more meaningful and authentic.

The metaphorical association of up and down is also important in the meaning potential of gaze. Metaphorical association has been shown to be central to visual communication (Arnhiem, 1969). For example, we might make a small distance between our thumb and forefinger to represent how close we were to verbally berating someone. In fact no physical proximity was involved in how close we felt at all, as it was simply a feeling of emotion. But the representation, the comparison, allows us to visualise this interaction. In Western culture up and down have strong metaphorical associations. We say, 'I am feeling down' or that 'things are looking up'. We can say that a person 'has their head in the clouds', or is 'down to earth'. We have upper and lower classes, and people with higher status are often seated higher than those with lower status. In images we often

find politicians, when represented positively, looking off frame and slightly upwards. In images in women's magazines, in contrast, we often find women looking slightly downwards, alongside captions like 'Can you trust your boyfriend?' The politician looks upwards to lofty ideals and to high status, whereas the woman in the magazine is worried that things are bad and requires the advice of the magazine to work things out. Where people in images look directly outwards, as in the image of Dylan, this can communicate a sense of dealing with issues straight on. Were he looking down we would have made an association of melancholy, where if we were looking up there would have been an association with him contemplating some higher ideals. Again these meanings will depend on other features like facial expression and pose.

Social distance

The meaning of posture and of gaze can be influenced by the extent to which intimacy is created through how close or far away the person in the image appears to be from us. This has the association of physical proximity and intimacy. In images, as in real life, distance signifies social relations. We keep our distance from people we don't like or don't know and get close to people with whom we are more intimate. Of course this varies between cultures but we would most likely feel that it was inappropriate, for example, if a person in the street that we had never met before came and talked to us, almost touching noses. We may see this as an act of aggression since they were not respecting our social space.

In images this kind of distance translates to close shot, medium shot or long shot. This is to do with simply how close to the viewer the person seems. So a longer shot is more impersonal and a closer shot more personal. On the Girls Aloud sleeve the girls are in medium shot and we are not meant to feel any intimacy with them. In contrast, on the Bob Dylan sleeve we can see that he is shown in close shot. We are encouraged to feel much closer to him and to his thoughts.

A band can also invade our space. This can show that they are assertive and in our face, as happens on some rap album sleeves such as in the Gravediggaz example in Figure 2.7, where the meaning potential of distance will be combined with a demand image where the mood is created through particular facial expressions. This invading of space can be done quite differently by, say, a boy band who invades our space with theatrical face-pulling and gurning.

Looking down at the viewer can also have a different effect depending on proximity. Jewitt and Oyama (2001) have shown that a viewing position can have meaning potential. When we look up at a subject

Figure 2.7 Gravediggaz 'Six Feet Deep' record sleeve

we tend to give them power, whereas looking down at them tends to give us power. Both McFly and Gravediggaz look down at the viewer but to a different effect. Of course, postures and other elements and features such as colour play an important role in the meaning that is created. In the Gravediggaz case the physical proximity combined with viewing angle is important, along with the other iconographical elements. In this image we could imagine the difference were we to see the same set of poses but from a distance and where we were looking down on them.

Objects

Here we are concerned with the ideas and values communicated by objects and how they are represented. What discourses do they communicate?

Objects can be things like cars, flowers, significant items of clothing, shoes, types of musical instrument. On this last point it is important to be mindful that what instruments we might see in a publicity shot or music video may not be what we hear on the record. For example, the British boy band Busted often appeared with electric guitars, slung low in punk style on videos, yet in the music itself guitars would not feature strongly and be dominated by bass and vocals.

Figure 2.8 Oasis 'Definitely Maybe' record sleeve

On the Girls Aloud sleeve we can see objects such as tight black clothing, platform shoes, make-up and glossy hair. These are all connotors of a particular kind of traditional, highly sexualised, femininity. This is the Power Feminism of Camille Paglia where women flaunt their powers of seduction with an in-your-face attitude. On the Dylan sleeve we have the tousled hair, scarf and tweed jacket. All suggest bohemian intellectualism, which connects to the kind of ideas about the individual soul and creativity that is at the heart of music and authenticity. This image shows Dylan through the discourse of the ideal creative genius. In contrast, Girls Aloud communicate not authenticity but confident sexuality. The target audience in this case would not be so much concerned with authenticity and creative genius as with power and femininity.

On the Oasis sleeve we find objects such as glasses of red wine and a polished wooden floor, a photograph of Burt Bacharach. These all connote sophistication and taste, although the poses of the band members suggest complete informality. Is this part of the way Oasis indicate their success, their taking-on of status but at the same time their retention of working-class attitudes?

On the Sandy Denny sleeve there are objects such as an oil lamp, old-fashioned drawers for keeping herbs and a range of containers that suggest craftwork. In the previous chapter we discussed the way that folk music works through a discourse of the traditional and authentic.

Figure 2.9 Sandy Denny 'The North Star Grassman and the Ravens' record sleeve

One important feature of The Clash sleeve is the rip. This gives the impression of something hastily prepared with little attention to cosmetic detail. This is something used on many punk record sleeves to communicate lack of being contrived and irreverence towards norms of tidiness and order.

Finally, on the Tinariwen sleeve we find the combination of the roughly painted guitar and camel. This kind of art work itself is used to connote 'Africanness' in the Western idea of ethnic culture, and the camel is used just in case there are any doubts. This is clearly marketed for a 'world music' consumer. The camel and the art style itself, Hesmondhalgh (1995) would point out, connotes the discourse of traditionalism or primitivism that stems from Romanticism, which is typical of how we see 'ethnic music'. Of course, on this cover, as with many of the others, colour is very important. This is dealt with in depth the next chapter.

Settings

Finally we look at the way that settings are used to get general ideas across, to connote discourses and their values, identities and actions. We can see the meaning potential of setting if we compare the Clannad, and Clash sleeves. As we would expect from a folk band like

Figure 2.10 Tinariwen 'Amassakoul' record sleeve

Clannad, the setting is a forest and lake shot in monochrome with mist, threatening clouds and ghostly saturated light. Mist is often used visually to connote timelessness. This is therefore an ancient or distant forest. Both darkness and mist can be used metaphorically through their associations of lack of being able to see clearly and therefore to represent mystery. Clearly a forest and lake on a bright sunny day would not work for a Clannad record sleeve. In fact these artists always use moody countryside scenes, perhaps old churches and castles. This is the imagined repertoire of a Celtic past. It is a music unspoiled by urban and technological contamination. As Chapman (1996) points out, this representation of Celtic tradition has nothing to do with any concrete relationship to any kind of place, time or people.

On The Clash sleeve we find an urban setting. It would not be appropriate to show the band members on a windswept hillside next to a ruined castle. And these are particular urban settings. We see a similar kind of setting on the Big L sleeve (See Figure 2.11). This is not surburbia or the glamorous cosmopolitan city centre, but 'the street'. The Clash stand against a rough brick wall in an alleyway. In publicity shots they are often depicted in average working-class street scenes with small shops and cafés. On the Big L sleeve we see street signs and a rubbish bin. Both settings connote a different kind of authenticity than we find in Clannad. The Clash and Big L are gritty, knowing and of the street, and therefore are unpretentious.

Figure 2.11 Big L 'Lifestylez ov da poor & dangerous' record sleeve

The sounds themselves will also connote these meanings, but the visual experience can also prepare us for these.

The Iron Maiden sleeve displays a setting typical of much heavy-metal record sleeves. In this kind of art work we often find castles and lakes, but these are notably otherworldly rather than from the past. This is a world where muscular warriors use incredibly big swords to slay fantastic monsters with scantily clad women clinging to their calves. This world has often been reflected in the lyrics produced by such bands, just as bands like Clannad sing of distant forests. Walser (1993) has suggested that the heavy-metal fantasy landscape creates a space where masculine identities can be played out. On stage some groups dress in the manner of such warriors. In this sense the lack of realism as opposed to the realism connoted by the sleeves of The Clash and Big L is important. Heavy metal has never sought such street credibility nor has it been associated with any kind of social observation as have The Clash and as is rap music. We deal more with measures of realism, or 'modality' in the next chapter. It is notable, however, that Iron Maiden record sleeves have often depicted street scenes, but these have been in cartoon style and often violent, depicting the character Eddie. This also relates to heavy-metal themes of death, suffering and the devil.

Another kind of setting is the studio, as in the Girls Aloud case. Studios themselves can connote modelling and beauty. But they can

also suggest being out of time and space. We deal with this in detail in the following part of the chapter on modality.

Salience

Salience is where certain features in compositions are made to stand out, to draw our attention. Such features will have the central symbolic value in the composition. Here we consider a number of the principal ways that salience can be achieved. We must be aware that different principles of salience may be more or less important in each composition and that a number of different features may be intended to be salient. But being aware of these different levels of salience can help us to build up a picture of how the composition works as a whole.

Potent cultural symbols

Certain elements carry much cultural symbolism. It is a good idea to scan the composition for such elements. For example, if the whole group is all wearing the same kind of shoes what does this mean, or do they all wear the same colour? Other symbols we have considered so far are the red wine on the Oasis sleeve which in Britain, although certainly not in southern European societies, means sophistication. On The Clash cover we see one of the band members wearing a shirt that carries a Union flag. In British punk culture this symbol was worn out of irony and a sense of disrespect. One of the McFly members wears half-length trousers connoting skater culture. Bands are able to build up a sense of their identity by using such symbols.

Panofsky (1970) emphasised the way that such symbols could come to mean a set of attitudes. Often, however, the origins of these meanings become obscured by history so that they simply appear as natural. For example, he describes the gesture of lifting one's hat as a form of greeting. In Britain in the early 21st century it is possible to see men in their 80s making a doffing gesture with their hand to represent this gesture. Panofsky (1972) explains that this has its origins in medieval chivalry where armed men would remove their helmets to make clear their peaceful intentions (p. 4). Likewise, van Leeuwen (2001) shows how we can understand certain representations of black people in Dutch advertisements through a history of associating black people with nature and innocence. Hence they appear with products related to laid-back lifestyles and fruit drinks.

If we want to understand the symbolism on the Clannad sleeve, or even on the Girls Aloud sleeve, we need to understand how these too have such a cultural history. Why does standing in the manner of the Girls Aloud members connote attitude, for example? Why would

this not be the same for men? On the one hand, physical movement can itself suggest the freedom to act, freedom of thought, in terms of metaphorical association. But, additionally, we would need to find out things about the way that women's roles have changed, why sexuality in the kind of 'pop feminism' of the Spice Girls itself became an expression of power.

Size

Size can be used to indicate ranking of importance, ranging from the largest to the smallest. On the Tinariwen sleeve the camel is much larger than the band who appear below. It is clearly more important to signify Africanness than to see the band themselves. On the Clannad sleeve it is the name of the band that is the largest thing. This is important as a number of similar bands use very similar imagery for their own record sleeves.

Colour

This can simply be the use of striking colours, rich, saturated colours or contrasts. Less salient elements may have more muted or less saturated colours. The Girls Aloud members wear a saturated black making them striking against the background. But we can use this to look for the way that we have been encouraged to draw our attention towards and away from certain elements and features.

Tone

This can simply be the use of brightness to attract the eye. Advertisers often use brighter tones on products themselves to make them shine. Big L, while he wears black, is the only person to wear a white shirt. On the Tinariwen sleeve the camel is white, not its natural colour, in order to make it stand out. We also find the lamp in the Sandy Denny image. We can ask why it was lit when clearly lighting could have been used behind the camera, as it most likely was. This helps to draw attention to the kind of light that it is.

Focus

In compositions different levels of focus can be used to give salience to an element. It can be heightened to exaggerate details. Or focus can be reduced. On the Dylan sleeve the background is out of focus giving him salience. This is not about where he is, just about him.

Foregrounding

Simply foregrounding creates importance. Elements that are further back may become subordinate. On the Big L sleeve he is foregrounded, although the people in the background take up more of the space.

The Burt Bacharach photo on the Oasis sleeve is positioned in the foreground. Foregrounding is also often used in bands to indicate the most well known or central members of the band, often important for marketing purposes.

Overlapping

This is like foregrounding since it has the effect of placing elements in front of others. This gives the impression that the element is in front of others. On the Girls Aloud sleeve we can see that there is some overlapping but this is to the extent that the members appear connected and certainly none of them is salient.

Modality

Often when analysing an image we want to describe how realistic, exaggerated or stylised it is. But we tend to lack the detailed vocabulary for saying exactly why this is so. In this section we outline a set of terms for doing just this. Some images are naturalistic in that they record exactly what is out there in the world. For example, a photograph of the place where you live will show the view pretty much as you saw it when you took the picture. The photograph is a record of what you saw at that moment. Such images, we can say, have a high degree of visual truth, or are of high 'modality'. Modality means how real a representation should be taken to be or how closely it represents naturalistic truth. We can see that the Big L sleeve cover shows a scene as we would see it had we been there. This is an image that has high naturalistic modality.

Modality can be higher or lower depending on how much an image departs from how we would have seen the view had we been there. But in images it is often the case that only certain elements are not as we would have seen them had we been there. For example, the colours on the McFly and Oasis record sleeves appear more saturated than they would have been in real life. Such changes are important. Being aware of what is changed, what is lessened or increased in importance, what is made less or more real can tell us much about the world that is being created for us. This section provides a toolkit for analysing such features.

Development of the concept of modality

Modality is a way of analysing images inspired by linguistic analysis (Hodge and Kress, 1988; Kress and van Leeuwen, 1996). In communication it is very important for us to be able to judge the

reliability of what we are told, or what we read. We need to be able to judge how certain are people about what they are telling us and convey how certain we are when we communicate about something. Halliday (1985) demonstrated that language provides us with specific resources to express kinds and levels of certainty. This centred on a grammatical system called the modal auxiliaries. These are verbs such as 'may' and 'must' and adjectives such as 'probable' and 'certain'. When we speak we can use these to express certainty or less certainty about different aspects of our statements. For example, consider the following two statements:

1 It is possible he was in the lecture.
2 It is certain he was in the lecture.

The first of these statements has lower modality than the second. There is less certainty. A representation that expresses high modality, therefore, claims to represent closely what we would expect to find in the real world. One use of this observation is that it allows us to look at what aspects of a written or spoken representation are offered to us as certain and what are distanced from the real world, avoided or edited out, or, as we will see, to be enhanced and made more salient. This can be a valuable resource for analysing language to see what discourses are being communicated and how the speaker aligns themselves alongside or against them. For example, a politician may remark:

3 This is a serious problem and the international community will respond. This government should be a part of that response.

We can see that the politician communicates certainty that there *is* a problem and that there *will* be a response but less certainty that his own government will be involved using the modal *should*.

Modality can also be communicated by the broader ways that we evaluate statements. For example, the same politician might say:

4 The terrorists seem to think that their actions will lead to negotiations.

Here what the terrorists believe is made to seem less truthful by using 'seem to think' to describe their beliefs. It would have been very different had the politician used the phrase:

5 The terrorists know that their actions will lead to negotiations.

We hear such use of language in everyday usage, such as when we say:

6 Bill seems to think there is a god.

Kress and van Leeuwen (1996) suggest that we should see the use of expressions of modality as 'interpersonal'. It is not about expressing truth but about the way, as we saw with the politician, we align listeners with some issues and distance them from others.

Hodge and Kress (1988) and Kress and van Leeuwen (1996) argued that the very same process can be found in the case of images, in visual communication. But in place of words such as 'possible or 'might', there are other techniques whereby modality can be reduced, and where what is communicated allows the visual designer to align viewers with some issues and distance them from others. For example, when we look at a publicity photograph of a band, or as they appear on a record sleeve, we can look at the detail of the subjects of the image and of the details of the setting. Has this been reduced, or sharpened? Has the certainty of what we can see been reduced in some way? Is it different than would be seen if we were there? If it is reduced then we can ask why. This reduction in attention to detail works in the same way as words such as 'possible' and 'might'. We can also examine arrangement of the elements in the image. Do they resemble the way that elements would normally be seen in the world? Do the colours in the images appear as they would if we were there?

Visual modality

Kress and van Leeuwen (1996) developed an inventory of modality scales for describing and analysing visual modality. These are scales that run from high to low modality:

- *Degrees of the articulation of detail* – a scale from the simplest line drawing to the sharpest and most finely grained photograph.
- *Degrees of articulation of the background* – ranging from a blank background, via backgrounds lightly sketched in or out of focus, to maximally sharp and detailed backgrounds.
- *Degrees of depth articulation* – ranging from the absence of any depth to maximally deep perspective, with other possibilities (e.g., simple overlapping) in between.
- *Degrees of articulation of light and shadow* – ranging from zero articulation to the maximum number of degrees of 'depth' of shade, with other options in between.
- *Degrees of articulation of tone* – ranging from just two shades of tonal gradation, black and white (or a light and dark version of another colour) to maximum tonal gradation.
- *Degrees of colour modulation* – ranging from flat, unmodulated colour to the representation of all the fine nuances of a given colour.
- *Degrees of colour saturation* – ranging from black and white to maximally saturated colours.

Maximum articulation
of detail

Minimum articulation
of detail

Figure 2.12 Modality scale for articulation of detail

Figure 2.13 Beyoncé 'B Day' record sleeve

We can begin with the two scales that deal with articulation of detail of objects and background. These should be seen as a continuum as in the difference between 'this is' to 'this is not' in language with a range of certainties in between such as 'this might be', 'I am fairly certain this might be'. This can be illustrated as in Figure 2.12.

On The Clash record sleeve it is difficult to make out the details of the band members' faces and clothing and of the background itself. Were we present we should have been able to make these out clearly. In this case modality has been reduced. Both the artists and the setting become less than real. Of course, this is not to the extent that we cannot recognise who the individuals are. In a further step to abstraction they could have been represented as drawings or even stick men. With such subtle reductions in articulation of detail we are generally dealing with an idealisation, a reduction in complexity. So this representation would be towards the middle of the modality scale for articulation of detail. We can see a similar, though lesser, reduction of details on the skin of Beyoncé, (See Figure 2.13). We also find that the background is out of focus with detail hardly recognisable.

Such reductions in detail can mean that an idea or concept is being communicated rather than the image documenting a moment in time. Where reductions are small it idealises. In the case of Beyoncé, she is not an ordinary woman but idealised in terms of beauty. We can imagine the difference had the cover carried a photograph of a very high modality Beyoncé. In The Clash case the simplification also idealises but further into the realm of abstraction where they symbolise punk values. Where artists represent themselves in high modality, with blemishes and spots and bad hair, they will wish to show themselves as honest, unmanufactured and connected to everyday life. We would expect the lyrics of such an artist to be about more realistic issues and the singing to be intimate. We can see that Bob Dylan is represented in this way. On the other hand, the Clash sleeve has the effect of a damaged image, one that is not pure and perfect. Again, this is how punk can connote lack of polish and artifice.

On the Tinariwen sleeve we find two levels of abstraction. The camel and guitar neck are represented in much lower modality than the band performing in the background, although they are still difficult to see. The camel is very low modality. We can imagine the effect of an image of a real camel on the cover. This would have made the 'Africanness' too literal. It is meant rather to connote African art and culture in a generic 'world music way'. Would such a band use a camel to market themselves in an African country we could ask?

We can also see the reduction of articulation in detail of the background in a number of other covers we have examined so far. On the Girls Aloud cover the women stand in front of a blank space, shifting attention completely to them. We can imagine the effect of the girls striking these poses and dressed this way they were placed in a very ordinary setting. Machin and Thornborrow (2003) describe the way that completely abstract, low modality, settings as these are often used in women's magazines such as *Cosmopolitan*. They liken these settings to those in fairy tales where we are told that a tree can talk or a boy has a magic amulet. These immediately tell us that this is a low modality world where different rules apply. In these worlds different kinds of actions and identities can seem reasonable and need not be held to naturalistic everyday standards. We can remove or dilute aspects of naturalistic reality that might get in the way. Machin and Thornborrow show how in women's magazines low modality settings are used to remove any connection to real life factors, so that objects, postures and participants can have greater symbolic weight. So our low modality camel and the low modality Clash band members and background place the meaning of the music in a sort of fairy tale space. If we saw three guys standing outside the students' union building in this manner we might laugh at them. The modality

changes this. In the case of Tinariwen the low modality camel helps to obscure the actual meanings of the camel and allow it to symbolise 'Africanness'.

On the Iron Maiden cover we see a further reduction of modality, where the world is represented in cartoon/fantasy art with a fantastic creature floating at the centre. Heavy-metal acts have often used such connotations of fantasy to combine, leather, demonology, warrior images also sometimes along with androgeny. Here the low modality helps these different themes to be more easily combined.

On the Sandy Denny cover we see only a slight reduction of the whole image due to a slight blurring, a slight loss of focus. This brings in a slight dreamlike quality, especially when combined with the softness of the natural colours.

Our third scale is articulation of depth. This runs from deep perspective to its complete absence. In naturalistic modality we would see depth as we see it in everyday life. For example, when we see a tree it is in full three dimensions where we can see the complexity of the depth of its leaves. In low modality we would find the same tree represented as in a two-dimensional drawing – an outline of a tree as children are first taught to draw. We might find two layers where a circle is drawn over the trunk to point to three-dimensionality. In between is isometric perspective where, for example, we might draw a cube on a piece of paper as we would see it in the real world. Depth can even be exaggerated such as in the use of fish-eye lenses. Lack of depth can again connote simplicity and a low modality world where different rules apply, as in the single field of depth of the background on the Girls Aloud cover.

Our fourth scale is degrees of articulation of light and shadow – ranging from zero articulation to the maximum number of degrees of 'depth' of shade. This is simply how real the lighting and shadow appear in an image. Beyoncé is well lit from a number of light sources, including backlighting which is usually used to connote a sense of truth as opposed to shadow. The room in which Oasis sit is much brighter than we would expect to find in a British 19th-century house. The members of Girls Aloud are lit from behind to the extent that they almost glow, as well as strong front lighting. The setting is also brilliantly lit, all connoting optimism. We can imagine the effect of placing the women in the Big L or Clannad settings.

The fifth scale is that of articulation of tone. Do we find a range of differences in tone, of levels of gradation of brightness or only simple polarities of dark and brightness? We often find such simple gradations in comics where the world is often represented in terms of extremes and again in the low modality world, normal rules of agency, action and identity do not apply. The reduction of modality on The Clash cover has been done partly through reduction in natural shading so

that there are extremes of light and dark. These have the association of extremes of emotion, or of truth and obscurity. In Western cultures brightness has metaphorical associations of transparency and truth, associated with the ability to see clearly, whereas darkness has associations of concealment, lack of clarity, the unknown, due to the association of lack of vision. In contrast, the Big L cover emphasises darkness. We could imagine the effect had the same photograph been taken on a glorious summer morning with everything brightly lit. The Clannad cover also emphasises darkness and sombre moods, but also bright, serene, beautiful light from above rather than the harsh brightness on The Clash cover. In both these cases we would expect the music and lyrics to also provide the same connotations. Big L produces music that is about the darker underbelly of society; Clannad music is about obscure mystery and legend but yet bright with spirituality and the emotions of community and belonging.

The sixth scale is that of colour modulation. This is the continuum from unmodulated flat colour as we might see on a cartoon to all the fine nuances of a given colour. For example, when you look at your clothing the colour you see will vary according to the way contours and folds catch the light. At no point can you indicate the true colour due to the modulations. We can see high levels of modulation on the clothing of McFly. In contrast, this has been reduced on the clothing of Girls Aloud. Flat colours can mean simplicity and certainty. We find such colours used by modernist painters such as Mondrian. Where modulation is high it suggests complexity and issues being dealt with. On advertisements we often find unmodulated colours. A photographer who specialised in promotional photography told the author that this has the effect of making the world in the adverts both slightly softer and also much cleaner. The world as represented in advertising, he suggested, is a world of certain meanings.

The seventh scale is that of degrees of colour saturation. This is how rich and full colours appear, ranging from black and white to maximally saturated colours. In between we can have degrees of dilution. We can imagine the meaning potential of an object coloured in a diluted colour to one with bright rich saturation. These can have the meaning potential of emotional intensity versus weakness or conversely emotional **loudness** against subtlety. With digital technology it is a simple matter to saturate, dilute or change the modulations on colours. We find examples of colour saturation on the clothing of McFly, Girls Aloud and also Oasis. This would be less likely to be the case on a Bob Dylan cover. Here more subtle colours connote measure and sophistication. Oasis, as with the other Britpop bands of the 1990s, such as Pulp and Blur, used a mixture of seriousness and brightness, both visually and in their music. Of course we would expect the Tinariwen sleeve to carry saturated colours to

represent the emotional nature of ethnic music. In contrast we often find classical music sleeves using muted, diluted colours to suggest contemplation and thought.

The eighth scale is colour differentiation. This is simply about how many colours there are, from maximally diverse, as would be found in naturalistic modality, to monochrome. Reductions in colour differentiation can be used to emphasise the connotations of one colour, such as if we find green or black. This can be used to emphasise polarity of feelings, simplicity or simply moderation. Monochrome is often used in pop videos to connote timelessness – along with another favourite, slow motion. The reduction of palate can be seen on the Clannad sleeve, which emphasises the connotational value of the dark and bright. The Clash sleeve has reduced differentiation to show something self-contained and measured. Later, in our chapter on musical analysis, we find that the same kinds of measure and containment indicated through choices of semiotic resources in sound in punk music. It is clear that neither McFly nor Girls Aloud could be represented in this way.

1 Compare the record sleeves of two genres of artist. Observe the patterns in choices of iconographical elements:

- Poses
- Gaze
- Social distance
- Objects
- Settings

2 Also assess whether there are any patterns in terms of modality:

- Articulation of detail of elements and background
- Light and shadow
- Tone
- Depth of vision
- Modulation of colours
- Saturation of colours

3

Visual Composition:
Typeface and Colour

The previous chapter provided a set of tools to guide analysis of a range of features that appear on record sleeves allowing us to reveal how discourses are realised, how bands communicate their identities visually. Emphasis was on identifying the choices available to designers and on the art of description. The chapter dealt with the meaning of objects, postures, gaze, social distance, settings and modalities. The current chapter deals specifically with two further features of record sleeves and promotional material that are crucial for meaning making: colour and typeface. Why do some bands use rich, saturated colours on their record sleeves and others use more muted colours? Why do some bands use thick angular fonts for their name and others slim curved fonts? Comparing the Willie Nelson and Donovan sleeves (p. 60) we find that one carries an angular font, the other curved. One is conservative with colours, the other not (you can see these covers in colour on the Web; e.g., Amazon). In both cases these semiotic resources are used to tell us something about these artists. This chapter provides lists of inventories that allow us to carefully describe the meaning potentials of colour qualities and typographical features.

Colour and meaning

When describing colours we tend to talk about their affect. We say a colour is 'lively', or 'sensual'. When we look at a record sleeve we might say that the colours create 'mood', 'excitement', 'tranquillity'. We might describe the Donovan sleeve as 'bright' and lively' in comparison to the colours on the Willie Nelson sleeve, which are more 'serious' and 'thoughtful'. But these adjectives do not describe what we see and are not based on any systematic observation. Rather they describe the *affects* of the colour. Most of us would be able to

describe some of the associations carried by certain hues. We might point out that black is a dark colour associated with moodiness or evil and that yellow is a sunny colour associated with brightness. These assessments may well be true but there is little in terms of system to such comments. Nevertheless this is the kind of colour analysis we come across even in the case of experts, such as in interior design programmes, where much of colour meaning comes from the association of hue.

While we have a rather unsystematic language for describing the meaning of colour hue we are even more limited when it comes to the qualities of colours. Why do some bands use muted colours on their sleeves and others rich colours? Why do some use pure colours and others impure colours? These are qualities of colour about which we rarely speak. A designer on a newspaper told the author that they had recently switched the paper they used to a flatter, purer, white. This was part of a broader redesign that included other visual changes along with changes in content and writing styles. The aim was to attract a different kind of readership which was of more interest to advertisers. Flat, purer white would be part of the way the new identity of the newspaper would be communicated. Clearly there are important symbolic meanings in both hues of colour – blue, red etc. – and in other qualities such as 'purity/impurity' and 'flat/contoured'. And all have meaning potentials. These can be harnessed by bands to communicate about themselves. While colour may appear chaotic and difficult to describe systematically it is possible to produce a number of categories that help us to focus. These are categories based on metaphorical associations, described by Kress and van Leewen (2002).

Communicative functions of colour

Kress and van Leeuwen (2002) were interested in the way that visual communication could fulfil the same communicative functions as language, as described by Halliday (1978). These are (a) to represent ideas – for example, a language must be able to allow us to describe things; (b) the interpersonal function, in other words to convey moods and attitudes; and (c) to create coherence within themselves. We can think about how colour can perform the same functions.

Ideational function

Colour can denote specific people, places and things as well as classes of these. Colours of flags denote nations; corporations use colours to

Figure 3.1 Willie Nelson 'Moment of Forever' record sleeve

Figure 3.2 Donovan 'Sunshine Superman' record sleeve

denote their identities. BMW makes sure their dark blue is different from the blue of Ford. On maps colours identify water, land and

forests, etc. Here there is an iconic element in the choice of colour. In medieval times colour symbolism was highly defined. For example, white was purity, brown the earth and red the body and mortality.

On the Girls Aloud cover, discussed in the previous chapter, the black clothes communicate the idea of both 'bad' and of 'glamour'. On the Willie Nelson sleeve, black connotes the idea of more sombre moods due to the association of bright with 'up' and cheery and dark with 'down' and deeper, darker thoughts. Of course the Girls Aloud members combine black with other semiotic meanings to allow them to connote glamour.

Interpersonal function

Colour is also often used to communicate moods and forms of address. We may use bright colours on documents in order to draw attention to them. Red might be used on warning signs. We now find that the bills we get from our banks and services are colour coded to give different moods. A recent telephone bill I received had text boxes filled with a highly diluted blue to suggest a calm mood. Interiors of buildings now are coloured to give calming affects. The Willie Nelson cover communicates a sombre mood, whereas the Girls Aloud cover communicates brightness and energy through brightness.

Textual function

In a textbook, or on a document, main headings might be in blue and subheadings in red. This helps to create unity and coherence. In an advert, colour may be used to emphasise links between elements on a page. Red lips may coordinate with a red logo. This may also be done by coordinating levels of brightness or saturation.

Of course a single colour may fulfil different functions at the same time. On maps colours may denote a kind of landscape, they might have interpersonal value, to draw attention to main roads, for example, and may have a textual function of showing ranking of roads where those of the same colour are of the same status.

The dimensions of colour

Kandinsky (1977) suggested that colour has two kinds of value. These are the direct value which is the effect it has on the viewer and the associative value. So we might associate yellow with sunlight and green with vegetation or we might associate white with purity and blue with truth. For Kress and van Leeuwen (2002) we can analyse the meaning potentials carried in terms of these two values. These are in terms of the associations and also by describing

the distinctive features of colour. They propose six dimensions of colour that all combine to give a rich array of possible combinations. They use these also to analyse the meaning of colour schemes as well as individual colours.

Brightness

The meaning potential of brightness rests on the fundamental experiences we have with light and dark. Most cultures appear to have rich symbolic meanings and values based around this distinction. Anthropologists have shown that dark has been associated with killing and light with curing (Whitehead and Wright, 2004), and that light has been associated with life and dark with death (Low and Lawrence-Zúñiga, 2003). In *Macbeth*, Shakespeare uses light and dark as important symbols of good and evil. Macbeth himself says 'Stars, hide your fires; Let not light see my black and deep desires' (I.iv.50–1). Darkness can be associated with secrecy, hidden lies, ignorance or even the irrational, the primitive (Lakoff and Johnson, 1980). We say that people have a dark side which evokes this irrationality and primitiveness. In contrast, light is associated with openness, truth and reason. We might connect this to our physical experience of light facilitating vision and dark, thus rendering objects and settings unclear. Light and brightness can also mean up in terms of mood. We say a person is looking bright, or even that they are 'shining'. We also say that someone has a dark mood. This comes from the association of shining and giving off energy and simply the feel-good nature of sunshine versus gloom. Intense brightness can also mean almost other-worldly as in spirituality, a purity of light and vision.

We can see these meaning potentials used on the Girls Aloud cover which uses a bright, shining background. The skin of the band members is also brightly lit. This communicates positive energy and also suggests openness and accessibility. We can see the difference as compared to the Willie Nelson cover, which uses a dark background connoting darker moods, less certainty and the hidden aspects of life and the human spirit. Both sets of artists wear black. But in the context of each setting this carries a different meaning. For the Girls Aloud it can mean naughty or elegant, whereas for Willie Nelson he merges with the darkness. He is part of the darker moods and perhaps the irrational and primitive. This is the visual realisation of the lyrics of his songs such as 'Night Life', which speaks of lost dreams and loneliness.

Saturation

This is the scale that runs from intensely saturated colours to the most diluted versions of the same colour where they become pale

DIRE STRAITS

Figure 3.3 Dire Straits record sleeve

and pastel or dull and dark. The meaning potential of saturation lies in its ability to express emotional 'temperature'. A highly saturated colour can mean a maximum intensity of feeling, whereas a pale colour can mean toned down, neutralised or subdued. Therefore, high degrees of saturation can mean exuberant, adventurous, playful and fun or alternatively can mean showy, vulgar and garish. Lower degrees of saturation can mean subtle and tender or brooding and moody, or they can mean mild, lacking in energy.

On the Girls Aloud sleeve the band members all wear saturated black suits. This suggests emotional temperature and certainly not toned down and subtle. The women are adventurous and fun. We also find increased saturation on the clothing of the members of McFly. In this case, rather than adventurous, the saturation (like the postures) connotes the boldness and intensity of fun, liveliness and playfulness. In contrast, on the Dire Straits sleeve we find a much more muted colour (see Figure 3.3). This connotes much more toned-down emotions and a degree of subtlety.

We would not expect sleeves by artists such as Bob Dylan to necessarily use saturated colours, although on the Willie Nelson sleeve the colour of the guitar appears saturated. While there is a dominance of dark colours, the brightness of his face and richness of the colour of guitar suggests that along with the moods and darker emotions, there is also warmth through the music and glimpses of hope.

Figure 3.4 Green Day 'American Idiot' record sleeve

Purity

This is the scale that runs from maximum 'purity' to maximum 'hybridity', although of course the idea of a pure colour is itself problematic. The terms purity and hybridity themselves suggest something of the meaning potential of this aspect of colour. Purity can mean simplicity and certainty, whereas hybridity can mean ambiguity and uncertainty, contamination and complexity. We can see these meaning potentials in art. The pure, bright reds, blues and yellows of the Mondrian colour scheme have become key signifiers of the ideology of modernity. Postmodernism, however, where hybridity is valued, is signified by a colour scheme of pale, anaemic cyans and mauves. We can see the purity of the colours on the Girls Aloud cover, pure black. The heart-shaped grenade on the Green Day sleeve is of a pure red (see Figure 3.4).

On The Clash sleeve, while the photograph shows extremes of bright and dark and low articulation of detail, the colours at the edge are pure and saturated. So here we find a combination of extremes of emotion but also a vibrance, some warmth and, through the purity of the colour, a certainty in their identity and message. This use of colour indicates that unlike Willie Nelson this band are not so much associated with complexity, darker moods and inward reflection.

On the Green Day sleeve the words 'american idiot', while of a pure colour, contain flecks of the black background, as does the band's

Figure 3.5 Mozart

name. This contaminates the colours, increasing a sense of complexity, uncertainty and ambiguity. On the Tinariwen sleeve, discussed in the previous chapter, saturated colours indicating emotional warmth and vibrancy are also contaminated here, indicating hybridity. This 'rhymes' with the hybridity of the iconography of the electric guitar and the camel. This would be expected on a record sleeve that needed to communicate 'world music'.

Modulation

This is the scale that runs from a fully modulated colour – for example, a blue that is richly textured with different tints and shades, as in paintings by Cézanne – to a flat colour, as in comic strips or paintings by Matisse. Flat colour may be experienced as simple and bold – or as overly basic and simplified. Highly modulated colour may be perceived as subtle and doing justice to the rich texture of real colour – or as overly fussy and detailed. On the Big L sleeve we find high modulation, here indicating no levels of simplification. We see the same on the Bob Dylan cover in the last chapter, and on the face of Willie Nelson. And we see the same on the Gravediggaz sleeve. This compares with the Beyoncé sleeve where the texture of the colour on her face and clothing has been reduced to create simpler flat colours, and the Girls Aloud sleeve where we see the same flat colours. Their clothing reveals no variations in the black as we would see were

we present. This technique is typical of advertising and is used to connote cleanliness, simplicity and certainty. In advertisements for furniture, for example, we find large airy rooms with high key lighting to increase brightness and optimism, almost to the degree of spirituality. Machin and van Leeuwen (2007) have argued that this is one way such images almost bring a morality to the products. Colours may be saturated or diluted but they will most certainly be reduced in modulation. Such simplification of colours helps to idealise the image. Beyoncé and Girls Aloud are therefore simplified, made certain and idealised. In contrast, Bob Dylan and Willie Nelson are left in their complexity. On the Mozart cover (Figure 3.5) we can see that the impression of modulation has been created through the use of lighting to create contours, suggesting the rich contours of the music.

Differentiation

This is the scale that runs from monochrome where we have one colour and features distinguished only by tone as in black and white photographs, although these might use other tonal variations of one single colour, to the use of a maximally varied palette. The use of many colours can mean diversity, exuberance, energy, liveliness, adventure and fun, or conversely can mean garish, crude, lacking restraint. Reductions in diversity towards monochrome can mean restraint, classiness, timelessness or conversely old fashioned, austerity, lacking energy and adventure. Low differentiation can also favour certain kinds of meanings, due to the meaning of hue or other features of the colour as when there is an overall haze of blue in a picture, or a restriction to browns and yellows in an interior. Here the meaning of hue is important, as we discuss below.

The Clannad sleeve (Figure 2.1) used only a monochrome of black and brightness, although it uses a much brighter, saturated, pure colour for the band title. Here there is a sense of timelessness, but the dark and light of course create a sense of both sombre and brighter moods. Iron Maiden (Figure 2.2) use a limited palette of blue, black and white, although the bright tones bring a sense of optimism and almost spirituality, which is typical of the other-wordly fantasy themes often dealt with by heavy metal. The blue also shifts from very bright tones to high levels of saturations to suggest emotional intensity. But the limited palette may be one way to indicate some measure of restraint and classiness. We can imagine the same art work with a much wider colour palette. Also important on this cover is the meaning of the hue, which we will come to shortly.

Of the sleeves we have dealt with so far it is the Tinariwen and the McFly covers that use some of the widest palette range. Tinariwen typical of world music sleeves, need to use the palette range to connote diversity, lack of measure, in order to communicate being in touch with

the body rather than restricted by the intellect. McFly need to indicate fun and energy, as do their postures. The Donovan sleeve shows the widest use of colour range. Here the range of bright saturated yet unmodulated colours indicate the free exploration of emotions that have been associated with 1960s music.

In fact many record sleeves carry monochrome or highly restricted colour palettes as bands connote timelessness, and classiness, avoiding garishness and adventure. We can see this on the Green Day, Willie Nelson and Bob Dylan sleeves. Interestingly, the Girls Aloud cover, while also connoting energy through posture and tones, also choose a limited palette to also communicate some classiness.

Luminosity

This is the scale from luminous colour, which looks as though light is shining through it (e.g., coloured glass), to its opposite. Luminosity has a long history of being associated with the unworldly glow of magic and supernatural beings or objects. The Iron Maiden sleeve (Figure 2.2) uses a blue which is luminous. Along with the other elements in the image, this connotes this other-worldliness and fantasy.

Hue

This has meaning potential due to the associations and symbolic associations of the colour itself. This is the scale that runs from blue to red. At the red end of the scale we have associations of warmth, energy, salience and foregrounding, and the blue end of the scale, coldness, calmness, distance and backgrounding. The blue–red scale has had many correspondences and uses. Itten (1974), for example, lists transparent/opaque, sedative/stimulant, rare/dense, airy/earthy, far/near, light/heavy and wet/dry. We often find colours such as blue used to indicate science and truth, and also often for royalty. Gage (1993) has shown that this use of blue has such associations due to the high cost of blue paint, and also due to associations of water with purity and therefore higher truth. Of course we must consider all of the above dimensions when considering the meaning of hue. A red may, for instance, be very warm, medium dark, highly saturated and pure, or dilute and contaminated. Its affordances for meaning makers and interpreters will follow from *all* of these factors and their specific combinations. Also colours have many symbolic associations, which can be more carefully thought about in terms of the way they combine with other features and qualities, such as white connoting cleanliness and order, and lilacs for femininity. Gage (1993) plots the symbolic meaning of colour and their origins in antiquity much in the manner of Panofsky's iconology.

The Sandy Denny sleeve uses browns and greens to signify earthiness and tradition. These are slightly saturated to bring a sense of

warmth. The Green Day sleeve uses reds for energy, warmth and salience and also to connote blood. The Tinariwen sleeve uses blues for calmness, although the saturation also suggests vibrancy and warmth, and greens and browns are organic colours which prevent the blue from signifying science or truth. The Oasis sleeve (Figure 2.8) uses neutral calming colours but also saturated blues which coordinate across the composition creating balance and linking, fulfilling Halliday's textual function.

It is important to note that colours can be used to coordinate not just through hue but also in terms of other qualities, for example, in terms of value (darkish colours harmonise), and saturation (intense colours harmonise with each other, or pastel colours), and in terms of modulation and purity. So in an image a person's clothes might be of a saturated and pure colour along with a particular object or aspect of the setting. This has the effect of indicating that they are of the same order and linked (See Table 3.1).

Table 3.1 Summary of colour qualities for Clannad and Tinariwen record sleeves

Colour quality	Clannad	Tinariwen
Hue	Black, blue-grey, font green with hint of yellow, obscurity, obscured truths and organic of the land with some brightness and optimism. Band appear at bottom of composition in monochrome blue	Blue, calmness, truth. Greens and browns and oranges of earth and desert to provide measure for blue. Used to create textual coherence with words and image and give sense of design style
Brightness	Extremes of light and dark, both spiritual truths and hidden mysteries	Bright blue and oranges suggest optimism
Saturation	Highly diluted blue-grey, saturated black and green font – both emotional intensity and subtle delicate thoughtfulness	High saturation, emotionally vibrant
Purity	Purity of blue-grey on image. Font is hybrid colour	Impure, postmodernity, lack of certainty
Modulation	Both exaggerated on water and clouds and muted out on forest due to extremes of brightness	Guitar and camel completely flat and low modality
Luminosity	Brightness and blue-grey gives just a hint of luminosity	No
Meaning of combination	Spirituality, emotional extremes, hidden mysteries, truth, slightly other-worldly	Brightness of truth and desert and earth colours and low modulation suggests honesty and simplicity in music. Highly emotional, with both certainty in and pastiche of styles through pure and impure colours

Typography and meaning

One important signifier of the discourses associated with a band is the way its name is written. Artists establish a fixed way of writing their name which is then used on record sleeves, on merchandise such as mugs, pens, badges and T-shirts, posters, and as part of live performances. At the beginning of this chapter we noted how Iron Maiden is written differently than Donovan. One seems heavier and more aggressive, while the other is softer and more gentle. Of course this is just describing affects and not the actual qualities of the typefaces themselves. In this section we look at ways to describe and analyse exactly how typefaces make meaning and connote discourses. We might readily accept that particular products must use typefaces to communicate something about brand qualities. A product that wishes to appear durable and technological will use a heavier, more angular typeface rather than slim curved letters that might be more characteristic of a cosmetic marketed at women. But it may be less obvious that bands too must use typefaces to communicate ideas and attitudes about themselves.

Typefaces have long been used to convey different types of meaning. We are familiar with this through the way that bolder fonts are used to add emphasis to a word or section of text. But more recently font design has been taken much more seriously by graphic designers with a range of book titles coming onto the shelves. Marketers and advertisers have become increasingly aware of the way that a typeface can help communicate the values of a product in the manner of the Iron Maiden font saying something about the band. And some companies such as the Poynter Institute have begun to offer research into the meaning of fonts through market research. They will advise on the way letter shapes communicate values such as 'drama' or 'quietness'. But this kind of research has still tended towards describing affect rather than providing any kind of predictive inventory of the

meaning potential of typographical features in the manner we have just done for colour.

Van Leeuwen (2005) suggests that typography can also fulfil Halliday's communicative functions of language in the same way that we saw colour did in the preceding section.

Ideational

This is the ability of a semiotic system to represent ideas about the world. In the case of the Iron Maiden font the heaviness of the letters is used to illustrate the idea of power. Slimmer letters, in contrast, could be used to suggest the idea of elegance. We can see this in the Girls Aloud font (Figure 2.5). We can imagine the effect were these fonts to be switched.

Interpersonal

This is the way language can be used to express attitudes towards what is being represented. Typefaces can do this through being bold to represent emphasis. A typeface might mimic joined-up handwriting to suggest an informal address.

Texual

This is the ability of semiotic systems to create coherence within themselves. A typeface might be used on a page to indicate levels of ranking or importance. So headings with the same font are of the same order.

Below we list the features of letter forms that we can use to create typographic meaning. Together they can create a kind of 'typographic profile'. But we have to remember that the meaning potential of such a typographic profile is only meaning potential that will be actualised when the letter forms are (1) combined with other features (colour, dimensionality, texture etc.) and (2) used in a specific context.

Weight

This is about how **bold** or **heavy** a typeface appears. This is not a binary but a gradual contrast – there is a continuum of boldness. Increased weight is of course frequently used to increase salience. If we see a sign placed on a wall it may have one word emphasised through being bolder than the other words, such as 'Do **not** remove'. But boldness and increased weight can, at the same time, be used metaphorically, to signify ideational and interpersonal meanings. Bold can be made to mean daring, assertive or solid and substantial, for instance, and its opposite can be made to mean timid or insubstantial. But the values may also be reversed. Boldness may have a more negative meaning. It may, for instance, be made to mean domineering or overbearing.

We can see the difference in the Girls Aloud and McFly typefaces. The McFly font appears much heavier, more substantial and therefore assertive than Girls Aloud. Clannad, Green Day and particularly Big L also use fairly heavy typefaces emphasised by very large sizes. In each case some degree of substantiality is connoted although each contains other features that add to and change the meaning. We will consider these as we move along.

In contrast, the Mozart typeface, Dire Straits and U2 use much lighter letters. In these cases solidity and substantiality are not an issue. This can be because such bands or artists wish to connote more sensitivity, subtlety or thoughtfulness.

Expansion

Typefaces may be condensed, narrow, or they may be expanded. Here there is a range between the maximally narrow and maximally expanded. The metaphorical potential of this feature is connected to our experience of space and how objects and persons take up space. Maximally condensed typefaces make maximal use of limited space. This can mean that they are precise and economical or even discrete. Wide typefaces, by contrast, spread themselves around, using space as they wish, making their presence felt. But the values of the contrast may be reversed. Wide typefaces may also be seen in a positive light, as providing room to breathe and room to move, while condensed typefaces may, by contrast, be seen as cramped, overcrowded, restrictive of movement.

In fact many of the sleeves we have considered carry wider typefaces. We can see this in the case of the Mozart and Girls Aloud letters. Particularly Clannad and Big L use very wide letters. Both then connote taking up of space. This can be important for marketing purposes where many other bands of the same genre use similar iconography. A number of artists use a similar look and sound as Clannad carrying the same images on their record sleeves so it is important for reasons of quick identification. But it also indicates their huge presence in the meaning of the image. We can ask how the meaning would change were the word 'Clannad' written in a much smaller, narrow typeface in one corner of the sleeve. The artists in this case indicate the way that they occupy and dominate this mythical landscape. Big L could be said to be a significant voice in the urban setting.

While the U2 typeface used for the band name and title of the album are not heavy they do take up all the space on the record sleeve (see Figure 3.6). They are spread out and confident. Yet lighter letters suggests that there will be some subtlety to this confidence, unlike, say, Iron Maiden.

Figure 3.6 U2 'The Joshua Tree' record sleeve

Slope

This refers to the difference between cursive, sloping, 'script'-like typefaces and upright typefaces as characterised by print. There are degrees of 'slope', and slope can also be either right-leaning or left-leaning, although the latter is less common.

The contrast here is between writing and printing. The meaning potential of this contrast is therefore predominantly connotative, based on the meanings and values we associate with handwriting and printing. Depending on the context, it might signify a contrast between the 'organic' and the 'mechanical', the 'personal' and the 'impersonal', the 'formal' and the 'informal', the 'mass produced' and the 'handcrafted', the 'new' and the 'old', and so on. This can also mean something impermanent as opposed to something permanent.

We can see that the Oasis sleeve has the title 'Definitely Maybe' in a handwritten typeface. Often female lone singers or singer-songwriters have their name written in handwriting style, such as Duffy on her album 'Rockferry'. This creates a sense of intimacy and connection. We can imagine the difference were Iron Maiden to write their name in this way.

Curvature

A letterform can stress angularity or it can stress curvature. Many typefaces mix straight and curved of course. The significance of

these may be based on experiential and cultural associations with essentially round or angular objects. Roundness can come to signify 'smooth', 'soft', 'natural', 'organic', 'maternal', and so on, and angularity 'abrasive', 'harsh', 'technical', 'masculine', and so on. Both may be either positively or negatively valued. Modernity, rationality, functionality etc. have often favoured the values of angularity, as, for example, in the paintings of Mondrian, while postmodernity has brought back round forms, for instance in car design and architecture.

U2 use angularity, as does Willie Nelson. The Willie Nelson font is both heavy and angular, suggesting something harsh in the case, combined with the dark moods. Iron Maiden use an even more exaggeratedly angular font to suggest abrasiveness and masculinity. In contrast, Donovan uses a curved font to suggest something softer, natural and more organic. Beyoncé uses a combination of angles and flamboyant curves. Here we find both abrasion and naturalness with a highly expressed femininity.

Connectivity

Letter forms can be connected to each other, as in running handwritten script, have hooked feet that extend to various degrees to the next letter, or almost touch it, or lack any of these features so that the letter forms are quite separate and self-contained. Letters can be closely PRESSED TOGETHER or they can be much F U R T H E R A P A R T.

Connectivity is, again, associated with handwriting, and therefore shares much of its meaning potential with 'slope'. But it also has its own metaphoric potential. External disconnection can suggest 'atomisation', or 'fragmentation', and external connection 'wholeness', or 'integration'. But values may be reversed, with disconnection signifying individuality of the elements as a whole, and connection its opposite. Or external separation is often used on art advertisements to connote space, freedom to move and room to think. Newspaper redesigns seeking professional earners used increased spacing between letters to connote these meanings. Internally disconnected letter forms, finally, have a sense of not being 'buttoned up', which may be negatively valued, as 'unfinished', or 'sloppy', or positively, as, say, 'easy going'.

We can see that the U2 typeface has fairly large gaps between the letters. This signifies individuality and also freedom to move and think. The Mozart sleeve has the same quality. This may signify the individualism of the musicians but also the space to think and move, time for reflection. McFly, in contrast, has its letters close together, suggesting integration and less thoughtfulness. The Clannad letters are expanded fairly wide which gives room to breathe but do not have so much space between the letters. On the other hand, the

letters of the word 'LEGEND' do have such spacing. Here this does suggest fragmentation and therefore a kind of uncertainty in the manner of the mists.

The letters of Big L are touching each other. This suggests wholeness and integration rather than room to move and think. This works to combine with the way the letters take up a lot of space, spreading out across the design confidently and proudly. It is heavy, bold and daring and there is a directness to this, rather than the peaceful contemplation suggested by spread-out letters.

Orientation

Typefaces may be either oriented towards the horizontal dimension, by being comparatively flattened where they have equal or even greater width than height or can be stretched in the vertical direction, where height is greater than width.

The meaning potential of horizontality and verticality is ultimately based on our experience of gravity, and of walking upright. Horizontal orientation, for instance, could suggest heaviness, solidity, but also inertia, self-satisfaction, while vertical orientation could suggest lightness, upwards aspiration, elegance, but also instability.

The Clash typeface (Figure 2.3) appears more or less of equal dimensions and appears stable. We could imagine 'THE CLASH' written in a tall elegant font as not being appropriate. The Clash would not wish to communicate lightness nor sophistication. 'TINARIWEN' is much taller, to suggest something more elegant and sophisticated rather than stable and solid.

While the U2 and Mozart fonts use slimmer letters to suggest subtlety and spacing to communicate room to think and express more subtle ideas they use flatter letter shapes to communicate groundedness. We can see here how fonts can use a combination of features to suggest a range of meanings. Solidity and stability can be communicated through flatness, while at the same time there can be subtlety through lighter, thinner letters and rationality through angularity. The U2 typeface is stable, yet light, subtle and gentle, with room to breathe. A more rounded version of the same font could have suggested more of a folk-music-style intimacy or gentleness.

Regularity

Many typefaces have deliberate irregularities, or an apparently random distribution of specific features. Regularity and irregularity have their metaphorical potential. If a product brand name or movie title

were to appear in such irregular letters there would be associations of playfulness, wackiness, instability or lack of conformity. It might also mean childishness. For younger children's advertisements fonts are used that mimic the unpredictable shapes of a child's early writing. This could also mean simple, unpredictable or creative. In magazines varieties of fonts are placed together to communicate energy and liveliness.

On record sleeves it has been common for punk bands to use irregular fonts to communicate chaos and non-conformity. Many drew on the jumbled, newspaper letter, collage styles of Dadaist art which itself was used to connote trouble. We can see in the case of The Clash sleeve that there is some irregularity in the letters, although to some extent this suggests a graffiti style and therefore the informality of sloping typefaces. In the cases considered in these two chapters we only find Big L using different font sizes, which suggests a degree of lack of following rules or of irreverence.

Flourishes

Typography has developed a wide range of flourishes and additions which also carry meaning potential. These may be rounded and expansive, include large loops or circles for the dots on the letters i and j. They may even include other iconography imagery. One important flourish is the 'foot' we find at the top and bottom of letters referred to as 'serifs'. These are associated with tradition. Where they are not present there is a sense of modernity. Newspaper titles generally carry serifs to communicate tradition, although newer redesigns tend to combine these with slimmer letters and more spacing to suggest less dogma, and a move towards having room to think and express ideas and culture.

The Mozart sleeve uses serifs, as we might expect for classical music. U2 use serifs, as do Girls Aloud, whereas many of the other artists in our examples do not, such as McFly. U2 and Girls Aloud therefore communicate something classical and traditional. Interestingly the U2 typeface uses spacing to suggest room to think but also serifs for something traditional. The message is that this openness is not so much something new and arty but something classical, perhaps slightly timeless.

The Willie Nelson font uses heavy serifs. This could indicate a very strong connection to tradition; in the case of country and western this is associated with songs about traditional values of love and loneliness of the cowboy. Beyoncé uses an Old English style to communicate timelessness, and Clannad use letter shapes that connote 'Celticness', that also look old and worn (see Table 3.2).

Table 3.2 Summary of typographical qualities for U2 and Clannad

Typographical quality	U2	Clannad
Weight	Light, subtle, not overly assertive	Heavy and large, assertive and solid
Expansion	No, although letters spread, individual letters are economical	Yes, letters fill width of cover and take up space
Slope	No	Yes, more organic and less formal
Curvature	Angularity technical and rational	Curvature, more feminine, soft and emotional, suitable to connote connection to tradition
Connectivity	Fragmentation suggests room to breathe, thoughtfulness, room for contemplation, reserved	Connectivity, integration and cohesion associated with tradition and unity of meaning
Orientation	Flat letters are stable	Wide letters very stable though flattening, suggesting immovability and firmness of tradition
Regularity	Regular, reserved, stable, respectful of conventions	Regular, reserved, stable, respectful of conventions
Flourishes	Serifs – tradition	Some serifs iconological, Celtic style
Meaning of combination	Delicate, room to breathe, thoughtful, classical and technical rather than emotional	Organic, emotional, stable and unity of tradition

4 Analysing Lyrics:
Values, Participants, Agency

This chapter deals with the discourses communicated by song lyrics. As with the visual analysis in the previous chapters the aim is to provide a systematic way to carry out analysis, asking specific questions of the semiotic choices made by the artists. As with the record sleeves, lyrics are one way an artist tells us how to listen to them, how to put meanings into their music. Lyrics are not only about artists telling stories but also communicating discourses about their identity. However banal lyrics might seem, as in the case of love songs, they can reveal much about cultural discourses of a specific time alongside which an artist may want to align themselves. Songs from different times and by different artists may cover the same basic issues, such as falling in love, but the identities, actions and values vary. Of course many lyrics do not seem to make much sense at all and there seems to be no coherent message. But these too can communicate discourses, along with identities, values and courses of action.

This chapter covers a number of levels of analysis. When analysing lyrics some of these forms of analysis may be more revealing than others depending on the particular case. However, using all of them helps draw attention to that which we may not otherwise have noticed. One of the basic qualities of Critical Discourse Analysis (CDA) is that it should allow us to reveal qualities in texts, and therefore the way they make meaning, that would not normally be obvious to the casual reader. The same principle applies here.

The first section shows how to reveal the basic discourse or 'activity schema' that underlies song lyrics; in other words, what happens in the song at the simplest level. This is one way to reduce lyrics down to their core of what they are about. In a story, for example, while there may be many characters, events and settings, the main plot could be 'boy gets girl'. Some theorists have argued that drawing out this basic core can be extremely revealing in terms of the cultural values being communicated. These values can often be hidden by the

layers of detail. Song lyrics can be analysed in the same way to reveal the core meanings.

The second section of the chapter shows how we can gain further understanding of lyrics by identifying the participants in the songs, how they are described, what actions they perform and in which settings this is done. CDA has shown that simple linguistic choices in how a person is represented can have a huge role in connoting wider discourses, for example if a person is a 'militant' or an 'oppressed worker', if aspects of their identity are foregrounded or backgrounded, for example if a man is described as 'Muslim' rather than 'businessman and father of three from London'. There is equal value in analysing what the participants are depicted as doing. CDA has shown that this is an important level of analysis in order to establish who is represented as having power and who not, to whose minds and thoughts we are given access. We also look at settings since these can also be used to connote discourses. Why have heavy-metal bands often mentioned 'the back streets' while folk bands speak of 'forests'?

In the final section we carry out an analysis of a song where there appears to be little sense at all in the lyrics. Many songs are of this nature. But here too there is much meaning being communicated.

Basic song structure

Our first step of analysis is to ask what happens in the song at the most basic level; such as 'boy gets girl, boy loses girl'. In other words, we look for the activity or *discourse schema* that underlies the song. This kind of analysis not only applies to narratives, but to all genres. It is not an analysis of the form of the text but the analysis of the form of the knowledge that underlies the text. Not all songs have a basic schema of activity, although many do. And while a number of songs may appear to be simply love songs, closer analysis often reveals different underlying schema and therefore differences in values, behaviours and identities. The activity schema for a Bob Dylan love song, for example, is very different to a Girls Aloud love song.

This kind of analysis is useful for revealing the social values that underlie the song. Social anthropologists and social psychologists have shown that while the kinds of stories, myths and folk tales humans have told throughout history may appear on the surface to be quite complex, with mythical creatures travelling across fantastic lands and being involved in all sorts of adventures, at their root are very basic messages about the kinds of values and identities cherished by a particular culture or about their concerns and worries and boundaries (Lévi Strauss, 1967; Propp, 1968). For example, Lévi

Strauss (1966) showed how in cultures in South America stories were populated by animals and people who exchange cultural artefacts such as cooked food and pots. He explains this as being due to the fact that the difference and similarity between nature and culture is of great importance to the way these people explain their world. This is very different from societies that use history and causal/ linear models to explain their present. It is such values that can be revealed by stripping a story or song down to its basic structure or activity schema.

Wright (1975: 12) has argued that the study of such stories

can enable us to achieve a greater understanding both of the mind's resources for conceiving and acting in the world and of the organizing principles and conflicting assumptions with which a specific society attempts to order and cope with its experience.

The work of Carey (1969) gives us a hint of the way that song lyrics can give us access to the psyche of the time or culture. He carried out a study of love songs between 1955 and 1966. Previous research on lyrics by Horton (1957) in 1955 had found that 83 per cent of all records were about love and therefore, he concluded, were repetitive, manipulating only a limited range of values. But in his much more detailed analysis Carey found that earlier songs tended to emphasise fate where relationships are something that simply happens to people while they wait around. In later songs couples have more control in bringing about relationships and there is a theme of the freedom to change, to make a relationship what you want it to be. In earlier songs being alone was valued negatively, whereas later it is evaluated more positively, as an opportunity to explore the self. Also there was a shift away from romantic love to physical desire. Carey suggests these findings reveal a cultural shift to greater individualism and reflexivity identity as well as more liberal attitudes to sex.

We can see the difference if we compare verses from songs from the earlier and later parts of Carey, sample:

Johnny Cash, 'As Long As I Live' (1955)

As long as I live if it be one hour
Or if it be one hundred years
I'll keep rememberin' forever and ever
I'll love you dear, as long as I live

In this case we can see the lack of control, since the narrator has no idea about time nor what will happen, and the emphasis is on romantic love. Simply what happens in this verse is that the narrator remembers a lost love.

Simon and Garfunkel, 'I Am A Rock' (1966)

I have my books and my poetry to protect me.
I am shielded in my armour.
Don't talk of love, I've heard the word before.
It's sleeping in my memory.
I won't disturb the slumber of feelings that have died.
If I'd never loved, I never would have cried.
I am a rock, I am an island.

In this case we can see a narrator that is much less idealistic about love and, unlike the previous case, has mechanisms to survive. In this case the verse is about him surviving as an individual.

Mamas and Papas, 'Go Where You Wanna Go' (1965)

You gotta go where you wanna go.
Do what you wanna do
With whoever you wanna do it with.

In this last case the verse is simply about individual freedom and lack of romantic ties.

For Carey such lyrics illustrate a shift from romantic devotion and passive roles to greater reflection, independence and physicality. Carey also points to a shift from women being put on a pedestal as passive objects to be worshipped to them having personalities, even being difficult.

In a broader sense these examples show that in the lyrics of pop songs there are basic differences in terms of the values expressed about how people should behave and why. We should be mindful, therefore, of dismissing the songs of today as simply romantic love songs. Through analysis we can reveal what other kinds of values, identities and sequences of action they describe and connote.

Activity schema in lyrics

Drawing on the work of Propp (1968) and Wright (1975) we can represent what takes place in songs in the form of an *activity* or *discourse schema*. This allows us to strip away the details of a narrative in order to reveal its core structure.

Propp (1968) used the idea of functions to look at the basic structure of narratives. He analysed 150 Russian folk tales showing that the same events kept being repeated. He argued that these were narrative functions and were necessary for narratives to take place. Breaking the stories down into their smallest irreducible units, he identified 31 functions, although not all of these need to be present in all stories. Examples of these functions are: pursuit, villainy, lack, rescue, punishment, solution, difficult task, etc. Through these functions it is possible to identify the role played by characters. So, for example, at

the beginning of a story a person might be displaced. This immediately allows us to recognise them as the hero. To illustrate, we find this in Disney's *Jungle Book* in the case of the character Mowgli (Simpson, 2004). He also has helpers, Baloo the bear and Bagheera the panther, who are identified by advising him of danger. Propp referred to this as the interdiction function, meaning that they prevent him from straying. There is a villain, the tiger Shere Khan, who attempts to take possession of the hero, the sixth of Propp's functions. Finally, the hero battles with the villain using fire, Propp's twelfth function: the intercession of a magical agent. Simpson shows how the same kinds of functions are present in *Harry Potter and the Philosopher's Stone*: a displaced hero, helpers, the villain and the battle. These functions do not have to take place in any particular order and can be found in very long or very short stories. The story will have involved descriptions of settings, such as the house and countryside where a hero lives, but these details are the dressing which is draped over the basic structure.

By identifying the role played by a character, our attention is drawn to the generic rather than specific role of the character. It is the generic role that is of interest to us in our analysis since this tells us about the cultural values about identities and behaviours that lie deeper in the song.

Drawing on Propp (1968), and also on Burke (1969), Wright (1975) believes that characters in narratives therefore represent social types acting out a drama in the social order. Each character represents a set of social principles. This can be most easily done through such stock characters. Wright thought that by reducing narratives, in his study of movie westerns, to their basic functions we can reveal the basic cultural values that form the driving force of the story and the way that characters are used to celebrate or challenge particular kinds of identities. Amongst his fascinating observations, Wright noted two huge changes in the basic structure of events and kinds of characters in westerns from the earlier movies in the 1930s and 1940s to those of the late 1950s and 1960s. Early westerns depict a lone hero who has special powers (fast with a gun, independent, shrewd) and is different from the wider society that is basically good but which is weak and needs the hero to save them from a threat.

Later, from the 1960s, the hero ceases to be a loner and begins to work in teams, which Wright calls the 'professional plot'. In these films society is no longer good but dull, petty and mercenary. The professional hero does not stand up for any morality as neither they nor society has any such thing. Rather the hero simply offers their skills to a group which has some kind of technical expertise or knowledge. By doing this the individual shows themselves to be superior to the petty, dull society. Unlike the earlier westerns the hero is not later unified with society.

Wright connects these changes in plot to perceived changes in feelings towards society becoming dominated by market capitalism, of contradictions in the values of individualism, and the difficulties of realising this in the market economy. Therefore, the change in plot represents changes in attitude to society, the self and our relationships with others.

In order to arrive at these kinds of observations Wright breaks down westerns into their most basic story structure. Here is an example of a story structure for a romantic film:

A loves B
⇓
B ignores A
⇓
A dies
(Wright, 1975: 26)

The actual movie may contain many characters, events and settings but this is what lies at its core. This is the basic activity sequence around which the movie is organised. In this way we can take the step of asking what roles the characters play in this sequence and what kinds of social values are being tested out. For example, Wright adds that if in this particular structure A is a man and B is a woman then this is simply a story about love between different sexes. But if A is also upper class and B working class, then it is also a story about class differences and the clashes of values that such interactions can involve.

In his summary of the kinds of values dealt with in westerns Wright suggests that in earlier plots broadly felt cultural conflicts are dealt with by one individual, such as progress versus freedom, law versus morality. In the case of the class differences it could be the breakdown of certain social boundaries by social change. The *Harry Potter* movies involve an element of class conflict where the Muggles family are taunted by Harry's enemies for their lowly position. This movie, like Wright's westerns, involves a society under threat by evil and the hero, Harry, is partly an outsider, discovering only late in his life that he is part of this society, although like the later westerns Harry works in a team. The society is basically good, although somewhat confused, and is unable to see its own problems within. To what extent, therefore does this basic plot chime with contemporary concerns regarding rampant global corporate activity and our inability to prevent wars that we do not support? It seems we believe society is still fundamentally good but that it has difficulty seeing the evil influences at work within it.

Following Wright's lead, Propp's functions can be used to describe the underlying discourse schema of lyrics. This allows us to think

about what is going on in the worlds created by lyrics, even where there seems to be no actual story being told. Sequences of activity can be communicated without traditional, linear narrative. Discourses in the Foucaultian view are chunks of knowledge about how the world works and how people behave, what drives them. A *discourse schema* simply means the sequence of activity that is the realisation of such a discourse. For example, at the time of writing, the discourse of 'enemies of freedom'/'terrorists' is strong in Western politics. The discourse schema for this might be:

<div align="center">

There is a threat to society
⇓
Society must meet this threat
⇓
Society is safe

</div>

In this way, of course, Western politicians can distract attention away from the root causes of challenges to Western supremacy. But the point here is that these discourse schema or functions can be realised by only one part of the sequence being used as a signifier.

Importantly, activity schema can be realised not just through narrative but in many genres such as dance, speeches and games as well as stories. In their work on legitimation in political discourse, van Leeuwen and Wodak (1999) point out that discourses have associated sequences of action or scripts as well as related identities, values, settings and times. These scripts can be connoted by a range of semiotic resources. What this means is that in the press, for example, such threats to society can be signified simply by an image of a Muslim person. By creating a discourse schema in this way, therefore, we can draw out what the characters actually do and what social values these actions embody.

Here is an example of an activity schema using lyrics from the song 'So Good' by the boy band Boyzone. First here is a section of the lyrics themselves. The full lyrics are easily accessible on the Internet, but this short section is sufficient to illustrate:

I've heard it before
And you're telling me no, and I'm crazy
We're talking too fast
We've just got to take it nice and slow

The schema for Boyzone's 'So Good' is as follows:

<div align="center">

Girl loves boy
⇓
Boy wants fun

</div>

This song is about a girl who is in love with the narrator who addresses his words to her. The narrator does not mention love explicitly and it is indicated only through him telling her to just 'take it nice and slow', have fun and 'be so good'. In this relationship he clearly has the power. At one point he even says 'I will show you whose boss'. We do not know the outcome as we hear only his address to her. These lyrics are much in the category of some of the later love songs described by Carey above. The narrator doesn't want romance, just fun. He is in control of his life and will do things when he is ready. We can draw out how the band uses these lyrics to connote something about their identity by comparing them with the lyrics from Bob Dylan's love song 'You're No Good'. Here is a sample of the lyrics:

You're the kind of woman I just don't understand
You're takin' all my money and give it to another man.

Well you're the kinda woman makes a man lose his brain
You're the kinda woman drives a man insane
You give me the blues, I guess you're satisfied
You give me the blues, I wanna lay down and die

<div align="center">

Boy loves girl

⇓

Love is unrequited

⇓

Girl uses boy

</div>

In this case, in the manner described above by Carey (1969) for Dylan's later set of 1960s love songs, we find a kind of love where the woman is much more complex. The narrator is in love and is the vulnerable one in this case. At times she doesn't let him in his own house and gives away his money to another man. Interestingly, the narrator seems trapped in the situation. His response is that he wants to 'lay down and die'. We could imagine that it would not be appropriate for a boy band such as Boyzone, whose main fan-base was teenage girls, to represent themselves in this manner. They may sing about regrets and a lost love, but certainly not about them being in such a drab, abusive, powerless situation. For Dylan, however, such lyrics convey authenticity and real-life drama where not only can love be unrequited but nevertheless something that traps us and leads to regular humiliations.

More will be said about discourse schema as we move through our levels of analysis. There is also much more to be said about the lyrics we have begun to analyse.

Participants in lyrics

A further level of analysis for lyrics is to ask who is represented and what they do. In this section we deal with the first of these.

As noted in Chapter 1, the core idea of the CDA is that we look at the way that linguistic and grammatical choices can connote whole discourses. CDA has shown that it is important to analyse texts for which kinds of social actors are included and excluded or made invisible (van Leeuwen, 1996) and in terms of what kinds of terms are used to describe them. Are they described in generic or specific terms, as collectives or individuals, for example? By analysing such linguistic choices we can assess what kind of world is being signified in the songs. Above we gave the example of the 'Muslim' person in the press who can be used not to represent an individual person, but a generic 'other' (Richardson, 2007) when they could have been represented as a 'father of three', for example. The first of these makes the person a generic anonymous type, whereas the second individualises them by introducing some personal information.

Analysis of participants also helps us to think about the kind of communication offered by the lyrics. Horton (1957) suggested that most songs were written in a mode of address of intimate conversation where the actors are 'I' and 'You' (p. 569). But what kind of world does a song connote where the participants are 'baby' or 'bitch'? Are they 'American idiots', 'The Lost and Lonely', 'a killer'?

Here are the social actors in the Boyzone 'So Good' lyrics:

Baby
We
boss
they

To draw out what this says about the world created in the lyrics we can compare them with the chorus from 'Fight the Power' by Public Enemy. Here, first, is a sample of the lyrics:

Elvis was a hero to most
But he never meant ---- to me you see
Straight up racist that sucker was
Simple and plain
Mother---- him and John Wayne
Cause I'm Black and I'm proud
I'm ready and hyped plus I'm amped
Most of my heroes don't appear on no stamps
Sample a look back you look and find
Nothing but rednecks for 400 years if you check
Don't worry be happy
Was a number one jam
Damn if I say it you can slap me right here
(Get it) let's get this party started right
Right on, c'mon
What we got to say

Power to the people no delay
To make everybody see
In order to fight the powers that be

To begin with the schema for 'Fight the Power' would be:

<div align="center">

Society is oppressive

⇓

There is a challenge to society

</div>

This is a political protest song. What is the precise problem, or the solution, is not clearly articulated in the lyrics. But at the time of its release the song was clearly part of a particular social situation. Warell (2005) discusses the way that acts like Public Enemy arose at a crucial period of struggle in US cities, capturing the conflicts caused by the conservative social policies of Ronald Reagan and George Bush Snr affecting impoverished communities already ravaged by drugs, guns and HIV. She suggests that such songs challenged the 'Me' decade that had preceded with its 1980s acts such as Flock of Seagulls and Duran Duran.

Turning our attention to the participants of the lyrics we find the following:

Elvis
John Wayne
Heroes
Rednecks
Racist
Sucker
Mother
Black
I
me
we
the people
everybody
the powers that be

To begin with we have a much longer list of participants than the Boyzone song. We can see that these include named participants. Names in songs can usually be the names of a lover such as 'Gloria'. In the Boyzone song the lover is not even named. In this sense she simply represents a kind of relationship, even a way for him to tell a story about himself. Named participants in lyrics can also be those that have iconic status. When we find such names in songs we can ask what kinds of discourses they are used to connote. In 'Fight the Power' we have American heroes Elvis and John Wayne who carry with them a particular set of values. But in this case these are collocated

(meaning used next to) terms such as 'redneck' and 'racist'. This in itself creates a sense of challenge in the lyrics, as when in late 1970s the Sex Pistols collocated the British Queen with terms such as 'anarchy' and 'fascist'.

In 'Fight the Power' the singer also puts himself in the lyrics saying 'I' and 'Black' and also as a collective 'We'. In this case it is not the same kind of 'We' as the Boyzone lyrics which would not claim any broader associations. In 'Fight the Power' this use of collective pronouns serves to point out that this is not just his voice, but that he speaks for many. We see this also in the use of 'the people' and 'everybody'. These terms ambiguously summon up people in general against a generic power referred to as 'the-powers-that-be'. Such use of 'the people' and 'we' has been common to many kinds of protest songs. Bob Marley in songs like 'Exodus' speaks of 'we' acting as in 'We know where we're going, uh! We know where we're from'. But who the 'we' is remains unclear. What is connoted is a collective that rejects the-powers-that-be in the manner of 'Fight the Power'. But who the 'we' is and how we identify our collective cause is not specified. This is one way that artists like Marley are able to address a range of listeners. Importantly, it is one way that popular music is able to signify anti-establishment while at the same time keeping this highly accessible to all. Hutnyk (2000) has written of the way that such alternative cultural pleasures can easily sit alongside broader lifestyles associated with consumerism and success in capitalist society. Kruse (1993) suggests that it is such devices that allow the listener to gain a sense of imagined shared identity through an unformulated oppositional stance (p. 34). This is one important discourse, she feels, in the difference between what we think of as 'mainstream' and 'alternative music'.

As discussed in Chapter 1, all this helps the listener to hear authenticity in the music. The blues is associated with authenticity as it is thought of as the authentic voice of an oppressed people, straight from the heart. This is even though when we hear it in a bar, it is performed by people who have not necessarily been oppressed and who play in a way that is highly formulaic of blues. In the same way, however vaguely articulated, a voice of anti-oppression in lyrics gives music greater authenticity. This, of course, also brings associations of music from the heart, rather than the intellect, which in itself carries connotations of non-conformity to bourgeois repression. Pop musicians can use this to indicate that they are anti-respectable to give a sense of challenging social convention, when in fact they offer no concrete or clearly articulated message.

Van Leeuwen (1996) offers an inventory of the ways that participants can be represented linguistically. We can draw on these to think more precisely about the meaning of lyrics.

- *Personalised/Impersonalised*. Do lyrics tell us about impersonalised agents such as 'the powers' and 'the system', or even whole nations such as America? Or are we dealing with named individuals? In other words, is it a personal story? In Boyzone's 'So Good' the unnamed girlfriend is impersonalised.
- *Individualised/Collectivised*. Are we made to feel close to some of the participants by being given personal details or do the lyrics depict groups who remain more distant from us? Of course groups such as 'we' or 'they' can be used for ambiguous calls to action as in 'Fight the Power'.
- *Nominalised*. Are participants named? This can have a personalising effect. In 'So Good' the girlfriend is unnamed. Nominalisation can create intimacy, although names can also have an iconic effect as in 'John Wayne' in 'Fight the Power'.
- *Functionalisation*. This is where participants are represented in terms of their role or function. Here we might have 'biker', 'ruler', 'warrior', 'innkeeper'. Functions can be positive and negative. The roles that people play can signify discourses, for example, if a song includes 'police' or 'criminals'.
- *Anonymous*. This is where a participant is inferred in the lyrics but never directly represented. This could be 'someone', or 'some people'. In 'So Good' we learn nothing at all about the girlfriend, not her name, what kind of person she is or what she does. More details about a girlfriend in a song can create a more intimate narrative.
- *Aggregated*. This is where people are represented as quantities. In a song we might have 'all the people', 'many people', 'thousands of people'. Such songs tend to be more prophetic. Oasis and Bob Marley speak of collective groups where number is clearly important.
- *Objectivated*. This is where a person is represented through a single feature such as 'the beauty', 'the gun'. This can have an effect of giving the power to the narrator, a sense of the world through their eyes. It also reduces the participants to generic role types.

Action and agency in lyrics

It is also useful to ask what the social actors are depicted as actually doing (Hodge and Kress, 1989). Are they working in a diner, surfing, suffering or travelling? Are they simply longing or hoping? In textual analysis it is important to observe who is active and who is represented as being self-reflective. We often find that there are specific patterns associated with genres of music.

Carey (1969) suggested that the role of women in love songs changed from one of passivity to agency, where they might even act selfishly. This in itself is an important observation, although in such cases a linguistic analysis would pay close attention to whether such actions are specified or remain in the abstract as in 'she hurt me bad', or specific as in 'she gave my money to another guy'. They would also want to know the extent to which their actions gave access to their state of mind. Were they 'thinking' and 'wishing' for example?

Previous analysis by linguists has shown that in fact people are depicted as doing very little in popular songs but rather 'wish' and 'hope'. While this certainly seems to be true, our analysis allows us to show that this is not always the case. Wilkinson (1976), in his analysis of agency in love songs, found that both men and women were represented as equally active with women often having most of the agency such as in 'These Boots Are Made For Walking' (1966), which portrays an aggressive woman who threatens to walk all over her unfaithful lover, and 'Mr. Blue' (1959) where the man remains at home distraught waiting for his love who is out on the town. However, in such cases we must be mindful to ask exactly what kind of actions particular participants are depicted as doing. In romantic fiction, heroines are often the agents of most of the actions but these tend to be more trivial ones, where she is left waiting for the hero, busily longing, wishing and worrying while he deals with some more material matter (Machin and Thornborrow, 2003).

We can more accurately approach what people do in lyrics through Halliday's (1978) observations on how action is represented in language. Halliday lists a set of process types, some of which involve physical action, and others which involve just thinking or talking or even just being:

- *Material* – doing something in the world, 'I started a revolution'.
- *Behavioural* – acting without outcome, 'I whistled'.
- *Mental* – thinking, evaluating, sensing, 'I thought about you'.
- *Verbal* – saying, 'We talked about the future'.
- *Relational* – being like, or different to, something else, 'I was better than them'.
- *Existential* – existing, appearing, 'I was in my room'.

Through his analysis, texts could be analysed to show how people were represented as behaving and who was shown as being active and who as passive. This is often less than obvious unless we take a little more time to carry out analysis. For example:

The Palestinian village had been destroyed.

In this sentence there is no actor even though we are offered facts and a description of a situation. In this way the agents, or those who destroyed the village, remain anonymous. Or a sentence might show someone as being very busy but in fact achieving little. For example:

> The heroine sat in the room and thought intensely. She read a little but listened carefully for a noise.

In such cases, however, it may be that the agent of mental processes can appear more sensible and careful and who may gain our empathy as we are given access to our feelings. In a speech a politician might represent enemies as acting materially in terms of 'attacking' and 'repressing', whereas our own country will 'think through', 'consider', 'be concerned'. In such a case rather than passivity this humanises the participants.

In order to be specific about analysing these processes of agency and action, Halliday used the terms 'actor', 'goal', 'process' and 'circumstance'. For example, in a news item we might find the following sentence:

> Jarvis will marry Deborah in this town.

The actor in this case is Jarvis who carries out the process of marriage. The goal is Deborah, and the circumstance is the town. We can apply these to any linguistic or visual communication to allow us to consider more carefully what is going on.

This is what the actor does in 'So Good':

> *I've heard it before*
> *We're gonna be so good*
> *I'm crazy*
> *Like I knew we would*
> *We're out on the town*
> *Getting lazy*
> *I'll show you who's boss*

We have mainly mental and existential processes as in he 'knew' and they were 'out'. This is not a song about performing actions that influence the world. The mental processes are all about the singer's experience and therefore power. He 'knew we would' and has 'heard it before'. There are directives (orders) such as 'Sit back let it flow now', further demonstrating that the actor in this song has the power. He is experienced in relationships and therefore it appears he has before repeated this pattern where the girl becomes attached to him, serious about the relationship, while he wants simply to have fun. We learn nothing about the mental processes of the girl.

We can compare these actions with those in Pulp's 'Disco 2000':

I said let's all meet up in the year 2000.
Won't it be strange when we're all fully grown.
Be there at 2 o'clock by the fountain down the road.
I never knew that you'd get married.
I would be living down here on my own,
on that damp and lonely Thursday years ago.
Oh what are you doing Sunday baby.
Would you like to come and meet me maybe?
You can even bring your baby.

First of all the activity schema here is:

Boy loves girl
⇓
Love is unrequited
⇓
Boy remains faithful

In this case we find a basic love song structure. The narrator speaks of his adoration for a girl which is unrequited. In fact he is completely ignored. The humour in the song is that she has never even noticed him while he maintains his desire even when they have grown into adults, saying that it is fine for her to bring her child along if she would like to meet up. Through these lyrics Jarvis Cocker is able to communicate a similar vulnerability to Dylan. But at the same time he conveys a clear self-depreciation as he sings about his own invisibility. As with other Pulp songs, and in the lyrics other Britpop bands such as Blur, there was during the 1990s a tone of the disappointment with society, of the way life can be filled with the mundane and routine humiliation. An important part of these lyrics was irony.

This is what the actor *does* in 'Disco 2000':

I was a mess
We never did it although often I thought of it
When I came around to call you didn't notice me at all
I had to watch them trying to get you undressed
I never knew that you'd get married
I would be living down here on my own
I remember every single thing
I used to walk you home

This actor does not act upon the world, since there are no material processes. Instead, the lyrics comprise predominantly mental processes where the protagonist thinks, or behavioural processes where he watches. In fact it has been shown that verbs such as 'thinking' and 'missing' are highly predominant in the lexis of songs (Murphey, 1992).

The goal of many of the processes is the girl who does not even notice him. He thought of sex with her, although it never happened. There are behavioural processes as he describes himself 'living down here' and going to her house. But he accomplishes nothing. The girl in contrast gets married and has a baby. Also much of the processes depict the passing of time which add to the lament and emphasises the narrator's own lack of progress.

'Disco 2000' is a love song but very different to 'So Good' and to Dylan's 'You're No Good'. The narrator here is neither a victim, nor in charge. Rather he looks back on his life and lack of progress with complete resignation yet without bitterness. While the Boyzone narrator is a shallow guy who likes fun and Dylan's a man in love with the wrong woman, Cocker's narrator is a fairly weak observer, a loser even. Yet it was just this, sung with bright pop melodies, which gave Pulp authenticity. Cocker played out an ironic anti-masculinity.

Settings and circumstances

In linguistics it is often considered useful to carry out a lexical analysis of words that tell us about circumstance or settings. As with description of actors, in songs there is often very little information about settings (Murphey, 1992; Cutler, 2000). Neither 'Fight the Power' nor Dylan's 'You're No Good' has any such reference. In terms of storytelling this is interesting. In a story we often require character and place. But song lyrics are often stories that have only participants and feelings. In 'Fight the Power' America is itself represented through participants.

In songs settings can be implied for example by lines such as 'I could hear the baby crying', or 'the music played all night'. Where lyrics do mention such detail we often have the association of the melancholic singer-songwriter. Nevertheless, the scant detail we are given about settings can be highly revealing about the world being communicated.

In Boyzone's 'So Good' the only indication of setting is the following:

When we're out on the town.

This is pretty much a decontextualised lyric. Had it not mentioned 'town' it would have been simply a set of feelings in 'no-place'. As mentioned at the beginning of the chapter different genres of songs often make reference to certain kinds of settings. Rap might speak of 'streets'; folk music of 'hills' and 'streams'; rock music of 'roads'. These locations, while generic, can communicate broader ideas. Rap music is based in an urban environment, folk music is about a simpler social order rooted in tradition and the land. Rock music often

emphasises escape and journeys. The town in 'So Good' is not a specific town but simply a 'town'. Some bands do in fact mention actual locations. Country and western music often does this: Memphis etc.

Also 'So Good' is not temporally located. The effect of this is to give the song a 'timeless' quality; it could easily apply to any such relationship as it is not specific to one generation.

Other songs use settings in much more detail, as in 'Disco 2000':

Be there at 2 o'clock by the fountain down the road
Your house was very small
With woodchip on the wall
on that damp and lonely Thursday years ago.

Here settings are used to create the humble context of the story. Cocker uses everything that is the opposite of cool. He evokes a drab, ordinary life, suggesting little sense of glamour, power nor future. Hsu (2005) suggested that this music created an important connection with a generation of young British men who lived through the post-Thatcher years of joblessness and lack of community. This sense of disappointment and absence of the common romantic fantasy of love is very different to the gritty version of the same message offered by Dylan.

Different genres of music (although, as we have already stressed, there are no strictly definable genres *per se*) can be shown to favour different patterns of participants and settings. We can show this by comparing one folk song and one heavy-metal song. First the folk song:

Clannad, 'Journey's End'

Hear the anchor sinking
Voices ringing clear
Farewell from my kindred
And friends I love so dear, and friends I love so dear
Journey's at an end, journey's at an end

Circumstance is clearly highly important in these lyrics. Throughout the song we find:

Lost streams
The vale
Meadows
storm
Hear the anchor sinking (ship)

The song is filled with references to idyllic unspoiled and ancient landscapes. And typically of folk music the narrator looks not to a future, or to change, but speaks of a longing for home and for tradition where

the memories of rivers and other rural markers are sadly beginning to fade. This message is reflected in the kinds of participants we find:

> Voices
> Friends,
> kindred
> I

The use of the word 'kindred' is typical of the genre, as is the use of 'friends', people with whom one shares close bonds. This is characteristic of the signification of tradition. Like the settings it is of the past and unspoiled by urban and technological contamination.

> Megadeath, '99 Ways to Die'
>
> There is only death and danger
> In the sockets of my eyes
> A playground of illusion
> No one plays they only die
> There's a prison in my mind
> And the bars are gonna break
> I'm as mad as a hatter
> And strung out just the same

Here we find no settings and no participants apart from the narrator. In fact the setting could be thought of here as the narrator's mind itself. The song is dominated by nouns such as 'death', 'danger', 'illusion'. Whereas the state of mind of the narrator in the Clannad lyrics is melancholic yet bright with the promise of a return to the homeland, here it is indicated by 'mad as a hatter', 'strung out', 'a prison in my mind'. These themes of death and madness are common to this genre of music. Walser (1993) explains that insanity is a theme common to heavy metal that became a trope for unconventional thought and an important signifier for those who feel alienated by the dominant social logic (p. 155). While heavy metal may appear to not deal with serious issues, rather being dominated by fantasy and mythology, Walser does see this as a way by which teenagers disaffected from power in the 1980s, in particular were able to provide a 'sense of contact with something greater than oneself' (p. 154). This helped to create a space where fans could find a kind of communion.

Lyrics where there is no activity schema

Lyrics often appear to be nonsense. But discourses can still be communicated, which themselves contain activity schema, although a

different procedure of analysis is required. In fact we do not need to have sequentiality or even logical relations in the way events are communicated in lyrics in order to find an activity schema. As listeners we know how to hear clauses or even words as a causative chain (Barthes, 1977). Even in the case of highly abstract texts listeners can still hear a narrative. Fabb (1997) argues that listeners will make an assumption that elements have some kind of relationship, that some story, a sequence of events, is being communicated, even where they seem difficult to find. Social psychologists have shown that humans are predisposed to see narrative, as is demonstrated where people can describe character and plot for randomly moving shapes (Bruner, 1990) – for example, a bigger shape bullies a smaller one. This is why it is important to think about the way that even songs that are fragmentary can 'narrate'. Even through the use of occasional culturally loaded words lyrics can connote sequences of activity and identities associated with particular discourses.

We can see this lack of obvious sense in the lyrics of 'Some Might Say' by Oasis. Here are the opening lines:

Some might say
That sunshine follows thunder
Go and tell it to the man who cannot shine
Some might say
That we should never ponder on our thoughts today 'cause they hold sway
over time

While it would be difficult to offer a discourse schema for 'Some Might Say', Todorov (1990) might describe the song as being an 'ideological narrative'. This narrative structure is one in which 'an abstract rule, an idea, produces the various [peripetia]' (p. 36). Todorov (1990) states that:

The relation of the propositions is no longer direct; one no longer moves from a negative to a positive version or from ignorance to knowledge. Instead, actions are linked through the intermediary of an abstract formula. [...] to find the relation between two actions that are completely independent of each other in material terms, we must look for a highly developed abstraction.

This can be one way of thinking about what we find in 'Some Might Say'. The phrases are carefully chosen to offer a sense of wisdom in the repeated 'Some Might Say', followed by what sounds like maxims – 'Go and tell it to the man who cannot shine' and 'we should never ponder on our thoughts today 'cause they hold sway' – combining with highly specific contextual terms such as 'kitchen sink', and broader ones such as 'heaven' and 'hell'. So while these lyrics are abstraction they are nevertheless used to communicate a number of things,

sometimes the details of everyday life and at others broader moral issues. If we look at what is done in the lyrics the lack of coherence is very clear:

> I've been standing at the station
> In need of education
> The sink is full of fishes
> She's got dirty dishes on the brain
> It was overflowing gently
> My Dogs been itchin'.
> We will find a brighter day
> Some might say
> they don't believe in heaven

Despite its sermon-like qualities, this is not a song about acting upon the world, as there is no goal. In 'Disco 2000' the goal was Deborah, in 'So Good' it was having fun. Of course, many songs that are considered to be meaningful do not have a clearly stated goal but this might be implied. Examples of this might include Dylan's 'Blowin' in the Wind'. These are songs where the discourse schema, at its most basic level, is something like: Some people do bad things in the world ⇒ we must change the world. In 'Some Might Say' we do find a collection of individual goals such as 'We will find a brighter day', even though it is never clear what was wrong in the first place.

We can learn more about what 'Some Might Say' communicates if we think about the lyrics through an analysis of the nouns. The nouns are: 'fishes', 'dishes', 'dog', 'kitchen', 'station', 'sink', 'heaven', 'hell', 'sunshine', 'thunder', 'education'. This list comprises a mix of the epic or abstract and the trivially domestic. The trivial here has a similar effect as the locations in Pulp lyrics. Sinks and dishes bring a sense of social realism and therefore social commentary in the fashion of Dylan.

If we think simply of the lexis of the verbs in the list above they are not unlike the typical verbs found in the songs analysed by other linguists (Murphey, 1992; Cutler, 2000). Cutler lists 'feel', 'waiting', 'got', 'try', 'look', 'thinking', 'come' as typical. In other words, these lyrics are not about acting on the world, but about mental processes and existential states. They are about desires and the moments where we wait for what we desire. 'Some Might Say' is consistent with this. But if we look at some of the mental states we find 'they don't believe in heaven', the use of 'heaven' gives a sense of seriousness, of lofty issues. We are not told who the people represented by 'they' are, but the fact that there are correctives leads us to assume 'they' are misled, the naïve. Oasis position themselves as the knowers, Lennon fashion, although they don't actually preach about anything serious or concrete. Lennon's songs – such as 'Imagine' – contain lines like

'You may say I'm a dreamer'. These songs are also about thinking and looking, but they have a goal, an outcome. 'Imagine' could be represented as a discourse schema since it is about resolving a problem. 'Some Might Say' also addresses the audience in one place as 'my friend'. This also connotes a sermon style, indicating the passing of wisdom. Again this is reminiscent of Lennon.

In the case of lyrics which appear as nonsense we can therefore still break them down into participants, actions and settings, also looking at the kinds of nouns that are present. From this we can establish the broader discourses that are communicated. In the above case, Oasis were able to communicate wisdom and social commentary through the chosen combinations.

Take four sets of lyrics from different genres of artist and analyse them:

- What is the discourse schema and what basic cultural values are at issue?
- Compare the participants.
- What kinds of verb process characterise the lyrics?
- Are there differences in the kinds of settings that are included?

When these observations have been made consider how this helps to communicate the artist's identity.

Activity

5

Semiotic Resources in Sound:
Pitch, Melody and Phrasing

In the study of popular music theorists have referred to the way that kinds of music have associated discourses. Hibbett (2005) made this case for 'indie' music which he said can be thought of as a set of conventions related to authenticity, purity and non-corporate ideals (p. 55). He studied these discourses through the way that those who identify with indie music speak of it, through the qualities they ascribe to good and bad music. He showed how listeners also use music to talk about themselves, and the importance of being non-mainstream. But Hibbett did not consider the music itself. Are there any kinds of melodies, rhythms and sound qualities that are associated with indie music? If its fans do talk about authenticity, purity and non-corporate ideals can we find signifiers of these in its melodies, pitches and sound qualities? And if so then can we find such patterns of choices in other kinds of music? This chapter is about providing the analytical tools that we use to carry out such an investigation.

Previous chapters have considered ways to analyse the patterns and established conventions in visuals and lyrics. Here the same is done as regards music and sound. In the way that choices of visual elements or lexical choices in lyrics connote discourses, the same is true of choices made in music through pitch, the notes that are chosen to comprise a melody and the way they are phrased.

The semiotics of music

Cooke (1959) and Tagg (1982) emphasise that, far from being a matter of simple creativity, since the 19th century there has been an established 'language' of types of music that connote moods, landscapes and character. Tagg writes of a **codal system of music** which is understood by people in Western societies. This system has come about largely through repetition. 'Time and time again the average

listener/viewer has heard a particular sort of music in conjunction with a particular sort of visual message' (Tagg, 1982: 4).

When we watch a movie or an advertisement, we understand the established meanings of the music that we hear. Many of us recognise musical codes that connote historical periods and geographical regions: for example, the bagpipes that connote the Scotland of Mel Gibson's film *Braveheart*, even though the instrument did not exist in this region until much more recently (Trevor-Roper, 1983), or the generic chanting music that can signify Africa.

Tagg (1982) discusses the 'Music Mood' collections that were available first on sheet music collections and later, beginning in the 1930s, on record. These were used for theatre and later for movies, advertising and television. These collections drew on the classical music of the 18th and 19th centuries, which started to use music as a narrative device to represent characters, places and moods. The musical mood collections would be categorised under 'action', 'comedy', 'danger', 'eerie', 'big', 'children', 'national', 'nature', 'industrial', 'leisure', 'space', 'suspense'. We still hear the basic themes from these pieces in contemporary adverts, movies and news reports. For example, a special report on street prostitution may use a piece of music to create a mood of 'loneliness' or 'darkness', depending upon the angle of the report. News introductory sequences might have rapid staccato pulses on an electronic keyboard to connote a teletype machine but also the rapid pace of news delivery. This will be backed by much lower bass drum rumbles to suggest gravity and importance. Then a higher pitched melody line might suggest a higher voice, or truth.

Cooke (1959) has argued that in contemporary music we can think about kinds of melodies, harmonies, instrumental sounds and vocal styles, all as carrying meanings. It would be possible in his view to create a kind of phrase-book of different kinds of melodies and say what it is that they mean – whether they are associated with sadness or anger, romance or danger, for example. He carried out a detailed and extensive study of classical music where composers evoked different kinds of moods and feelings. He suggests that codes were established after much repetition. These codes would be built upon other metaphorical associations, such as booming thunderous sounds for danger, soft sounds for gentleness, sweeping sounds to represent landscapes.

Van Leeuwen (1999) has attempted to provide some kind of order to these kinds of associations, to break them down into a kind of inventory of sound qualities. But like the meanings that we can associate with choices in visual communication, such as the colour qualities we examined in Chapter 2, we need a system of description and analysis that allows us to reveal how such choices have meaning potential that is realised in use with other choices. The stages

of analysis we carry out in this chapter are artificial as the meaning comes from the whole mix and not from these individual sound features and qualities. But as in previous chapters we can then use these individual observations built up here and in the next chapter to assemble a broader framework for analyses. In this chapter we analyse pitch, the meaning of notes of the scale, arrangement and perspective, sound qualities and rhythm.

The meaning of pitch

We begin by looking at a basic feature of sounds and music, that of pitch. This is simply how high or low a sound is. A scream would be a high note, thunder a low note.

The meaning of pitch is rich in metaphorical associations. Cooke (1959) has suggested that high pitch means effort, low the opposite; in other words contained, immobile and static (p. 102). We could think of this metaphorically as being like someone speaking in a low deep voice as compared to raising their voice in excitement. But from this higher pitch we can also extend to mean agitation and low drooping despair. Cooke shows that classical composers have used high pitch to suggest 'up and away' due to its energy and low pitch to suggest 'closer, down and relaxation' (1959: 103). In Western culture we have the association of up, meaning 'feeling good', and down, meaning 'feeling down'. We transfer this meaning to pitch even though there is no reason why a high pitch should be thought of as 'high' at all, as height is not involved.

We also have associations of the way things in our everyday world produce different pitches of sounds. Heavy objects can make deep sounds when they move or fall. Smaller animals might make higher pitched squeaking sounds. Deep sounds give a sense of danger or something ominous as in thunder. This could be why deep sounds are often used to symbolise gravity or danger.

High pitch can be associated with brightness and low with darkness and evil. We have associations of brightness with truth and dark with obscurity. Cooke adds that pitches beyond the range of the human voice can, in the cases of higher tones, give a sense of the ethereal, lightness, transcendence. This would be one reason for the pleasure brought by the voices of castrati and still by pre-pubescent boys in choral music. Deeper adult male voices, even if beautiful, cannot in the same way connote this transcendence.

When we analyse popular music we can simply ask whether the singer uses higher or lower pitches. Higher pitches can mean lightness, as we might find in a female folk singer, or agitation, as we might find in punk music. Lower pitches can mean bleakness as

used sometimes by Tom Waits. We can also look at the pitches of the instruments themselves. Some songs use a lot of bass while others do not. We will consider this further in the context of some examples shortly, but first we need to deal more with the meaning of movement in pitch. In music, after all, pitches rarely stay at one level.

The meaning of ascending and descending in pitch

We have listed a number of meaning potentials for high and low pitches. But often when we hear sounds and music there is generally movement in pitch. Perhaps a vocal line rises in pitch. The direction of this movement can also have meaning potential. Cooke (1959) suggests that in classical music ascending melodies are associated with outward expressions of emotions, whereas descending melodies are associated with incom emotion. This is due to the association of higher pitches with higher levels of energy and brightness and lower pitches with associations of low levels of energy. The movement from one to the other expresses a shift in either direction. A movement from a high pitch to a low pitch indicates that the meaning is of a falling of energy. The opposite, a gradual slide from low to high pitch, gives a sense of a picking of spirits. National anthems use stepped increases in pitch to suggest the brightness and energy of the national spirit. If you hum the first six notes of the 'Star-Spangled Banner' you will hear this effect – try singing it instead with a descending melody. Anthems will often also use some lower pitches to suggest the power and gravity of the nation.

We can show how increase and decrease in pitch works in a familiar popular song. Here is the melody from the start of 'Blueberry Hill'. First I show the direction of the movement of notes under the lyrics and then represent this as a graph (Figure 5.1).

I FOUND MY THR– ILL ON BLUE—BER— RY HILL
↑ ↑ ↑ ↓ → ↓ ↓ ↑ ↓

The arrows positioned under the lyrics indicate whether the melody of the song, the notes, are ascending in pitch, descending or staying at the same level. This can be seen clearly on the chart. In this case the first four words of the song ascend. If you hum the tune yourself you will be able to hear this. Therefore, we can say that the singer here is expressing an outgoing emotion or an increase in optimism. The melody then levels off and descends back to its starting point, although there is an important ascending note before this on 'BERRY'. So the outward expression of emotion, of joy, is followed

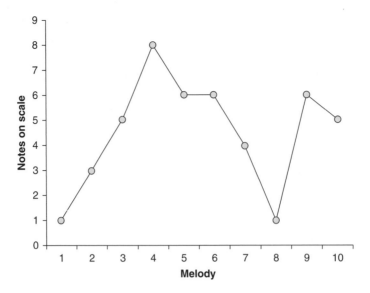

Figure 5.1 'Blueberry Hill' melody

by a move back to something more grounded and relaxed, perhaps more thoughtful. But the other ascending note on the second syllable of 'BERRY' marks another burst of emotion before it tidily resolves back to its starting point, giving a sense of closure. If the melody descended from the start then, according to Cooke, there would be incoming emotion, such as a received sense of joy or consolation or even, we would suggest, a simple slide to bleaker thoughts and self-absorption. So in terms of pitch 'Blueberry Hill' is an outburst of positive emotion. Shortly we will consider examples of songs where melodies descend and where they stay at the same level.

What is the range in pitch between the highest and lowest note?

As well as whether pitch increases or decreases there is important meaning potential in the range of these changes. A large pitch range means letting more energy out, whereas a small pitch range means holding more energy in. So we might think of a singer like Bob Dylan holding energy in, while a singer like Freddie Mercury lets it out. Van Leeuwen (1999) draws on work in linguistics by Brazil et al. (1980), who argue that pitch range in speech is akin to excitement, surprise and anger. Narrow pitch is boredom and misery. Pitch range in speech is also associated with emotional expressiveness. In

Middle C

A B C D E F G A B C D E F G A B C D E F G

Figure 5.2 notes rising in pitch on piano keyboard

Anglo-American societies, men have less pitch range than women (Liberman and Prince, 1977; McConnell-Ginet, 1988). So small pitch ranges can be associated with holding in, or even modesty. In Bob Dylan's singing about tragedy or injustice, using a limited pitch gives a sense of resignation or contained pain, perhaps giving it a different kind of gravity than an opera singer using a large range to sing about tragedy. We can show this if we return to our example of 'Blueberry Hill'. Here we look at the way the melody uses notes from a scale of eight notes in order to show pitch range.

I FOUND MY THR–ILL ON BLUE---BER----RY HILL
1 ↑ 3 ↑ 5 ↑ 8 ↓ 6 → 6 ↓ 4 ↓ 1 ↑ 6 ↓ 5

Songs normally draw on a scale which is comprised of eight notes. Note 1 gives the name of the scale and is called the root note and the eight notes after this rise in pitch. Since there are eight notes in the scale, note 8 is the same as the root but an octave higher. We can see this on the illustration of the piano keyboard in Figure 5.2. Middle C is note 1. If we move up eight notes to the right we again come to C. If we move eight notes down eight notes to the left we find the same sequence of notes repeated.

Above, the notes in 'Blueberry Hill' are represented with numbers to indicate where they are in the eight notes of the scale. In this case the higher the number, the higher the pitch of the note, although if we see a 1 followed by a downward arrow and then a 7 this would mean that the melody had descended to the 7th note below.

What we find in 'Blueberry Hill' is a large pitch raise in the first phrase 'I FOUND MY THRILL'. Here there is a leap of eight notes. This is therefore an extensive release of energy and brightness. Following Cooke (1959) we can say it is an outward expression of energy. This interpretation suits the lyrics, which seem to be highly positive. However, if the notes had descended or been over a limited range, it would have resulted in a very different expression of those lyrics.

Semiotic Resources in Sound

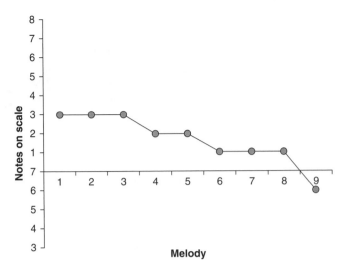

Figure 5.3 'Babylon' melody

As it is, the work represents a celebration of the event; a descending pitch would perhaps lend a mourning, pining quality to the song.

In 'Babylon', by David Gray, we have an example where each line of the verse descends. Here is one of the lines:

```
FRI----DAY  NIGHT  AND  I'M  GO---ING NO    WHERE
3  → 3    →   3  ↓ 2 ↓ 2 ↓ 1 → 1 → 1 ↓   6
```

Here the melody begins on the 3rd note and then descends in steps as can be seen on the chart. This suggests the opposite of outgoing emotion. This can give a sense of not particularly attempting to reach out to communicate as well as a falling of mood. We can imagine that if the same lyrics were sung with an ascending melody it would seem as if he were pleased he was going nowhere.

Some melodies neither ascend nor descend but are very static. We can see an example of such a limited range of pitch movement in 'Anarchy in the UK' by the Sex Pistols:

```
I    AM   AN   AN---- TI CHRIST, I   AM  AN  AN   ---ARCHIST,
1 → 1 → 1 → 1 → 1 ↑ 4 ↓ 1 → 1 → 1 → 1 → 1 ↑ 4 ↓

DON'T  KNOW  WHAT  I WANT  BUT  I  KNOW  HOW TO  GET  IT
1  →   1 →  1 → 1 → 1 → 1 → 1 → 1 → 1 → 1 ↑ 4 ↓ 3
```

Here we can see that much of the melody remains on the first note. There is therefore very little outward giving of emotion or positive energy. This means that there is something very contained about the way it is sung. In fact the vocalist sings the song generally at a

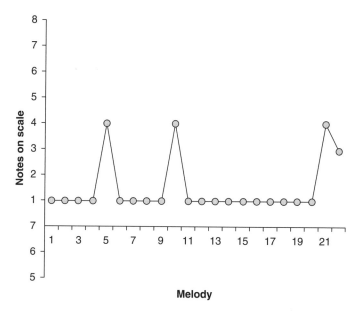

Figure 5.4 'Anarchy in the UK' melody

high pitch which conveys an emotional intensity. Yet in this intensity there is no emotional outpouring or pleasure as in 'Blueberry Hill'. There are only short sharp occasional outbursts to the 4th note. This is fitting of the punk discourse of nihilism and cynicism. The lyrics themselves offer only a kind of destruction yet without any real reason nor direction. This message is communicated also through the pitch stasis in the melody itself and the higher pitch of its delivery in general.

On the verse of David Gray's 'Babylon' we find a reasonably high pitch range. In the case of the descending melody this suggested a pretty moody slide in energy. On the chorus we find something quite different.

LET GO YOUR HEART, LET GO YOUR HEAD-AND FEEL IT NOW
1 → 1 → 1 ↓ 7 →7→ 7 →7↑ 1 ↑ 3↓2 ↓ 1 →1 ↓
BAB -Y - LON
1 ↓ 7 ↓ 5

Much of this takes place over the two notes, the 1st and, one note below, the 7th. While the lyrics suggest letting go of emotion the melody suggests containment. This then changes gradually, opening out for the words 'FEEL IT NOW' and then falls away for 'BABYLON'. Singer-songwriter music, following a tradition in protest songs, can often use a mixture of melodramatic falling melodies and contained melodies. The last of these, with other musical semiotic combinations,

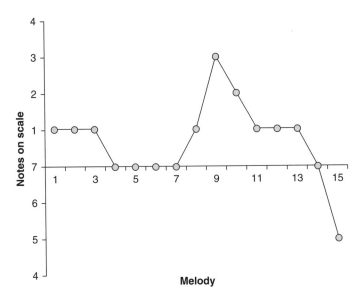

Figure 5.5 'Babylon' chorus

can mean a contained anger and feeling rather than a more exuberant outpouring. We will say more about this difference as we move through the chapter.

The meaning of using different notes of the scale

This is the part that the non-musician may find slightly more off-putting. But it is very simple and technical terms are avoided.

In a scale there are eight notes. So in a scale of C there are eight notes following from note 1, C. The 8th note, the octave, marks a return to C. A song is normally based on one scale of eight notes. Both the notes in the melody and the notes in the chords of the accompaniment are drawn from these notes. In between these eight notes are other notes that do not belong to the scale, but to other scales. These can be used in songs to add more drama. But the majority of pop musicians have little understanding of all this and use copied formulas or simple sounds they like.

To make up a melody any of the eight notes can be used. But each of the eight notes has a different kind of sound which in turn has a different kind of effect for the listener. Because they have different effects, certain notes and certain note combinations are usually used. Cooke suggests that since we have been hearing these combinations and making certain associations for a long period in our

culture, we can now easily recognise what is being communicated, what mood, what idea, what emotion. In his book, *The Language of Music*, he attempts to create a kind of phrase-book of how using certain notes and certain combinations can have reliable communicative results. These 'translations' of musical notes are of course not innate but socially codified, defined by Western society's long associations with them. Of course, precisely how these combinations communicate will be influenced by other factors in the music. We will be describing these later in the chapter.

In melodies certain notes of the eight in any scale are used a lot as they create a solid connection to the musical accompaniment, which will also draw on the same notes. These commonly used notes are mainly notes 1 and 5. Note 1 is the main defining note of the scale. In the scale of C therefore, note 1 is C. So this anchors the melody to the scale firmly and roundly.

Note 5 is similar in sound to note 1 and therefore is also good for anchoring the melody to the scale. Also important is note 3. These structures, using notes 1, 3 and 5, have become the basis of Western music.

Notes that anchor the melody to the scale and to the accompaniment allow the music to feel 'easy' or 'rounded.' In contrast, jazz will use many notes that do not create this solid connection in order to create **tension** and 'trouble'. Blues music often uses the occasional difficult, or 'blue,' note to create and release tension.

If we look at the melody of 'Blueberry Hill' above we can now think about exactly which notes are used in the melody. The first four notes are 1, 3, 5, 8. Since the 8th note is the same as note 1 we can say the first four notes are 1, 3, 5, 1. Such a combination will anchor the melody, the song, to the music underneath very roundly. In the case of 'Anarchy in the UK' we can see that much of the melody stays on the 1st note. This is a highly untroubled melody therefore. We might say that this also communicates something of the singer's mood. There is no complexity, trouble or doubt in what he feels.

The 3rd note is important for other reasons. It is the way that the 3rd and other notes are used that can bring much more complexity of emotion and feel to a melody. You might be aware that, in general, a minor key is sad and a major key is happy. Research suggests that major notes and chords are associated with positive feelings. A minor key is created by lowering some of the notes in the eight-note scale: the 3rd and the 7th notes. These are lowered to notes in between the notes of the scale. So they become a bit like a 2 and a half and a 6 and a half. If a melody has the standard 3rd and 7th notes then it is a major melody and is therefore happy and joyful. If it has the lowered 3rd and perhaps a lowered 7th, it is sad. Looking at the example of 'Blueberry Hill' above we can see that the 3rd note used for 'FOUND'

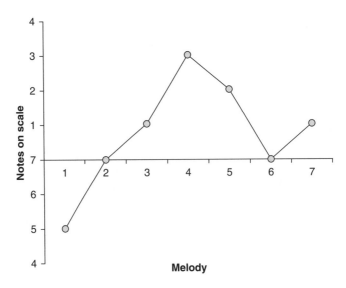

Figure 5.6 'Ain't No Sunshine' melody

is a standard 3rd, also known as a major note. The song goes straight to this defining happy note from the 1st note. Therefore it is happy. Since it is an ascending melody we can comfortably say that we have an outward expression of joy and brightness.

In contrast, in the following example of Bill Withers' 'Ain't No Sunshine', the 3rd and 7th notes have been lowered creating minor notes. This can be seen under the words 'NO,' 'SHINE' and 'SHE'S':

AIN'T NO SUN—SHINE WHEN SHE'S GONE
5 ↑ min7 ↑ 1 ↑ min3 ↓ 2 ↓ min7 ↑ 1

This creates a sad feel to the melody. If you hum the tune you will be able to hear this. Since the melody clearly ascends at the start (as we can see in Figure 5.6)we can say that this is an outward expression of emotion, but that with the minor note this becomes one of pain. There is an increase in energy, therefore almost like a cry out in anguish. As with 'Blueberry Hill' the melodies matches the topic of the lyrics.

In the case of 'Ain't No Sunshine', the pitch range is less than that of 'Blueberry Hill'. We can therefore say that while it does let out energy it is, to a lesser degree, slightly less exuberant. But there is certainly not the same degree of stasis that we find in 'Anarchy in the UK'.

Cooke suggests that if a melody goes directly to a major or minor note or vice versa without passing through another then this signals an acknowledgement of the tragedy or joy. He says that this can even give a sense of courage. 'Ain't No Sunshine' does this immediately, in fact twice in the first four syllables. In this case the song is a statement, an outward, open, brave acknowledgement of the pain.

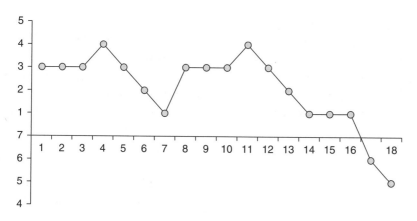

Figure 5.7 'Walking in Memphis' melody

If a melody starts on a note then moves to a minor note and then back again this gives a massive sense of immobility. But this can be true of any melody which moves between a small number of notes. This can give a sense of brooding, of being trapped, but also of confidence, as we saw in 'Anarchy in the UK'.

The 4th is a note that Cooke suggests is associated with building or moving forwards. It can also give a sense therefore of space and possibility. We can see that in 'Anarchy in the UK' the verse melody is comprised of the 1st note and the 4th note. So while the melody is dominated by stasis, which we suggested in this case could mean confidence or at least contented lack of interest, there is a repeated 4th to suggest some building. The meaning would have been very different had the first note always moved towards a minor 3rd or minor 7th. Here is an example of the use of the 4th on the chorus of 'Walking in Memphis':

```
I   WAS   WALK ING  IN  MEM PHIS,   I   WAS  WALKING WITH MY
3→ 3 →    3    ↑4↓3↓ 2  ↓1     ↑3→3→ 3 ↑4 ↓ 3 ↓2  →

FEET TEN FEET OFF OF BE ALE
1→  1→  1   ↓   6↓  5
```

Here we find lots of use of the happy major 3rds which are followed by the 4th which helps to give a sense of building. The line starts with some stasis on the major 3rd, although since this is a joyful note it creates a positive feel. Then over the whole line we move over almost an entire eight notes suggesting emotional exuberance. The line contains two bursts of emotion starting on the joyful 3rd, rising to the building 4th and then descending down to the grounded 1st. This gives a grounding and relaxing effect to the word 'MEMPHIS'. The rise from the 3rd to the 4th creates a sense of building and of

promise, which quickly resolves back to the grounding first note. The end of the line descends down to the 6th, also an optimistic note to the major 3rd, and then ends on the grounded 5th. The overall feel is one of an outward expression of joy, possibility, but also contentment where the melody relaxes, descending at the end.

While the minor 7th note is associated with dischord, often called a 'blue note', the major 7th has been associated with longing. We can see the extended use of this note in 'Babylon':

```
LET  GO YOUR  HEART,  LET  GO YOUR HEAD-AND  FEEL  IT NOW
 1  →   1  →  1 ↓ 7 →  7  →  7→  7 ↑  1 ↑     3↓2↓1 →
```

```
BAB-Y-LON
1↓7↓5
```

Above we found that the opening of this chorus had little pitch range, suggesting stasis rather than emotional growth or decay, and descends slightly to the 7th note to turn this into a wistful longing. As it falls in pitch only slightly from the 1st note to the 7th below there is little outpouring of emotion.

The 2nd note has been associated with transition by the suggestion of movement, or the promise of something to follow, or lengthened 2nd notes can suggest limbo or entrapment. This is because of it position between the strongly related 1st and 3rd. 'Ain't No Sunshine' uses a 2nd note for the word 'WHEN'. The lingering on this note suggests a sense of limbo.

We can see the use of the 2nd here at the end of the verse of 'Anarchy in the UK'. Rather than resolving to the 1st, the verse ends with the 2nd which suggests that more is to follow:

```
I  WANNA  DEST--ROY    THE   PASSER    BY COS
 1   →   1  → 1  →1  →   1 → 1   →  1  →1 → 1
```

```
I WAN---NA    B---E     AN -----AR------CHY
5→ 5   →5 ↓ 4↓ 3  →  3   →   3↓   2
```

Above, 'Walking in Memphis' uses emphasis on a 2nd note for the word 'FEET'. Such emphasis can increase a sense of the cohesion of the melody. We can see, though, that if a melody ends on this note it implies that another note is to follow. The 2nd can also have the effect of delaying or diluting the effect of a note. The shift from a 1st up to a minor 3rd indicates an outward and direct burst of pain. The use of the 2nd can delay and therefore dilute this effect. A 2nd positioned between a 1st note and a major 3rd could suggest a slightly less confident statement of joy.

The 6th note is very much like the major 3rd and can therefore be used to ground the melody. On 'Blueberry Hill', we find much use of the 1st, 3rd and 5th, which give the melody a grounded solid feel, and also the 6th which has the same effect. The only note that does not have this grounding effect in this melody is the 4th used for the word 'BLUE', which suggests building.

Phrasing

There is one further aspect of pitch that is important. When we analyse melodies in this way we can also consider the rate at which pitch rises and falls. This might happen over several bars in a long outpouring of emotion or in lots of short bursts as is characteristic of some singer-songwriters, which suggests containment with bubbling feelings underneath that leap out. 'Ain't No Sunshine' has a gentle rise and fall in its melody. This gives a sense of an emotional outburst, not abrupt, but an exclamation nevertheless. In 'Summertime', by Billie Holiday, there are long extended rises and falls in pitch, often with extended gentle decreases in pitch over a word. Here there is not so much an outburst but an emotional lingering. Such songs are *about* emotion.

In music, the terms attack and decay are used to describe the way sounds emerge and diminish. We can use this to think about the rises and falls in the **phrasing** of a melody so that we can represent this visually. A sound or melody can have a long or short attack and a long or short decay. We can illustrate this by the following:

Sound A

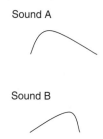

Sound B

Sound A has a short attack and a long decay compared to sound B, which has a much more gradual attack and short decay. The sound of a bell being struck would have a very short attack and a long decay. When we listen to the way singers produce their phrases we can think about the attack and decay of their words. Are these short bursts or do they have much longer decay? So the way that Billie Holiday sings the word 'Summertime' would be characterised by sound A.

Summer t ------- i ------- m ------- e

The long decay suggests lack of haste and relaxation, a lingering in the emotion. If the notes are major notes this could be dwelling in pleasure, and using minor notes could mean trapped or wallowing in sadness, loss or lack of energy. Singers that use shorter bursts of attack and decay in contrast can suggest energy, excitement or disquiet. Singer-songwriters such as David Gray use this on songs like 'Babylon'.

Fri----day night and I'm go---ing no where

There is something nervous about this kind of phrasing that helps to connote disquiet or trouble in the melody, but nevertheless energy. This is appropriate since singer-songwriters should be generally quite cross with the world, or have some kind of interesting or profound observation to make.

Van Leeuwen (1999) has noted that these kinds of shorter phrases are associated linguistically with sincerity, certainty, weight and therefore with authority. We can imagine the effect if someone were to speak to us in bursts of a few words. This is common to the way that newsreaders speak, for example. In the case of newsreaders it can also connote the urgency and immediacy of news. We might therefore be less surprised to hear folk singers using such short bursts. Of course the meaning of such short bursts, whether loud or soft, major or minor etc., will influence the meaning.

The opposite case where singers produce longer lingering statements suggests slow burning internal emotion rather than sincerity or authority. Those who speak with authority seldom use long emotional outbursts as in 'Summertime'. While a jazz singer might be rather troubled due to the way the world treats them and be emotionally engaged or tortured by this they do not express urgency, attitude or authority. In the two forms of music, trouble is connoted by different semiotic features.

In the vocal line of 'Anarchy in the UK' below we also find longer notes. But here the meaning is created by the emphasis on the rapid decay of the phrase. This gives the impression of exclamations and the opposite if the lingering decay of 'Summertime'. The longer attack also gives the impression of intensity and confidence. Of course much of the way meaning is created here lies in voice quality, which we shall come on to shortly.

I am an an----ti christ , I am an an ---arch-ist,

6

Sound Qualities:
Arrangement and Rhythm

The previous chapter explained the way that pitch, pitch range and movement and the different **notes on the scale** all have meaning potential. These provided a system of choices through which artists can communicate that draw on a long-established cultural set of meanings. In different genres of music different choices are often made to connote attitudes such as indifference, as we saw in the Sex Pistols' 'Anarchy in the UK', optimism, as we saw in 'Blueberry Hill', and lack of energy in David Gray's 'Babylon'. But clearly in pop music there are many other features and qualities of music that make up a sound. The Sex Pistols' simply sound very different to David Gray. Their music is raw, loud and energetic, whereas his is intimate and more introspective. But again these terms describe affect. We need a toolkit that will allow us to say just why some artists have a 'raw' sound and others an 'intimate' sound. This chapter shows how we can think about what sounds we hear, how they work together, or alone, what the qualities of these sounds are, and finally the way they are performed rhythmically. This chapter looks at the way the melodies and pitches of the songs analysed in the previous chapter are used in the context of these qualities.

Arrangement and perspective in music

When we hear sounds around us in our everyday life some are much closer than others. Sitting at our computer we can hear the radio in the foreground and the traffic in the distance. Occasionally there is the sound of the dog barking next door that lies between the two. This foregrounding and backgrounding constructs our point of view. This idea is used in sound mixing in radio and in film. Some sounds

simply set the scene while others provide a more direct point of attention and effect. In movie soundtracks, news broadcasts, radio-play and ambient the different sounds create layers that create our point of view in the **'soundscape'** (Schafer, 1977). In pop music ⓖ 'perspective' is created by different instruments or groups of instruments playing at different levels, or by the number of instruments playing a part.

Murray Schafer uses different terms to help distinguish the different levels of a soundscape: *'figure'* for the 'focus of interest'; *'ground'* for the 'setting or context'; and *'field'* for the place where observation takes place. These categories can be used to think about the way that music creates perspective and the meaning of arrangement (van Leeuwen, 1999). When listening to popular music it allows us to think more carefully about the hierarchy of instruments and voices.

- *Figure*: This is a sound, or groups of sounds, which has been made louder than the other sounds that can be heard simultaneously. This sound is therefore indicated as most relevant to the listener and the one with which they must identify or react in the first place. In popular music this might be the vocals, guitar or keyboard, for example.
- *Ground*: This sound or sounds have been made louder than other sounds in the immediate environment, but not to the extent of the figure. It is therefore to be treated as part of the listener's environment. In a piece of music there might be backing vocals that appear at this level. As we will see shortly this is important in terms of the extent to which the music connotes individuality or collectivity.
- *Field*: This sound or sounds have been made softer than other sounds. These sounds are treated as being part of the listener's physical world but not their social world as in figure and field. The listener does not pay any particular attention to them. Pop music is often used in supermarkets as field, so that our background physical world is not the tedious stressful one of shopping but one of relaxation and informality.

In a piece of music, perspective and foregrounding can change throughout the composition as backing voices are brought forward or a particular instrument comes to the ground or fades back into the field. This allows us to describe the way that instruments are given salience in the hierarchy of the song.

In David Gray's 'Babylon' the song begins with a high-pitched guitar riff using major notes played on an acoustic guitar in the position of the figure. As the song progresses this guitar sound fades into the field. At the start this communicates the iconographical meaning of

the acoustic guitar and sets the expectations of the listener with a high-pitched and therefore positive and light mood. Once the singer begins the voice takes the figure position. In a heavy-metal tune, in contrast, a deeper, distorted guitar riff might take figure position throughout or share with the lead vocals.

Van Leeuwen (1999) suggested that the way that voices and instruments are positioned as closer or more distant from us in a sound mix has important associations with social distance. When we are close to people both physically and emotionally we speak softly. This soft speech can also exclude others in the case of whispering. As social distance grows, the voice not only becomes louder but also higher and sharper, and is therefore more easily overheard, or even intended to be heard by everyone in range. Therefore in music social distance can be realised by both degrees of loudness and timbral quality. In 'Anarchy in the UK' the vocal is high pitched and loud. While in terms of the melody and pitch the song has stasis and lack of emotional outpouring; the words are broadcast out for everyone to hear. In David Gray's 'Babylon', in contrast, the vocal on the verse is more at a soft conversational level. Here greater intimacy is created. He is not talking up social space. Often, female jazz singers such as Julie London can be heard almost whispering lyrics. This increases the sense of intimacy and therefore the level of personal contact. In turn, this can connote greater depth of emotional communication.

Also, loudness relates to power (Schafer, 1977). In society those who have more power are allowed to have themselves heard and make more noise. In the pre-industrial landscape the church was allowed to make the loudest noises, whereas powerless individuals such as street musicians could be prosecuted for making a comparable small amount of noise. In our own societies jet planes and police cars can make a lot of noise that is acceptable, whereas a gang of bikers would be considered a disruption. Schafer explains that the problem is not so much to do with the degree of noise but because it challenges the socio-acoustic order. It is important therefore to consider which singers shout and which singers do not, or which instruments or songs appear to be loud and which are not. Since we have had microphone technology there is really no need to shout. You can turn your mike up and still talk, without the need to raise your voice. But shouting as a singer is clearly associated with passion, emotional outburst and high energy. Although emotion can be conveyed in different ways through quieter voices which sing in restricted pitch ranges.

Van Leeuwen sees volume as being connected to social status (1999: 133). Noise takes up a lot of social space. Cooke (1959) noted that volume in music (crescendo, diminuendo) has its roots in the

Middle Ages, as composers began to have a growing urge for human realisation. Before this time, music was played at consistent volumes. So volume itself became associated with personal expression.

When teenagers open their bedroom windows to blast their music out into the summer air, it might be thought of as occupying space. It is imposing a measure of control on that space, defining it as their own. We can imagine the difference in meaning if songs like 'Anarchy in the UK' were sung gently. It is hard to imagine British punk music of the 1970s without shouted, snarling vocals. These voices were making themselves heard. They were invading a space, and in your face even though when they did this there was little emotional expansion in melodies. Literally, therefore, they are shouting about their lack of emotion.

Instrumentation in arrangement

We can also ask to what extent instruments and voices work in *unison,* where they have the same volume and play the same notes. Van Leeuwen (1999) suggests that, metaphorically, this can indicate social cohesion. Where instruments all work together, where voices sing in complete harmony, they represent themselves as one unit. He gives the example of men singing in a beer advert, where voices sing in unison but yet can all be heard separately. Therefore they are represented as being together, yet retaining some individuality. A counter-example might come from the Welsh male-voice choirs, where a sense of community is emphasised by the tight harmony of the massed vocalists. The vocals of boy bands are mostly in complete harmony and unison, whereas rock singers will tend to break with the pitches and melodies played by the backing.

Groups of people singing can of course be hierarchised. A lead male singer such as Bob Marley will have greater volume and therefore foregrounding than the female 'backing' vocalists who are recorded at a lower level. Therefore they act as background, support. In other words, different distances, realised by different dynamic levels, create listener positions from which different types of speakers or singers are at different social distances.

The same kind of figure and ground and playing in unison or apart, is found in instrumental playing. In a piece of music two or several instruments can work on equal levels. In some pop music, guitars, keyboards and bass all play in such unison that it is difficult to distinguish the different sounds. Vocals will then be placed above these in the arrangement. On blues records star saxophonists will guest with a band led by a pianist/vocalist. In such a case the saxophonists will be given much greater foregrounding than might normally be

the case. In all these cases we can attend to the equality given to the different voices and instruments.

Tagg (1994) and Tagg and Collins (2001), like van Leeuwen (1999), considers these different patterns in unity and foregrounding to create different kinds of roles for individuals and communicate different kinds of social organisation. In traditional jazz there are collective forms of improvisation as well as collectively played melodies. In bebop there is a short collective section and then extensive individual soloing. In West African polyrhythmic music different rhythms and timbres will occur at the same time but which must all interrelate. There are individual voices, always distinct, yet these must always in the first place interplay and be aware of the other voices. In heavy metal the singer and lead guitarist provide figure with the drums, rhythm guitar and keyboards in the ground.

In different cultures different rules of figure and ground apply. This, Tagg (1994) relates to the role of the individual in different populations at different times. In the case of heavy metal he explains that the backing culturally encodes the background of our social and cultural environment, the rumble of traffic, etc. Therefore it 'stylises, humanises and culturally encodes a particular sense of time as experience in contemporary society' (p. 12). It is an overbearing society with little room to manoeuvre where you can only be heard by yelling out. In such a society there is the need to seek some kind of agency or voice. Since we have no control over the background noise we can only compete. The message in heavy-metal music, therefore, is that you beat the system on its own terms by being louder and sharper. The trouble is, he suggests, that you therefore ultimately become part of the noise yourself. In heavy-metal music it is often the case that even the drums move into the figure as the drummer carries out drum rolls and a series of smashes on cymbals. On the one hand the ground seems to become a cacophony of noise, an industrial landscape. But on the other, in rock it is even possible for the drummer to reach out into the figure.

Tagg suggests that the rave music that emerged in Britain in the 1990s marked an important change in terms of figure and ground in music and also helps to illustrate the way that arrangement can tell us something about the broader social climate. In rave music the figure is missing. We find instead three basic types of content that all take place in the ground: a simple repeated bass riff or even single notes (this does not provide the field as it does in some heavy-metal music such as Megadeath, where it provides an earth-moving underlying menace); a metronomic-style drum machine beat, and a syncopated keyboard riff. There is rarely a vocal line but rather a few words sampled and repeated. All of these sounds are given a deliberately synthesised quality.

Tagg relates this move to synthetic sounds and lack of figure to the socio-political climate of the 1990s. At this time Britain moved to a higher level of consumerism and individualism. Rock itself was recruited into this project. Van Halen were used for army recruitment, and cars were sold through the songs of Eric Clapton and Queen. Yet it is in this context that the youth was supposed to take the idea of rock as 'rough', 'oppositional' and 'bodily emancipating' seriously. The emphasis on sampling and the synthetic in rave also took a step away from the idea of musical quality being rooted in its authenticity, and being music from the heart. Tagg openly accepts he has no firm answers to where, therefore, rave was a challenge to individualism, a new kind of collectivism, or alternatively a symptom of giving up and surrendering to the collective spirit. But he recommends that these are the kinds of questions we should be asking of music.

Hifi and lofi soundscapes

In some musical arrangements foregrounding and backgrounding are important while in others sounds tend to merge. Schafer (1977) distinguishes these as 'hifi' and 'lofi' soundscapes.

A **lofi soundscape**, Schafer explains, is typical of our modern cities. There is such a jumble of sounds that we do not really hear any of them distinctly. We pick out one car moving along the street but the noise of its engine merges with those of all the other cars. The voices of the people on the busy street merge into a unified murmur. So in lofi soundscapes individual sounds and their origins are obscured. This kind of soundscape is typical of some rock music. There may be several guitars playing and a keyboard but the sounds merge. Even the vocals are partly absorbed by the other sounds.

A **hifi soundscape** is very different. This is like being in a forest where you hear a branch snap somewhere nearby and a rustle of leaves slightly further away. The same soundscape is present in a church where you can hear every shuffle or cough of the congregation. In these environments there are much longer reverberation times. Sounds are not competing, but it is nevertheless difficult to locate the sounds. The hifi soundscape is typical of ambient music, or of some kinds of folk music that wish to increase sensual effect. In Clannad's music it is often possible to hear the breath of the singers and the touch of fingers on the fretboards of the instruments. In this kind of soundscape there is no overwhelming background hum. Rather there is a space and calmness that can connote pre-industrial settings in the manner required by Clannad.

In 'Anarchy in the UK' we find a lofi soundscape. The sounds of the instruments merge. You cannot hear fingers on frets nor the breath

119

of the vocalist. But the Sex Pistols wish to connote the chaos of the modern city. Volume and shouting are emphasised to take up space in the soundscape. In the case of David Gray's 'Babylon' we find a song that is much closer to a hifi soundscape where we can hear more contours of the voice, the ringing of the guitar strings and the timbre of the drums.

Different pitches also have a role in the way that a listener can be immersed in a soundscape (van Leeuwen, 1999). Bass sounds carry much further than high-pitched sounds and also fill spaces much more completely. It is far more difficult to identify the source of a low-pitch sound. Rave music uses bass sounds for immersion, along with high pitches, suggesting brightness and the ethereal.

1 During the day at two separate times in different locations describe the sounds you hear in terms of your perspective using the three categories of figure, ground and field.

2 Choose one sequence of a movie or television drama and again describe the sounds you hear in terms of the three categories. Consider whether these are different to the perspective in naturalistic settings.

3 Choose three different songs from acts of different genre. Describe the sounds in terms of figure, ground and field and also in terms of unison. Taking the views of Tagg and Schafer what does this tell us about the role of the individual versus society in each case?

The meaning of sound quality

Over the last section and in the previous chapter much importance has been given to the meanings created by pitch range, the notes on the scale and of arrangements. This has allowed us to explain some important differences between the songs of artists such as the Sex Pistols and David Gray. But clearly there are other important differences. These artists simply have a very different 'sound'. The vocals in each case sound different, as do the guitars and drums. The Sex Pistols have what people might call a 'raw' sound compared to the 'melodic' or 'soulful' sound of David Gray. But these adjectives are vague and do not help us to break the sounds down in order that we can understand exactly what kinds of meaning potentials they draw upon. In this section we are interested in carefully describing sound quality. Drawing on van Leeuwen (1999) we consider the associations of different kinds of sound qualities. This begins with the

origins of the meanings of sound qualities: **provenance** and meta- Ⓖ
phorical association.

Provenance

This is simply when a sound comes to have a particular meaning. Pan
pipes suggest nature or simple, ancient cultures especially from Latin
America. The sitar is used to represent the whole of Indian culture
or the esoteric and mysticism in general. Such associations may have
no actual connection to time or place; for example, the bagpipes are
associated with Scotland even though historians tell us they were only
recently introduced early in the 20th century. The point is that asso-
ciations have become established whose origins could be discovered.
Yet in our own usage these associations will have been forgotten.

Such associations can be used by pop artists. A band might introduce
an instrument such as the sitar to signify Eastern spirituality or a violin
to connote folk. A synthesiser sound was associated with modernity,
the technical and dehumanised in the music of the 1980s. Some of the
bands using these sounds such as Bauhaus also associated themselves
with modern art and danced in robotic movements. Gary Numan and
Tubeway Army accompanied repetitive electronic synthesiser riffs
with lyrics about dehumanised androgynous and android futures.

The same can be true of speech. British singers used American
words and pronunciations in order to connote Americanness. Later,
punk bands used regional British accents to signify authenticity and
disrespect for mainstream values.

In advertising, products can be associated with particular times,
places and discourses through the different instruments used in ad
jingles. How would a beauty product be presented differently if the
jingle used pan pipes as opposed to a Spanish guitar? One can mean
the space, peace and nature of indigenous music the other the passion
and seduction of flamenco. Of course these will have different mean-
ings and associations in different cultures. In Spain itself the Spanish
guitar might to some simply mean old fashioned and lower class.

These observations are useful for analysing popular music. We can
consider the associations of different kinds of sounds and the instru-
ments that make them. We can ask what kinds of places, cultures and
times they suggest.

Experiential meaning potential

The meaning of sound quality may also derive from associations of
things in the real world. Our physical environment produces noises
all the time. These may be due to certain qualities of the element

that makes the sound or even its meaning to us in our lives. Thunder makes a booming sound which may mean violent weather or lightning, things that frighten us or present danger. The sound of thunder also gives the impression of vastness where the whole sky appears to be filled with the noise. This means that such booming sounds therefore, when made artificially, can be used to communicate something ominous, something powerful or massive.

The qualities that make the sound of thunder are to do with its loudness and its pitch. So in creating our own sounds these meanings can be combined to indicate danger or menace. Below, drawing on the work of Lomax (1968), Shepherd et al. (1977), Shepherd (1991), Tagg (1989, 1994) and particularly van Leeuwen (1999) we consider eight such sound qualities that all us to describe all the sounds and their meanings in accordance with the way they are combined in different ways.

Degree of tension

This ranges from the very tense to the more relaxed sound of the wide-open throat. We can hear tension in the vocals on 'Anarchy in the UK' as compared to 'Summertime'. The closed throat of John Lydon suggests pent-up tension and perhaps even aggression, although, as noted in the previous chapter, the melody itself is emotionally contained. The tension in the throat, however, combines with phrasing, with its sharp decay, creating little emotional lingering with a sense of quick exclamations where there is little room for contemplation. In contrast, the wide throat of a jazz singer on 'Summertime' suggests space for contemplation, for musing. This combines with the longer decay of the vocal statements to suggest emotional lingering.

We can also find tension in the ways that musical instruments are played. In some music we hear the guitar strummed in a way that allows the strings to ring out freely. In other music they are restricted, as in the manner of the throat regarding voice, giving the impression of restriction and control. This is characteristic of the 'chopping' style of the guitar in reggae. Drums can also be played loosely with high-hat cymbals being allowed to crash, or can be played with it tightly controlled. In each of these cases there is the association of looseness and tightness, relaxation versus tension. Arrangements can use combinations of tension and relaxation in different instruments to create different kinds of grooves.

Degree of raspiness

This ranges from highly raspy, rough and gravelly to very smooth ('raspy' here means noise other than the tone itself). Raspiness can suggest contamination of the actual tone, or worn and dirty. It can also mean aggression as in growling. High degrees of raspiness can even obscure the tone itself. We hear this in rock music where guitars

are highly distorted. This raspiness and grittiness can be associated with excitement and aggression as opposed to the well-oiled warm soft sounds of an acoustic guitar on a folk record. In more spiritual music we do not want to hear contamination. In the romantic tradition we need to hear the pure voice to feel the pure emotion. It would not do to hear distortion on a violin at a concert recitation.

Of course, distortion and raspiness can also mean pure emotion where excitement and tension are not suppressed. Distortion can mean a representation of the modern world as it really is, with dirt, lack of order, chaos. The British punk music of the 1970s emphasised distortion and such lack of order. Guitar sounds were gritty, as were the vocals and the overall arrangements. There was a lack of smoothness, tidiness and order. This kind of roughness can be associated with wear and tear, so connoting a world that is not pure where clean emotions can be expressed but one that is worn and dirty. As we can, see both the smooth and the raspy can connote authenticity, but this will depend on other qualities of the sound.

The electric keyboard music of the 1980s moved away from the distorted guitar of punk to the cleaner sound of the synthesiser, although the earlier moog-type sounds formed instead a warm, non-human buzz. This unvarying sound was able to connote technology and modernity, whereas the guitar could signify human expression. The predictable sounds of each note meant either order or restriction. The relative 'buzz' and modulation in the note could be increased to represent space-age or alien sounds. A cleaner sound would simply represent modernity, perhaps comparable to the modernist paintings of Mondrian where colours were simple, even and flat.

We can compare the kinds of distorted sounds we hear in music. The distortion used on guitar by a punk band such as Sham 69 is very different from that used by a heavy-metal band such as Metallica. One is a rough, dirty sound and the other an aggressive, driving buzz. In the Sham 69 case the distortion communicates roughness and lack of purity, whereas the Metallica guitars suggest something slightly closer to the machine, to technology, as the actual tone itself becomes less distinctive (Tagg and Collins, 2001). As the naturalistic sound of the guitar becomes less apparent so the symbolic sound of the machine-growl becomes more important. In the terms of Schafer and Tagg above, the metal sound takes the sound of the urban environment and uses them to scream out.

Degree of nasality

Some writers have associated degrees of **nasality** in vocalisation Ⓖ with degrees of repression. Certainly we would be surprised to hear someone in power, say a politician or newsreader, speaking in a markedly nasal manner. This is often tied in with value judgements

about accents. This effect can be produced by simply allowing air to leave through your nose as you speak. Nasal sounds are also associated with tension (Lomax, 1968) and we hear nasality in whining and moaning (van Leeuwen 1999: 136). For Lomax (1968: 198) this indicates the opposite of a 'wide', 'open' relaxed voice. In rock singing, according to Shepherd (1991), **resonance** is all produced in the throat. For him the screaming male voice, about an octave higher than their normal speech, signifies a manner of engaging with the social world, of shouting out above the noise. Tagg explains this literally shouting at high pitch to make yourself understood, to express yourself as an individual above the noise and masses of the urban society (1990: 4–11). In contrast, if we listen to 'Anarchy in the UK' and many other punk songs we find a high degree of nasality. This was common in punk music in the late 1970s and early 1980s. This gave the impression of reluctance and lack of enthusiasm, and a whining feel. Alternatively, a jazz singer may use soft, warmer, open vocals. Like rock the sound resonates in the throat but there is less volume and roughness. If we listen to 'My Way' performed by Sid Vicious we can hear that in the opening section he sings from the back of his throat and with little tension. When the electric guitar riff begins he switches to a tight throat and intense nasality. Combined with volume here the combination expresses pure contempt.

Register high(s) and low(s)

This is the range from very high to very low sounds. As we have discussed as regards melody these can have associations of high with brightness and energy as opposed to low with gravity and weight.

Breathy/Non-breathy

We can think of the contexts in which we hear people's breath. This can be when they are out of breath and panting, because of some physical or emotional exertion or strain. It can also be in moments of intimacy and sensuality. When we hear a person's breath when they speak this may even be a moment of confidentiality as they whisper in our ear, or share their thoughts with us when they are in a moment of emotional strain or euphoria. These sounds are also more characteristic of the hifi soundscape where we hear sounds like breath clearly articulated, sounds that would be lost in a lofi soundscape. Therefore, **breathiness** can connote delicate intimacy, as well as sensuality, eroticism and emotional intensity. We may hear delicate breathiness on a Clannad track to intimacy and emotional closeness. This is important in the context of the authentic emotional connection to land, tradition and history. In punk we might be less likely to hear breathiness, although it might be used in openings of songs, perhaps to indicate emotional exasperation.

Loud/Soft

Loud sounds can mean weight and size of importance. They can therefore be used to suggest a threat or danger. Loud can also suggest overbearing and unsubtle, while soft can mean thoughtful and gentle. Loud/soft can also be about taking up space. If someone is shouting, this suggests the need to take up space. If they are soft it suggests intimacy and confidentiality, even secrecy. Of course, soft can also mean weak; for example, if a male singer uses a soft high-pitched voice. Some vocalists such as Morrissey of The Smiths have used this to ironic effect. Artists such as Metallica might use softer vocals for the typical heavy-metal 'atmospheric/thoughtful' intro section to a song before they burst in with the main riff. In this case the softness is normally still combined with voice tension and higher pitches.

Vibrato/Plain

Van Leeuwen (1999) relates vibrato to our physical experience of trembling. The meaning of vibrato will depend on its speed, depth and regularity. High regularity might suggest something mechanical or alien. Flying saucers in old movies used to make such vibrato sounds. Increasing and decreasing vibrato is common in movies to create romantic moods, indicating increasing and decreasing levels of emotion. Absence of vibrato can suggest constancy, forward moving and steady or free of emotion. Much synthesiser music of the 1980s used unwavering sounds to suggest the mechanical, technological and modernity. Electric guitar solos, particularly in the rock music of the 1970s and 1980s, drawing on blues influences, often used extensive vibrato to communicate emotion and mood. This was found much less in punk sounds.

Reverb/Echo

Doyle (2006) suggests that echo can be used to suggest space. Echoes are normally experienced in large empty spaces, either in churches, caves or rocky mountain valleys. When we think of the voice of a sermon in a church or temple, or the singing of a choir we hear the reverb. Recordings of Welsh male-voice choirs are often given reverb, not because they were performed in large churches (as traditionally they were not), but to give them association with a massive landscape. In this way reverb can suggest a sense of the extraordinary or sacredness. Such meanings might be particularly useful for the recording of national anthems. In movies God's voice is often given echo, which suggests power and spread but also a sense of the massive space over which it has dominion. Rock bands often appear in their videos on mountain tops, also using reverb on voices and guitars. While heavy-metal bands may sometimes play songs that do not use distorted guitars or have mellow introduction sections before the riff starts, they will use extensive reverb on both

the guitar and the vocals. While there are softer sounds these are no less epic and sacred than the massive riffs that are to follow.

Owing to the association of echo and reverb with space it can also be used to suggest isolation and loneliness. A singer can be portrayed as alone and isolated in a pop video and the reverb can realise this effect through sound. Of course, reverb can also be an important way to suggest a hifi soundscape since the reverb in the voice or other instrument can be heard and is not lost amongst the sound. Tagg (1990) points out that in fact in busy urban streets there is reverb but before we can hear it the sound is overwhelmed by a new sound. Therefore hearing reverb allows us to make associations with lack of business, or emptiness.

All of these sound qualities can be applied to both vocal and instrumental sounds. Low pitches in instruments or percussion can suggest gravity, whereas high pitches can suggest lightness and energy. In Disney cartoons the instruments used to make the sounds of a character's footsteps is used to communicate much about their character. Deeper pitches can mean clumsiness or threatening. Higher pitches can mean lightness and brightness. So when deer skip around a princess, footsteps do not resemble the deeper hooves on the forest floor sound but are expressed by small symbols 'tinging' or a flute. In video games the walk of a monster might be represented by a metallic thud, suggesting immovability and invulnerability or unearthliness. Instruments can be played in a breathy way to suggest emotion. A breathy saxophone suggests intimacy and sensuality, whereas a growling solo can suggest high levels of raw sexual tension. Guitar strings strummed hard or soft can indicate levels of aggression or thoughtfulness. They can be muted to suggest restraint and confinement. Piano keys can be touched gently or hammered aggressively. Drums can be swept lightly with brushes, played with crashing abandon, or firmly but tidily. All these can bring associations of emotions and attitudes.

Activity

Choose two vocalists. Listen to a number of their songs and describe them in terms of the following sound qualities:

- Tension
- Raspiness
- Nasality
- High/Low register
- Breathy/Non-breathy
- Loud/Soft
- Vibrato
- Reverb

After describing voice quality using this list, use the explanations in the previous section to assemble an overall account of the meaning of the two voices.

Rhythm

Rhythm is the way that sound is ordered into structured patterns (Cooper and Meyer, 1960). It is accomplished by all of the instruments in a piece, the vocals, and by the kinds of melodies that they play. For this reason, rhythm is illusive for purposes of analysis.

Rhythm or beat is what we often think about as central to popular music and the reason why people like to mark out time has fascinated psychologists and biologists. Some suggest that it is related to the way that humans organise their experiences of the world around temporality. The brain seems drawn to mark off time, although, as we discussed in earlier chapters, it is interesting that we generally do not consider the ticking of a clock or the regular clicking of a machine as having a rhythm. Therefore, we have to accept that what we even consider as rhythm is not necessarily in the sound itself.

This section considers a number of ways that we can usefully describe rhythm and beat drawing on Cooke (1959) and van Leeuwen (1999). The first of these relates rhythm to associations with kinds of bodily movements and the second looks for clues in the rhythms of speech.

Rhythm can be thought about more clearly through three of its aspects (Cooper and Meyer, 1960): 'pulse', 'accent' and 'meter'. Pulses are like the ticks of a watch. In this case pulses could be the bass drum, although they could also be notes produced by an instrument and the way that these are clustered. Accent is difficult to define but means roughly where the emphasis is placed – for example, which pulse is played with greater force. Meter describes the number of pulses between accents. In a waltz there are three pulses between accents, as in '1-2-3, 1-2-3'. In popular music there are usually four pulses, as in '1-2-3-4, 1-2-3-4.' In popular music the pulses are usually laid down very clearly by the drums. This is done with a combination of bass drum, snare drum and high-hat cymbal. Below is a schema for representing a drum pattern for a four-beat pop tune. 'H' is the high-hat cymbal, 'S' the snare drum and 'B' the bass drum:

1	2	3	4
H	H	H	H
	S		S
B		B	

This pattern is the basis for most dance music. The bass pulses on beats 1 and 3. Reggae music also uses four beats but, in contrast,

the accent is on beats 2 and 3, which creates a much more staggered, creeping forward motion.

If we imagine a bass drum pulsing on all four beats there is a sense of only counting out the pulses rather than a forward motion. The forward motion is created in the above example through the energy shift created by placing the higher pitched snare drum on beats 2 and 3 and through the use of the high-hat cymbal, which gives the effect of the two drum pitches sliding into each other. Listen to any dance music to hear this effect. In music based on three pulses, as in a waltz, there is a sense of hesitation as the two pulses follow the accent on the first beat. This creates a sense of lightness and side-to-side motion rather than forwards. Jazz musicians will often give a three-pulse feel to four-pulse pop songs when playing their own versions of them, to give them space and lightness.

In jazz music it is not unusual to find five or even seven pulses, which create more unsettling rhythms. Since, in popular music, we normally find four pulses, we can assume that it is generally about moving forward rather than floating.

Rock music often places even greater accent on beats 1 and 3 through two half-pulses on the bass drum. This is the effect on Queen's famous 'We Will Rock You'. This double beat creates more of a stomp than the lighter step of dance music where there is always movement to the next sound. The rhythm becomes much more anchored to the certainty and weight of the bass drum. Imagine 'We Will Rock You' with only one bass pulse instead of two.

However, while it is possible to describe some of the kinds of rhythms created by drums and cymbals, instruments and vocals can play the same role. A guitar can emphasise accents on certain beats. Where the vocalist places the emphasis on individual words it can create a solid or unsettling rhythm.

One way to think about the combined effect of percussion, instruments and vocals creating rhythms is offered by Cooke (1959), who showed that we can relate the metaphorical meanings of these rhythm sounds with the human activity of walking. Walking is normally smooth and gently rhythmical, moving forward. It can also be bouncy, possibly with a sway, or with heavier or lighter stomping. The rhythm for dance music we described above might be thought of as more driving through the slide between the higher pitch high-hat and lower pitch bass drum. The weight of the heavy bass drum suggests a heavy footfall and the forwards movement is created by the slide suggested by the high-hat cymbal to the higher pitch of the snare drum. Listen to any dance track and think about the way the sounds suggest a particular kind of walking.

Of course rhythm can also be quickened or slowed. In general quicker rhythm is seen as more animated. A slower rhythm with emphasis on even

steps can imitate lazy trudging. In jazz, the slower tempos generally combine with a complete lack of bass drum creating a lighter step. Much of the beat may be created by a combination of a soft-brushed snare drum and a walking bass line (one which plays a note on each pulse or beat). This creates a much smoother groove feel. Newsreaders might read with a fast tempo to suggest urgency and immediacy. Those who have listened to the commentary of horse racing will be aware of the way that fast tempos can be used to convey excitement and action, even where what we are watching is five horses taking quite a while to run around a circuit, which looks very much like the last race we saw.

Quicker or slower rhythms can change the way we experience the actual notes that are played. A minor ascending melody played slowly can be an outward admission of pain. Played quickly, however, it can become hysteria.

Rhythms can also be jerky, as in walking with a limp or struggling to walk. Jerky rhythms at a faster tempo can create a lot of tension and energy (Cooke, 1959: 100). But at a slow tempo the jerky rhythm can create a dragging feeling. Such rhythms are rarely found in popular music, however. These techniques were utilised in the earlier Walt Disney cartoons to express the character and mood of their animals as they moved.

There is therefore meaning potential in regular rhythms versus irregular rhythms. Regular rhythms can suggest the impersonal. Newsreaders speak in regular rhythms to suggest something official. Literally it is regulated. This gives a sense of the removal of personal inflection and creativity. Irregular rhythms can communicate creativity but also instability.

From these observations we can ask then how a piece of music asks us to move. Do we move quickly forward, from side to side remaining in the same place? Do we stomp or tread lightly? Do we skip happily or do we hesitate perhaps? Do we step evenly or unevenly? All of these can have meaning potentials which will be realised in combination with other semiotic choices. A hesitating rhythm can suggest caution, or simply coolness through lack of haste. A swaying side-to-side rhythm can mean lack of need to move forward, contentment or conformity. The latter would also be accompanied by other rhythmic or melodic features which suggest unity and possibly tension as in the tight snare drum sound of marches.

Some rhythms, in Cooke's sense, could be said to be more artificial than others. Walking and running and shifting from one foot to the other have a binary nature. Triple time is therefore not a natural rhythm. Van Leeuwen (1999) suggests that artificiality can indicate high status as it involves artifice rather than nature. In jazz 4/4 time songs are often played with a triple-time feel called 6/8 to make them lighter and precisely to avoid the constancy of the binary rhythm.

Sound Qualities

It is also important to think about the way the vocalist relates to the rhythm created by the instruments. Do they embrace the time, allowing it to govern them, or do they struggle and refuse to be contained by it? In the example of the nursery rhyme 'The Grand Old Duke of York', below, the words are placed on the accents. You will hear this as you tap out the beats and sing the words.

	1	2	3	4
The	Grand old	Duke of	York	He

1	2	3	4
Had ten	Thousand	Men	

Such an alignment of words to beat aids collective recitation. But it also suggests lack of trouble and even conformity to the beat. In contrast here we see a classic blues-type line placed over the four pulses.

1	2	3	4
This w	oman treats me	So bad	

Here the words are not placed directly on the beat. The blues music while having a strong rhythm, which usually suggests a slow forwards walk, uses this technique to communicate trouble, lack of conformity to the rhythm as the singer appears to sing in their own time, not obeying the accents.

Both Tagg (1984) and van Leeuwen (1999) have given much thought to the meaning of musical time. Tagg (1994) has discussed how the shift to music being dominated by metronomic time is associated with the move to modernity and the rise of the clock and mechanisation. Music before this was not subject to metronomic time. Music without metronomic time was the favoured music in the church of the Middle Ages. Van Leeuwen (1999) suggests that this sound itself signifies eternity. It was only later when power passed into the hands of the merchant classes that measured time came to dominate (in what we now call classical music). This was also a signifier of calculability and quantification that were so central to capitalist industrial society. When we now hear such music– for example, certain forms of church music – we experience this as mystical and spiritual, not regulated and structured and therefore mechanical. Bands such as Clannad are able to draw in this effect

using sections of music without clear time to connote the ancient and pre-modern.

In the context of the blues singer, Tagg (1984, 1994) suggests that music allows us to express our attitudes towards the regulation of time and our social worlds. The bass instruments create the clock-work beat against which we must all live. The other instruments and the vocals, while having no real control over time, are able to use syncopation to locate themselves creatively against this time. And vocalists and lead instruments can shout out above this time. Of course in some forms of music there will be the opposite and all the instruments will be swept along with time. In rave music, machine-like repetitive bass and drums encourages people to give themselves up to time regulation. To this are added euphoric high-pitched minor 7th notes moving in small pitch ranges (Tagg, 1984: 31–2). These sounds are normally softly synthesised and sound other-worldly through association. Literally we give ourselves to the rhythm and this is ecstatic.

Some melodies can be extremely emotionally expressive, using a wide pitch range but also conform considerably to time. Unlike in jazz, this allows the emotions to sound less problematic and less like trouble and regret. We can hear this in Queen's 'Somebody To Love'. First, here is the melody:

```
CAN  AN---Y  BO----DY  FIND ME    SOMEBO-DY     TO LOVE
 5  ↑  1→   1↑  2 →2 ↑ 3↑  5↓    1 →1 ↓6     ↑7 ↑  1
```

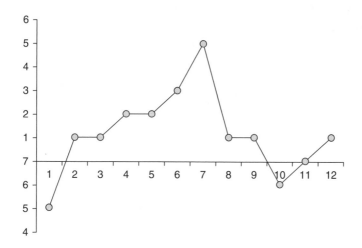

Figure 6.1 'Can Anybody Find Me Somebody to Love' melody

The melody takes place over the whole eight notes which rises from the 5th below the 1st note to the 5th note above. All are major

happy notes and much of the melody is comprised of upward-moving positive outbursts of energy, even though the lyrics suggest something more melancholy. From the chart we can see the emotional reach of the ascending notes, a pause for breath and then a further outburst.

Looking at the way the notes relate to the beat we find an emphasis on the lack of trouble with time and with regularity. There are no deeper troubles here therefore.

	1	2	3	4
can	a-------ny	Bo--------dy	fi------------nd	Me-------------

1	2	3	4
some	body to	love----------------	----------------?

Analysing Genre:
The Sounds of Britpop

In this chapter we apply the tools developed in the previous chapters to three songs to explore the way that genres of music can have shared features and therefore communicate the same discourses. The songs we use for the analysis were part of the Britpop scene in the UK in the 1990s. This exercise allows us to assess whether or not these songs have anything in common. Often the music press speak of a collection of artists as being of a particular genre of music or a scene. It has been pointed out by a number of theorists (e.g., Frith, 1996) that such categories are generally rather vague and perhaps more than anything serve the needs of record companies and marketing. But in this case we can ask what a number of bands have in common musically. What kinds of discourses are being communicated by the music in the three songs and are these consistent?

Hibbett (2005) suggested that 'indie' music, with which Britpop was often associated, could be thought of as a set of discourses related to authenticity, purity and non-corporate ideals. While he revealed these discourses in the talk of those who identified with indie music he did not consider how the music itself communicates these discourses. Are there any kinds of melodies, rhythms and sound qualities that connote indie? As we have seen in previous chapters, authenticity, purity and non-corporate ideals are qualities associated with many different kinds of music. So what is specific to indie music?

In this chapter, three songs from Pulp, Blur and Oasis are analysed in order to reveal the discourses communicated through the music. Of course we cannot come to any great conclusions from the analysis of three songs, but we can certainly make a start in showing how we can use this toolkit to begin to answer these kinds of questions. While it might not be possible for non-musicians to work out the exact notes used for melodies it should be a simple matter to analyse uses of pitch and pitch range, rising and falling melodies, arrangements, sound qualities and rhythm.

Each song is analysed in terms of melody, musical sounds, arrangement and rhythm. Some reference is made to the meaning of the lyrics, some of which have already been analysed in Chapter 3, and also to visual representation used in the videos that accompanied the tracks.

Britpop was the label given to a wave of British music in the mid-1990s. These were indie bands such as Suede, Blur, Pulp and Oasis, which were for the most part guitar-based bands and often sang about specifically British issues.

Pulp: 'Disco 2000'

Vocal melody

We begin with Pulp's 'Disco 2000', starting with the melody of the vocal line.

WE WERE BORN WITHIN AN HOUR OF EACH OTHER
1↑ 2 ↑ 3 → 3 → 3→ 3 → 3 ↓ 2 2 ↓ 1

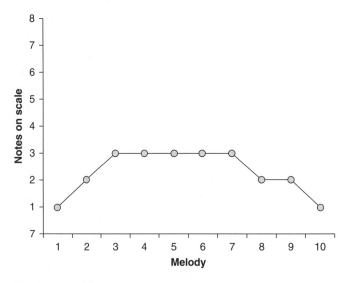

Figure 7.1 'Disco 2000' verse

The direction of the arrows under the lyrics, also represented in Figure 7.1, indicates that this is a limited emotional rising only three notes. It starts by ascending with an outward giving of emotion and increase in energy. This is done using major notes. Therefore it is joyful, although it does not go directly to the major 3rd note, but through the 2nd. So it is not a confident statement of joy, perhaps more of optimism. But this is a fairly contained outburst.

In the middle of the line there is no movement in pitch so there is stasis. This is done by staying on the joyful major 3rd note so the singer expresses something very pleasant and positive about this particular fact. We can imagine the different effect had he stayed on the minor 3rd note to suggest pain. Then the melody descends back to its starting point. In structure it is much like 'Blueberry Hill', a joyful statement. But it is different since the stasis in the middle reflects inertia, something trapped. This is also reflected in the pitch range which is only over three notes in the scale. Very little emotion is given out, although the use of the major 3rd means that this does not become at all depressing. The same is true of the chorus:

LET'S ALL MEET UP IN THE YEAR TWO THOU-SAND
3 → 3 → 3 → 3↓ 1 →1↑ 2 ↓ 1↑ 2 ↑ 3

WON'T IT BE STRANGE WHEN WE'RE ALL FU--LLY GROWN
3 → 3 → 3 → 3 ↑ 4 ↓ 3 ↓ 1 ↑ 3 → 3 ↓ 1

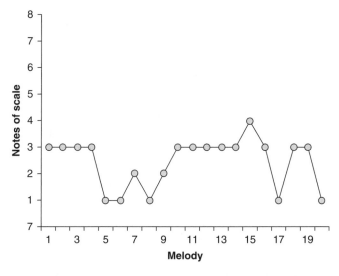

Figure 7.2 'Disco 2000' chorus

There is an initial increase in energy as the chorus ascends to begin on the positive 3rd note. This brings a feel of positive energy which continues throughout. But rather than immediately ascending or descending the melody then stays on the 3rd note, suggesting more stasis and therefore lack of emotional expansiveness. After the stasis the melody descends to the 1st note. This suggests a sense of gravity and importance to the date but also a lack of real enthusiasm as would have been indicated by an ascending outburst. After another five notes of stasis on the 3rd note there is a jump to the building 4th

note and then a rapid fluctuation in pitch which suggests emotional anguish.

In fact behind the melody of the chorus the guitars and keyboards do play minor chords on occasion. The mixture of the two creates a sense of joyfulness in a background of melancholy. The mood of the melody also remains positive through the sense of building created by the use of the 4th note on 'WHEN'.

Instruments and sound qualities

The 4th note is important in the song as a whole. The verse is sung over a guitar riff that is based on moving the 4th note to and fro, making it higher and then lower again. Through his analysis of classical music, Cooke (1959) shows that fourths used in this way are associated with building, with moving on (p. 81). So we have a contradiction in the restricted pitch and stasis of the melody and the building of the fourths.

The guitar that plays the riff is heavily distorted. This is a fairly smooth, regular, sustained raspiness as compared to the dirty guitar sound associated with punk music. This distortion is much more machine-like, but is by no means as powerful and surging and sustained as that used in heavy metal. There is a sense of technology being communicated but this is more about control and modernity than the post-industrial sounds of metal.

The guitar riff is not strummed in a wild or energetic manner, but with restraint and precision. The controlled strumming also creates some tension which combines with the 4th note to create a highly motivated forward motion. The controlled manner of the guitar riff also avoids the lofi soundscape that can easily be created with distorted rock guitar sounds. This is important to leave the space for the intimacy created by the vocals. Indie music, such as in the case of artists like Suede, combined higher levels of distortion along with emotional intimacy.

From the first chorus we find an electronic keyboard sound behind all the other instruments. These play at a low volume and at a fairly high pitch with short accented notes. They are bright but take up little social space. This sound brings a clear sense of technology of modernity. Whereas the dirty broken sound of the guitar of the Sex Pistols is about dirt and the chaos of life, and the purity of folk music is about origins and authentic tradition, we can think about the electronic keyboard as being associated with certainty and modernity. But like the synthesiser-based bands of the 1980s (such as Tubeway Army and OMD) this sound communicated authenticity through the way it revealed the threat to human expression, our subjection to the machine and to computer technology. It was during the 1980s that many young people experienced unemployment as manufacturing became automised and performed by robots.

The vocals themselves are delivered initially in a manner close to talking, with a medium level of breathiness. There is no raspiness, although at times there are high levels of tension. Some of the words, such as the name 'DEBORAH', are whispered, giving a sense of intimacy and confidentiality. The conversational style gives a sense of story-telling and of biography. The singer creates a character that is able to share some of the most intimate and slightly humiliating moments of his life. Later in the song, particularly on the chorus, the voice becomes particularly tense and shrieking.

The lyrics are delivered in short emotional statements with relative equal attack and decay for the verse, suggesting sincere statements. The chorus is done with longer sustained bursts, especially over lines such as 'WHEN WE'RE ALL FULLY GROWN' where there is a particular emphasis on the decay of the note which falls in pitch, not unlike the melody of 'Summertime' discussed previously, although at this point Jarvis Cocker also uses much tension in his voice. So in the chorus we find the vocal moves away from statements of sincerity to dwelling on emotions.

One very important feature of 'Disco 2000' is the use of a regional British accent. Trudgill (1983) has suggested that before the British punk music of the 1970s pop singers used mainly American-type pronunciation. But the use of British regional accents offered authenticity. This was how real people spoke without self-conscious stylisation. This could be thought of as a kind of grit, something which is not edited out. It serves to make the vocals – and indirectly the music – less generic, increasing authenticity and a sense of personal identity.

Rhythm and arrangement

The drums under the guitar riff follow in a pattern associated with dance music which emphasises bouncy rhythms – heavy, slightly quickened regular footsteps, with the shoulders swinging from side-to-side – that make us want to move with them. Like dance music this rhythm is played in almost metronome style and without embellishments, creating a stable and regular ground. In heavy metal drums are often played creatively as they too can leap into the figure playing higher pitched bursts of energy. In 'Disco 2000' the drums are completely about metronomic time.

The guitar riff and the vocal melody move in unison with the pulse of the drums. There is nothing difficult or troubling signified by the way the voices in the figure relate to the ground. As seen in Figure 7.3, words are placed on beats 1 and 3. The melody therefore takes place subordinated to the confines of the ground and of society.

In terms of foregrounding, at the figure we first hear the guitar riff that then moves into the ground as the vocals begin. This is not lofi and there are clear musical layers. This song is about the vocalist as

1	3	1	3	1	3	1	3
Born within an hour of each o		-ther	they	Said we could be sister and b		-rother	her

Figure 7.3 Beat and phrasing in 'Disco 2000'

individual. He sings above the other instruments and there are no backing vocals. This is very different to the other Britpop songs that were more about the unison of the band. Pulp were very much about their lead singer, Jarvis Cocker, who formed almost single-handedly the public face of the band.

Words and image

The lyrics are basically about the singer's love/obsession with a working-class girl who never took any notice of him. Vocalist Jarvis Cocker used these kinds of lyrics as part of his anti-hero image. But whereas such self-depreciation or theme of failure of sexual prowess would not be common in rock music more so perhaps of folk, Pulp combine this with positive melodies and upbeat rhythms. The melodic restraint of the vocal lines also adds to Cocker's coolness and sense of irony.

In Figure 7.4 we see a still from the 'Disco 2000' video, also used as a record sleeve. In the image we find an ordinary ladies' washroom in a nightclub. Through lighting and colour it is slightly bleak. We see three young women who don't appear particularly happy. Their clothing is not particularly flattering. Important in this image is the colour. Pulp videos used bright saturated flat colours, connoting 1970s technicolour. For this reason Britpop was referred to at the time as 'Bubblegum Pop'. In videos for songs like 'Disco 2000' and 'Common People', mundane iconographical British settings such as rows of Victorian terraced houses, supermarkets and local town discos are represented in reduced modalities with sensory and simplifying uses of colour.

The song and video make gestures towards social realism and social commentary in the fashion of folk protest music with the commentary on mundane everyday settings. As we saw in the chapter on lyrical analysis, 'Disco 2000' is about a relatively poor working-class young man who sexual prowess is very low, yet who seems oddly resigned to this and lives unconcerned by the humiliation of his continued interest in the object of his affection. Lyrically the social realism is pointed to by indications of settings: 'your house was very small with woodchip on the wall' and 'by the fountain down the road'. This is unlike much of the lyrics of genres such as heavy-metal music with its strong themes of horror and mysticism – although this is not to say that these too do not have social relevance (Walser, 1993).

Figure 7.4 "Disco 2000" sleeve

The Britpop bands, like Pulp and Blur, had clear influence from The Smiths whose lyrics certainly contained much social commentary about living marginal and disappointing lives. The Smiths' videos would show bleak urban scenes in Manchester. But the likes of Pulp, with a similar sentiment, were able to lift this kind of observation through the musical semiotic choices described above, through driving riffs and dance beats and also through the low modality visuals. In the video to 'Disco 2000' we find mundane settings but filmed in flat, saturated colours. This served to lower the modality; the use of a bright colour palette also suggests playfulness. The same scenes shot in black and white would have moved further towards social realism. This lowering of modality makes for clear indications of distancing from the actual depressing nature of these representations.

The melodies themselves help to create a positive feel with lots of major 3rds and ascending phrases. We could imagine the same lyrics sung with descending melodies, with minor notes, with a slow strummed acoustic guitar accompaniment and where the video was the same without the saturated colours. Any of these changes would dramatically transform the meaning.

'Disco 2000' and indie discourse

Hibbett (2005) suggested that indie music is characterised by certain discourses. These were about authenticity, purity and anti-corporate

ideals, and was characterised by raw sounds. He established these discourses through speaking with indie fans. But to what extent are we finding these kinds of discourses realised in the music itself?

In Chapter 1 we found that authenticity was itself complex and an idea that is mostly used as a kind of 'moral slang'. It is a concept used to assess the sincerity of an artist. This stemmed from the romantic tradition which connected creativity to the individual and particularly to their soul rather than to the rational intellect. Authenticity was not therefore about design and strategic creation but about raw talent and self-expression. This notion tied music to the body rather than to the mind. African or Black music is the paradigmatic authentic music due to the romantic notion of African culture being simple and innocent as opposed to the intellectuality of Western culture.

In this context we can see why punk music is authentic as it is deliberately rough and honest. Even where a punk band appeared to be more or less a copy of another, this authenticity could be signified through a number of musical features. Melody lines use restricted pitch range to show self-containment and, along with the tension and nasality of the vocal style, contempt and aggression rather than the emotional indulgence of longer phrases with gentle decay. Phrasing of the vocal lines will be short and abrupt to connote honesty and sincerity. Guitar sounds will be dirty, as will drums. There will be overall lack of polish to suggest spontaneity. Even where a band is simply following this formula, as certainly many did in the early 1980s, authenticity could still be communicated. So what about indie, at least in the case of Pulp?

Looking at 'Disco 2000' what do we find? There is no real sense that Pulp were ever anti-corporate and were a band that were well marketed. At the height of their fame the music press was flooded with posed publicity shots of the band. However, we might say that Jarvis Cocker's apparently moody and intellectual anti-hero was able to connote something unmanufactured. If he was making a fortune, therefore, it was from his individual talent.

Cocker also appears to sing from the heart. They are stories about his own failures, lack of sexual prowess and often the way that people in society, his characters in 'Disco 2000' and 'Common People' simply do not notice him. In this sense these songs are authentic. Indie music has long been associated with sadder themes and emotional pain, but in a more tortured, darker fashion than the 'longing' of the blues.

Are the sounds raw? Is there authenticity in the sounds of 'Disco 2000'? There is raspiness in the guitar sounds, but this is fairly controlled and the composition is clearly carefully thought out and polished. But indie bands often used intense guitar sounds to create a 'buzz' without the power of rock guitar. On the section of the song where the lyrics refer to Deborah's very small house we hear a

classic indie-style droning guitar riff behind the vocals. Such sounds in movies are often used to suggest psychological anguish or tension. Then behind the chorus itself we find a very high-pitched keyboard sound. These give a suggestion of emotional intensity which can also suggest rawness. Vocals range from soft-spoken intimacy to tense high pitches with raspiness which is common to indie. These ranges suggest emotional outpourings on different levels. This is much less typical of other genre of music. Rock music tends to remain at higher pitches using an open throat, but always powerful. Pop music tends to not contain such emotional extremes of whispered intimacy and shrieking hysteria. Also important in vocal lines are the restricted pitch ranges combined with tension and high pitches. These helped to communicate the emotional entrapment that is characteristic of indie.

One important indicator of authenticity in Pulp's music were the visuals. On the one hand these flaunted art-school aesthetics. But the iconography of the videos showed grim working-class contexts but highly stylised. The band itself also clearly looked 'indie'. Several of the Pulp band members wore long fringes, hair dyed black with pale complexions and black clothing.

Blur: 'Parklife'

Vocal melody

The verse of 'Parklife' is spoken by an actor commentating on the trivial things that he does each day. He says he gets up when he wants, gets rudely awakened by the dustmen, puts his trousers on, has a cup of tea and feeds the pigeons. The spoken low voice creates a sense of intimacy for the listener. There is no attempt to shout or to occupy social space. We are simply allowed into his own space. He speaks with a regional British accent and with some graveliness, or dirt, in his voice. He gives a sense of being very pleased with himself, despite the utter dullness of what he describes. As with 'Disco 2000' we are dealing with a kind of social commentary.

The chorus is as follows:

ALL THE PEOPLE, SO MANY PEOPLE, THEY ALL GO HAND IN HAND,
1 ↓ 6 ↓ 5↑6↑ 1→ 1↓6↑5↑6→6 up further than eight
 notes to descend

HAND IN HAND TO THEIR PARK LIFE
note by note to resolve into guitar riff.

The chorus is rooted close to the underlying music through the use of the 1st and 5th notes on the words 'ALL', 'SO MANY' and 'PEOPLE'. In between these notes there are 6th notes which work like the 3rd.

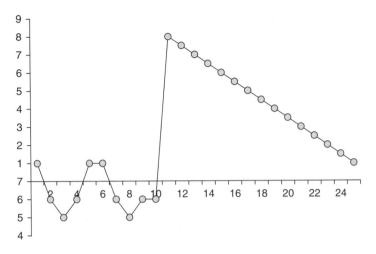

Figure 7.5 'Parklife' chorus

So this is joyful. The lyrics are about mundane British suburban life, not hugely dissimilar to the theme of Disco 2000, but the melody is highly grounded and positive.

The first two bursts of the melody 'ALL THE PEOPLE, SO MANY PEOPLE' use decreases in pitch with slight increases at the end. The decrease in pitch here seems to suggest a falling away of energy. Since the feel of the music is positive this gives a sense of laziness or deliberate lack of effort. For Cooke (1959) such a melody would be an incoming positive emotion, like a consolation perhaps. This was certainly in the case of melodies such as David Gray's 'Babylon' dealt with in the previous two chapters; this would seem to be the case. Here it gives a slight impression of exasperation as when we might tell someone 'OK' with a descending pitch on the two syllables when we are not all that enthusiastic.

After the word 'THEY' the melody leaps up over eight notes, a huge outburst of outgoing energy, to then descend, by half notes, to where it started. These half notes are called a 'chromatic' scale. When you hear anything falling in a cartoon, or a movie, you will probably hear a descending chromatic scale. These are associated with a falling away, a slipping away of something. The effect of this is that while the verse is spoken by the actor, the chorus is sung brightly by voices in unison. This energy outburst rises, emphasising joy and fun, although the chromatic scale sees all this drift away and returns us to the mundane. So a huge outgoing burst of positive energy which slips away to reflect the lack of life and vitality of the world is depicted in the lyrics.

Instruments and sound quality

The song is musically dominated by a guitar riff, which is raw and dirty, played at a high, bright pitch suggesting optimism. The riff,

while bright, is repetitive and monotonous, also suggesting entrapment. It is strummed with a degree of control of the strings. They are not allowed to simply ring out. But there is a deliberate untidiness and lack of precision about the riff. The looseness suggests rawness and lack of control rather than the kind of relaxation of softness of an acoustic guitar being strummed with open strings. This suggests both tension but also the irreverence of the voice of the band. The lack of polish is also characteristic of the way that the drums are played with the crashing high-hat cymbal. As with the guitar both create a level of 'dirt' in the music that suggests a lack of pretence.

A keyboard provides backing over the chorus. Rather than the synthesiser sound on 'Disco 2000' this sounds more like the organ keyboard of the 1960s. This keyboard/guitar mix has been very much part of the indie sound and, as with the Pulp example, reflects the modernist art-school aesthetic.

There is a guitar solo later in the song. This is not the rock-type solo that might leave behind the time of the song and play at high-pitched emotional levels, with rapid excited patterns of notes. Here it is a short riff on slightly high pitches that, like the main riff, plays its role in the general bounce of the music.

The vocal sound on the spoken section flaunts a regional accent and the voice is slightly gravelly and nasal. The spoken section suggests conversation and a personal address. On the sung sections the accents remain, as does slight nasality. But there is increase in pitch. There is little tension or dirt in the voices which sing with open throats. The articulation of the words are longer with gradual decay which appear therefore brightly emotional and open. Unlike 'Disco 2000', there is less sense of making statements or of sincerity, at least on the sung section.

Rhythm and arrangement

There is a repetitive bouncing, almost clumsy, rhythm played out by a drum beat with a crashing cymbal. This is accompanied closely by the guitar riff. It is both about stasis and plodding, trapped in something, but at the same time bright and swaying side to side. The use of 4th notes on the guitar riff prevents complete stasis.

The guitar riff follows the drum rhythm which is like a dance beat but played with an open high-hat cymbal. So rather than the bass and snare slipping into each other, they are accompanied by a slightly wild crashing pulse. This suggests a side-to-side motion rather than forwards as in dance music.

There is unison in the song created by drums and guitar, until the chorus. On the chorus there are vocal harmonies which pick out the notes and follow the music, but always with the main vocals foregrounded. There are some backing vocals where another member of

1	3	1	3	1	3	1	3	1	3
All	the P	eople		so	many P	eople	They	All	go

1	3	1	3	1	3	4	1
Hand in	hand	Hand in hand with		Their	park l		ife

Figure 7.6 'Parklife' beat and phrasing

the band shouts 'Parklife'. This sounds distinctive and is not blended into other vocals. This preserves a sense of individuality. Often the voices of the members of boy bands are completely undistinguishable in the music, suggesting cohesion and conformity. Here the band remain distinct voices. All instruments remain distinctive despite the use of the distorted guitar sound.

The guitar does enter the figure position during the solo. But here is it still completely subordinate to the metronomic time of the rhythm and pulses created by the backing. Therefore, even though the individual can stand out from society, they are nevertheless still governed by its basic patterns.

In Figure 7.6 we can see that the rhythm of the vocal line on the chorus stays quite close to time created by the music. The lyrics sing about the entrapment in a dull and trivial suburban life. At the same time the placing of the words is also governed by the metronomic time set by the drums. This contrasts to the spoken verse where the speaker ignores the pulses of the drum and guitar. He is not part of the music or the band and his lack of concern for the rhythm of the music can also be seen as part of his arrogance. But the fact that he does not sing means that there is limited emotional expression, no increase in pitch and no tension. While he is not tied to the rhythm he is equally monotonous.

Words and image

Overall 'Parklife' is lyrically about being trapped in British suburbia. This can be seen in the following line:

I put my trousers on, have a cup of tea, and I think about leaving the house. (Parklife!) I feed the pigeons, I sometimes feed the sparrows too

The voice that tells the story recounts mundane daily routines such as the fact he feeds the pigeons, that he thinks about leaving the house. In Chapter 3 we found that asking what people do in a set of lyrics is a useful question to ask and that the processes of doing could be

broken down into six categories. The most active of these categories were 'material processes'. In this case the material processes are far from exciting. We also find mental processes such 'thinking about leaving the house'. This is fairly boring and even an indulgent detail to recount. Often mental processes can be used to draw us closer to the subject. In this case it is evidence of his dull life but also his sense of importance in it. He tells how he is woken on Wednesdays by the collection of the dustbins. These facts add to both the dullness of suburban life but also the petty state of mind that this can foster.

In the 'Parklife' video we see members of the band carrying out, and parodying, typically suburban activities such as jogging. One member of the band plays the role of a double-glazing salesman. We also see the band larking about, energetically on the same sets. As with the Pulp videos we find an iconography of British suburbia. We see a row of terraced houses, an ice-cream van. As with Pulp there is a sense of social commentary. As with the Pulp videos we also find the same use of bright saturated, pure and unmodulated colours with a wide colour palette. In the same way this serves to bring playfulness and fun to commentary.

'Parklife' and indie discourse

As in the case of 'Disco 2000', 'Parklife' places itself in a real time and place which is used to make an ironic observation about British social life. This is done both through lyrics and visuals. From the time of the blues, social commentary in pop music suggests seriousness and integrity which is important for authenticity. But like Pulp, Blur were hardly anti-corporate. They were commercially successful and while on an indie label, 'Food', this was a subsidiary of Parlophone which was in turn part of EMI. Like Pulp, Blur's height of fame saw their posed photographs everywhere in the music press. Damon Albarn's looks also allowed them to appeal to younger female audiences.

In terms of sounds and sound qualities there is certainly a rawness about the guitar and drums and of the arrangements. Guitar sounds are natural and dirty, drums crash. The vocals appear to be unprocessed and imperfect. Compared to the polish of the music of some artists such as Beyoncé there appear to be far fewer signs of studio production. This also helps to connote authenticity.

'Parklife' also, like 'Disco 2000', uses the distortion necessary for indie music, but avoiding the lofi soundscape of metal. All sounds are always distinctive, although there is enough noise to communicate a 'natural' dirty sound. They also use keyboards, in this case with a 1960s sound.

Visually too, like Pulp, Blur were able to look indie, especially through the indie trademark long-fringed haircut of the bass player

Alex James. Indie music has always been associated more with student culture and has art-school intellectual associations. Both Pulp and Blur openly discussed their art-school connections.

At this stage we can ask a further question. Can we yet make any comments on the nature of Britpop? To begin with, both songs have very similar lyrical content in the two songs and both are heavy on parody. There is a difference where, in 'Disco 2000', the vocalist positions himself as the object of the joke, whereas Blur remain lively and fun and external to the mundane British everyday life that is described.

Musically we find intimacy created in both songs by spoken words and also tension and joy in rising melodies on choruses. Both vocal melodies remain closely grounded in the song with use of 1st notes, 3rds and 5ths. On both we find the use of regional accents to suggest naturalness, and authenticity. Guitar riffs are building with 4th notes and use distortion, although not in the wall-of-sound lofi manner of rock music. All instruments can be heard separately. This is not the music of urban chaos, being heard above the noise, shouting out. Both suggest slightly sad though comical social worlds where the best approach is to make fun rather than shout out. And in the arrangements there is always the space to move in order to do this, as opposed to the urban buzz of metal where the only way out is to join in the shouting in order to be heard. While the lyrics speak of the urban world in the music this is one where there is space musically. But then it is not so much that the individual in these songs becomes unheard, but rather that they are part of the very routine, almost expected boredom and lack or possibility.

Both tracks use repeating guitar riffs that, while building, also suggest lack of change. Drums play slightly different beats yet both suggest bounce, brightness and energy. For 'Disco 2000' we have an anonymous almost automated drum beat, whereas the 'Parklife' drums are slightly wilder and more brash, like the character depicted in the song.

Overall these two Britpop songs are characterised by brightness and energy and outgoing emotion. While lyrics are about relatively depressing matters they use musical semiotic resources to keep these buoyant and fun. Visually we see the same, what could be tedious, settings, but made upbeat with visual semiotic resources. In sum, so far Britpop is a comment on British social life, not in a lofi urban noise sense but one where there is space and the possibility to be heard without necessarily screaming out. The modern world is not so much overwhelming but empty. The only solution is for parody rather than fighting back. Finally, we look at the music of Oasis, the other band associated with Britpop, and, as we will see, musically very different.

Oasis: 'Some Might Say'

Vocal melody

```
SOME  MIGHT  SAY  THAT  SUNSHINE  FOLLOWS  THUNDER
1 ↑    2    ↓    1  → 1 → 1 →  1   ↑  4 ↓ 3 → 3 ↓ 2

TELL IT  TO   THE  MAN  WHO  CANNOT  SHINE
1 ↑ 2↓1      ↑2   ↓ 1  ↑ 2  ↓  1   ↑ 2 ↓  1
```

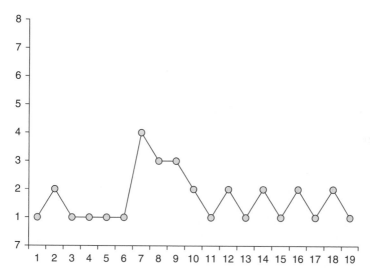

Figure 7.7 'Some Might Say' verse

The melody opens with stasis and little release of energy. It begins on the 1st note ascending only to the 2nd and then back to remain on the 1st note. The 2nd note here suggests something is about to happen which is appropriate for the lyric which forms a kind of prophesy, although what does happen is that the melody returns to stasis on the 1st note. There is therefore very little energy given out. Nevertheless, these first three notes provide a slight outwards burst of energy. After this there is a jump up to the 4th fourth which gives a sense of building, again not surprising considering the 'wisdom' being communicated by the lyrics. This then descends through the joyful major 3rd to the 1st. The line ends with complete stasis between the 1st note and the 2nd note. This is therefore highly grounded, asking questions and hinting and something yet to happen, followed by more groundedness. Lack of pitch range can also mean confidence and objectivity as in the way that news presenters speak. This again would be fitting with the lyrics which claim wisdom.

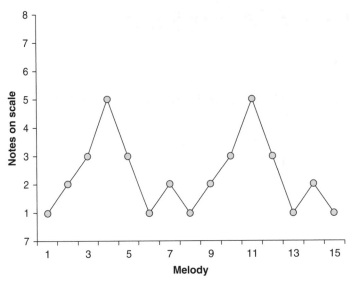

Figure 7.8 'Some Might Say' chorus

The chorus opens up the pitch range a little, over five notes in the scale. The melody ascends and descends in two short statements.

COS I'VE BEEN STANDING AT THE STATION IN NEED OF
1 ↑ 2 ↑ 3 ↑ 5 ↓ 3 ↓ 1 ↑ 2 ↓ 1 ↑ 2 ↑ 3 ↑ 5 ↓

ED—U--CATION
3 ↓ 1 ↑ 2 ↓1

This line is comprised of two ascending bursts of energy rising to the 5th note through the major 3rd, to descend through the major 3rd again to the 1st note. Again we find the use of the 2nd note mainly to moderate the level of joy expressed. But for the most part the chorus is a positive release of energy that is highly grounded in the music through the use of the 5ths. There is a hint of pain as the 1st note used for the word 'EDUCATION' becomes a minor 7th due to the chord the guitar plays beneath.

Instrumentation and sound quality

The musical accompaniment is not characterised by stasis. This is done by two means. First, the guitars play chord (groups of notes) changes that emphasise motion and direction. Chord changes are emphasised, itself signifying movement, development and direction. Second, the guitars are strummed in a way that creates a confident drive with a clear expenditure of energy that is consistent. This is done not in a frantic manner as in some rock music but smoothly and firmly. In fact, while the melody stays fairly still and is repetitive

the chords are driving, moving on in intervals of five notes, which furthers this effect. This combines with the stasis of the melody to create a sense of confidence and power.

Guitars are heavily distorted and loud, often with feedback breaking through, particularly on the opening guitar riff. The rhythm created by the guitars quickly disappears into a lofi soundscape. Whereas Pulp and Blur used constant guitar pitches, here we find both high pitches for brightness and optimism but also low pitches for gravity and deeper meanings; for example, accompanying the lines 'SOME MIGHT SAY'. Over the distorted strumming there are constant flourishes of guitar riffs, individual voices expressing themselves in the soundscape. These gain some salience through higher pitch which brings brightness. But these never rise to figure in the arrangement as in the fashion of the rock solo. There is never this kind of open show of individual expression.

The vocal melodies in the foreground, although not in the manner of Pulp and Blur. Here they are almost part of the ground. This suggests that they do not need to stand apart from the ground in the manner of a heavy-metal vocalist. At times the vocals merge completely into the lofi soundsacpe. The vocals themselves are rasping and nasal with a high degree of tension. These suggest a degree of whining and reluctance rather than emotional expression and openness.

There is emphasis on Mancunian accents with extended consonant sounds such on the 'n' in the word 'shine'. Although there is also the use Americanisms such as in 'Gonna', not used by Pulp and Blur also connoting connections to rock heritage, something Oasis always made very clear in interviews.

Volume is also important in the voice. There is no breathiness or intimacy suggested. Lack of pitch range, nasality, tension and volume in vocals along with the driving chord changes, build to add to the confidence and 'wisdom' expressed through the lyrics.

Rhythm and arrangement

The drums create a slow driving forwards beat with open crashing unrestrained cymbal sound with a double-bass drum strike. This is much more of a driving forward rock beat than the side-to-side steps of Pulp and Blur. This is also part of the mechanism by which the guitar strumming is driven forwards. The stasis and containment of the melody line works alongside the volume and forwards drive all to help make the lyrics about power and meaning.

All instruments play in unison. Even though there are continuing background guitar riffs these never leave the ground as they would in rock music.

The vocals clearly follow metronomical time. They are accented on beats 1 and 3 in each bar although they anticipate them slightly.

1 3	1 3	1 3	1 3
Some might say that s	unshine follows T	hunder	Go and t

1 3	1 3	1 3	
-ell it to the m	an who cannot s	hine	

Figure 7.9 Beat and phrasing in 'Some Might Say'

Just as the guitar riffs never leave the ground, so the vocals have no interest in breaking free of the backing regimentation of time but give themselves up to it. On 'Some Might Say', Oasis present themselves as one solid powerful voice, with everything in unison and close to the ground. It is at this musical level that they present the lyrics.

Words and image

The lyrics to 'Some Might Say' as discussed in Chapter 3 have no coherent story or sequence of events. Rather they are a set of statements that together give the impression of wisdom and profundity, along with some social realism through phrases such as 'The sink is full of dishes'. There are maxims like 'Go tell it to the man who cannot shine', that make little sense. It is filled with directives ordering the listener to do things, so taking the stance of authority. It hints at moral issues, 'We will find a brighter day', but does not articulate these in any way that makes them concrete. A lexis analysis revealed words such as 'heaven', 'hell', 'sunshine', 'thunder' and 'education'. The song combines a mixture of the trivial and the epic. These lyrics combine with the confidence of the lack of pitch range in the vocal melody, the driving guitar strumming and the unison of the instruments.

Visually the video to 'Some Might Say' is black and white footage of a gig, being on stage, backstage with groupies and travelling to the gig with scenes from the USA. On stage we see the group in slow motion, a lowering of modality which enhances our attention to details. This is a well-worn film technique that serves to make the subject appear epic and timeless. The iconography suggests a massive rock band on tour in the USA and the frenzied life of adoration. The band occasionally stare at the camera as if enjoying our attention, making us accept our awareness of their greatness. The footage is black and white but also uses intensely bright washed-out lighting as if overexposed along with darker shadows. With the fast editing this adds to the emotional intensity of the video, with the darks and lights suggesting emotional highs and lows. The video is a celebration of the kind of status the band plays out in its performance of both the lyrics and the music of 'Some Might Say'.

Discourse and Britpop

Overall is there a discourse of Britpop to be found realised in the sounds? In terms of vocals all use regional accents. These of course help to connote Britishness along with honesty and therefore also authenticity.

Lyrical content has degrees of social commentary, although in the case of Oasis this is more the appearance of it. In the case of Pulp and Blur the use of irony also helps in this respect. Irony is not something that is generally considered to be mainstream or manufactured.

All three songs use distorted guitars. The similarity is in the use of guitar riffs that drone behind the singing. This is typical of indie music. But the kinds of distortion used are different, as are the soundscapes and arrangements. Oasis use powerful overwhelming rock-style distortion. As Tagg (1994) would suggest, this is the post-industrial sound of grinding machines and engines. Pulp use more of a regular synthesised 'buzz'-sounding distortion, which suggests modernity, and Blur use a raw dirty guitar sound that sounds much less 'produced' and natural. This is clearly part of their relaxed sound. We can say therefore that all three allow some of the dirt and wear of society into their music. None use pure clean sounds such as the acoustic guitar. Also Blur and Pulp use keyboards. These are not pianos but synthesisers. These connote modernity.

Rhythmically vocals are all fairly subordinate to metronomic time. None of these therefore in Tagg's (1994) terms wish to escape from society, or compete with the noise and rhythms of society. Pulp and Blur both use rhythms closer to dance music while Oasis are pure rock.

There are differences in arrangements which give us clues as to the kind of social landscape being created. 'Disco 2000' sounds more produced as an arrangement, although instruments can all be heard individually. This is an urban environment but not one where we might feel the need to shout out, as when the vocals whisper to us. On the verse this changes as they become shrill and tense, almost hysterical. 'Parklife' is a step towards a hifi soundscape as we hear all the sounds distinctly. The voice used for the verse feels no need to shout. This changes on the chorus where the band do increase pitch and volume. In these two cases we find the individual trapped and accepting their social position which is treated ironically. In both cases the chorus allows this voice to leap out. Had the voices remained much closer to the ground, the instrumental backing throughout this would have appeared very depressing. The bright, higher pitched choruses using major notes allow the emotion to break out. In this case what is connoted both in lyrics and music is an awareness of the way we can become trapped in society, that society is fairly silly and dull, but that we can be above this.

'Some Might Say' in contrast is lofi. It differs greatly in terms of volume and all instruments and voices play in complete unison. This allows them to represent a collective. They do not appear to wish to stand out from society as individuals but wish to be typical rock stars. This is represented both in their interviews, videos and clearly in the music. In contrast Pulp and Blur make room for individual voices. All of the vocal melodies use restricted pitch ranges in verses. This in itself can communicate an overall feeling of self-containment and lack of eagerness to please. But it can also communicate authenticity through its power, distortion and therefore lack of polish and impression of lack of production.

Overall we can certainly see that these three Britpop songs in different ways are able to connote authenticity. They also have a 'raw' sound in different ways. They all communicate deeper troubled emotions and in their different ways appear anti-mainstream. For Blur and Pulp this is through the way they laugh at society.

Conclusion

The aim of this chapter was to use the toolkit developed particularly in the previous two chapters to look for the way that sounds, instruments, vocals and arrangements could communicate broader discourses and allow us to ask whether a handful of songs that were grouped together as a particular kind of music, Britpop, could be found to have anything in common at this level. Of course this exercise used only three pieces of music, meaning that it is not possible to arrive at any general statements about these artists. But the analysis did allow us to reveal some common choices in sound qualities, melodies and pitches, particularly between Blur and Pulp. And this did allow a consideration of the kinds of discourses these sounds were able to signify. As Hibbett (2005) revealed that there were common discourses in talk about indie music so we find common discourses realised in the sounds. Most importantly this chapter has revealed that it is indeed possible to carry out such an analysis on the way that the sounds made by artists can themselves can be analysed and compared. This is a first step, but it would be possible to carry out broader comparisons of the patterns found in the music of particular artists or to make comparisons between those of different music genre. Cooke (1959) had the aim of providing a phrase-book for classical music. Here he described some of conventions in terms of melody, pitch, choices of notes, rhythm and arrangements that composers produced specific kinds of meanings. The possibility of producing the same for popular music could certainly be explored.

Choose three songs from one particular genre of music, such as rave, garage or boy band. Compare them in terms of:

- Vocal melodies (pitch ranges and directions)
- Sound qualities
- Arrangement
- Rhythm

What discourses do these communicate? In what ways do these work along with or against the meanings communicated by lyrics and visuals?

8 Analysing Music in Film

Through repetition in movies we have come to associate certain kinds of melodies and sounds with romance or danger, or with certain kinds of characters (Tagg, 1989). We can easily recognise that certain instruments and melodies communicate comedy (Mera, 2002) or kinds of settings and cultures (Cook, 1998). Tagg (1989) has attempted an inventory of the kinds of musical instruments and sounds that have come to make such associations. Much of this meaning comes from established musical repertoires from the 19th century. But this has later merged with developing film-making techniques and conventions, recording technology and the more recent use of pop music.

This chapter draws on principles of film music described in earlier scholarly work and uses the tools developed in previous chapters to show how this can help us to focus on just how music, in terms of pitches, melodies and sound qualities, can contribute to meaning in movies, often working alongside and merging with sound effects.

The history of film music, put very briefly, is as follows:

- *1895–1915*: Early films were accompanied by piano music. This was used to drown out the noise of the projector and also because otherwise people were sat in the dark in silence and there was concern that this was unnerving. It was also thought that the action was ineffective without sound. In early film there was no use of close-up shots for identification with characters so music could indicate their roles and motives (Manvell and Huntley, 1957; Brown, 1994). The music could also provide continuity between scenes. Sound effects could also be produced using machines such as the kinematophone. The music was mostly inspired by 19th-century classical along with opera vaudeville and music hall. Examples of this are the classic *Great Train Robbery*.

- *1915–25*: Max Winkler and John S. Zamecnik pioneered a system of cue sheets which were timed pieces of music usually taken from 19th-century bourgeois repertoire (Tagg, 1989). These pieces would be identified by their mood 'happiness', 'sadness' or by their connotational potential such as 'morning', 'autumn', 'calm ocean'. Many of these pieces of music have become established as the musical clichés we regularly hear in movies and which form part of our own internalised repertoire.
- *1925–33*: The early soundtrack in the form of sound-on-disc machines such as the vitaphone. This disc was separate from the film reel and was to run in synch with the movie. Earlier efforts had problems. The first major successes were *Don Juan* (1926) and *The Jazz Singer* (1927). These films used very little music unless it was actually performed in the film in musicals. At this time it was still not possible to dub music in afterwards. Some have argued that the arrival of sound returned movies to their infancy in terms of editing and camera work (Cook, 1990).
- *1933–69*: Walt Disney developed the 'Mickey Mousing' system where the music corresponds to the action. This can be seen in films like *Dumbo* where footsteps are represented by particular sounds or the chugging and whistle of a locomotive by strings. Also the Hollywood production *King Kong* was the first score written specifically for the action. Composers mainly from Europe developed the 'leitmotiv' approach drawing on Wagner's operas. This is the use of motifs or themes to indicate characters' feelings or to the meaning of action. These can be a melody, or even a rhythm.
- *1969–present*: Film and television music still relies mainly on traditional Hollywood style. But important developments have been the use of popular music for key moments in films or to draw on the discourses connoted by particular kinds of musical genre. Opening credits often feature a pop song. Does a movie begin with rap music or folk music, for example? The first example of this was 'Raindrops Keep Fallin' On My Head' in *Butch Cassidy and the Sundance Kid* (1969).

Writers on film music such as Manvell and Huntley (1957), Hagen (1971), Brown (1944), Buhler (2001) and Kassabian (2001) allow us to summarise the roles that film music can take. The following draws particularly on the classification offered by Gorbman (1987):

1 *Unobtrusiveness*: It should not be something of which the audience is conscious. It should unobtrusively contribute to the film experience, to form part of the action and plot. Manvell

and Huntley (1957: 7–9) note that in some ways it is an odd thing that audiences are able to accept film music. For example, a person is told of something bad and we hear an aggressive orchestral gesture. Yet we don't consider if the characters can hear this sound. In *High Anxiety* (1978), Mel Brooks parodies this by looking around when he hears loud music on being told bad news. Shortly afterwards we see a bus filled with an orchestra (Mera, 2002).

2 *Action*: Sometimes music can follow action very closely, as in cartoons where each footstep is represented by a note on a horn, or bassoon depending on the qualities of the character. Or it can be used less closely to suggest speed or moments of confusion.

3 *Emotion*: It should signify emotion in the manner of leitmotiv. It should provide atmosphere and mood and provide insight into the inner worlds of the actors, indicating fear, anticipation, joy, etc. Even weak dialogue can be made to sound powerful and emotive with the right music or sounds.

4 *Setting*: It can create a sense of time and place evoking geographical locations and moments in history. Of course for the most part these will draw on clichés along with the language of 19th-century romantic music. But these will be used to create a sense of authenticity, such as a Celtic landscape, an African landscape, etc. This will be an interpretation of what that place stands for, rather than representing the place naturalistically. Normally these will emphasise particular motifs of these times and places: are they peaceful, mysterious or lively, etc.? Frith (1984: 84) puts it:

> The 'reality' of film musical setting actually refers to historical and geographical myths (themselves constructed, in part, by previous musics in previous films set in these places and times). Thus the music for *Zorba the Greek* became so powerfully connotative of 'Greece' that Greek restaurants (even in Greece itself) have to use the music to convince customers of their 'Greekness'.

5 *Continuity*: Music should play a part in film continuity. This can be through coherence with the use of musical themes for characters, places and kinds of events. Or it can be by suggestion that action is about to commence or to be resolved. Music can simply be background filler. Movie scenes without any music can often seem excessively naturalistic or even dramatic. Period drama may not use music. At the end of *Taxi Driver* (1976) there is no music during the violent scene in order to emphasise the sensory effect of the aggression.

One further point to look for when analysing film music is whether it is diegetic or non-diegetic. **Diegetic music** is that which can be seen Ⓖ produced in the world represented in a film. So we might see and/or hear a band playing or hear a radio. Both of these might be off-screen but will be perceived by the audience as part of the represented film world.

Non-diegetic music has been added to the film afterwards and is not part of the represented film world. So we may see a couple kissing and hear an orchestral score.

However, this difference is not always so clear. An actor may sing and then be accompanied by an orchestra that is off-screen and dubbed in. We might see a small number of musicians playing and yet hear a massive orchestra and a choir of accompanying voices. We may also find that people's actions and the movement of objects have been enhanced by including additional sounds or music. Footsteps might be emphasised with percussion, for example.

Analysing film music

The rest of this chapter analyses how music and sound is used in a number of films in terms of action, plot, character, setting and continuity. We begin with pitch, melody and sound qualities. Afterwards we look at the use of leitmotiv for representing character in film. Finally we move on to modality in sound. This is about drawing our attention to how realistic the sounds we hear in films are. We ask which sounds have been changed and how. One important use of music is as an enhancement or replacement for naturalistic sounds. A closing door can be dramatised by use of a bass drum or an orchestral stab, for example. A train that is out of control can have a deep synthesiser keeping rhythm with the usual beats of the wheels on the track. The analysis of modality in sound allows us to assess the kind of film world that is being created for us, where reality in some ways has been reduced or augmented.

Music in setting and action

In this section we draw on the analysis of pitch, melody and sound qualities described in Chapters 5 and 6. First here is a summary of the qualities described.

For melodies we described the meaning potentials for ascending notes and descending notes. Some songs like David Gray's 'Babylon' use descending melodies, while 'Blueberry Hill' uses an ascending melody. We can summarise the meaning potentials of these melodic pitch movements as follows:

- Rising melody – activation and optimism.
- Level melody – stasis or calmness.
- Descending melody – deactivation or pessimism.

There are also meaning potentials of melodies with larger or smaller pitch ranges. For example, the Sex Pistol's 'Anarchy in the UK' stays for the most part on one single note, whereas Queen's 'Find Me Somebody to Love' has a large pitch range. The meaning potential of pitch range can be summarised as follows:

- Increased pitch range – emotive expansion.
- Decreased pitch range – emotive confinement.

There was also meaning potential in shorter and longer melodic outbursts. Billie Holiday's 'Summertime' used longer bursts compared to David Gray's rapid shorter bursts on 'Babylon'. These meaning potentials can be summarised as follows:

- Longer melodic phrases – relaxed, emotionally open.
- Shorter bursts of melodic phrasing – formality, emotionally closed, anxious.

We also considered the value of the notes of the scale. Some songs use mainly notes 1, 3 and 5 which create a rounded, grounded sound as in the case of 'Blueberry Hill'. Songs that use these notes much less will sound less grounded and more 'difficult' as in the case of jazz. Songs can use minor 3rd and 7th notes to create a sense of pain or sadness such in 'Ain't No Sunshine'. The 4th gives a sense of building, found in 'Anarchy in the UK', and the 2nd a sense of movement, or of something more to be told. In the last chapter we found that this was used extensively by Oasis on 'Some Might Say'. In summary their meaning potentials are:

- 1 – anchoring, stable
- 2 – something in between, the promise of something else
- 3 – stable and happy
- Minor 3 – stable but sad or painful
- 4 – building, creating space
- 5 – stable, like the 1st note
- 6 – generally happy like the 3rd
- 7 – slightly thoughtful and longing
- Minor 7 – pain, sadness

It is important to add that there are other notes outside of these, such as the lowered 2nd or 5th notes. These tend to bring a sense

of trouble or unsettled feel to the music as we often find in certain forms of jazz.

All of these meaning potentials are used in the analysis that follows. Since melodies can suggests emotional containment, building or pain, through choices in pitch range and notes of the scale these are useful tools for suggesting characteristics of settings and action in movies.

The setting and action in *Cliffhanger* (1993)

In this section we turn our attention to the use of music to give meanings, setting and action in the Hollywood blockbuster-type movie *Cliffhanger* (1993). Here we attend only to the music. In a later section on modality we include an analysis of the sound effects, some of which are also created by musical instruments. This particular movie has been chosen for analysis for no other reason than it is a typical use of film music and importantly it is easy to locate this section of the film on the Web.

Cliffhanger stars Sylvester Stallone who works at a mountain rescue centre. The film starts with the death of his friend's girlfriend in a climbing accident. Feeling responsible and partly blamed by the friend he leaves for a time, abandoning his own girlfriend. When he eventually returns it is timely as his old team have become entangled with gangsters whose aircraft has crash landed in the mountains and who are searching for money which fell from the plane. Stallone manages to defeat the gangsters through his mountain know-how and lots of daring stunts. In the process, of course, he has the chance to redeem himself with his friend and overcome his sense of guilt for the previous accident. Analysis here is of the opening scene of the movie where we are introduced to the setting and the opening of the plot. Some of the main melodies are picked out which are used at key moments in the sequence.

The movie starts with a black screen for the opening credits. We hear high-pitched, low-volume, tinkling bells playing minor notes – sound used to metaphorically represent snowfall or Christmas, except here with the minor note we get something slightly unsettled and chilling. We then hear a number of sustained notes played on horns. These are:

2 ↓1 ↑5 ↑2

This melody is an emotional outburst. The first note heard is the 2nd, indicating something is going to happen. Then we hear the melody

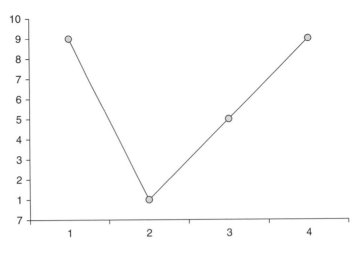

Figure 8.1 Expansive landscape melody

ascending up from the 1st to the 5th to end again on the 2nd note. There is a combination of the groundedness of the 1st and 5th notes but also the possibility created by the 2nd note. The melody ascends over an octave which suggests not just emotional expansiveness, but also, along with the use of the 2nd note, 'searching' and adventure. This effect is also achieved through the use of horns. This instrument along with trumpets and other brass were associated with masculinity in 19th-century classical music (McClary, 1991). Horns also have associations of 'regality' and hunting calls. The same kinds of melody and instrumentation are often heard on space exploration dramas such as *Star Trek*. The longer articulation of the notes, rather than staccato, jumpy notes, suggests relaxation and emotional dwelling rather than tension and drive.

Still seeing the black screen we hear the sound of a helicopter. As the shot of the helicopter dissolves into view we hear a melody on strings, associated with softer feminine emotions in contrast to horns and trumpets (McClary, 1991). This melody then takes part in a dialogue with the same melody played by horns. The masculine voice moves in, slightly dominating the feminine voice.

1 ↑ 4 ↑5 ↑6 ↑min7↓ 6↓5 ↓4

The opening section of this melody is quick paced and ascending to the minor 7. It then slows to descend gradually back to the 4th.

The 4th note is important in this melody which creates space and a sense of building. This is where the melody goes directly after note 1 and to where it hangs at the end of the phrase. This creates a sense of moving forwards, the future, and in this case adventure and

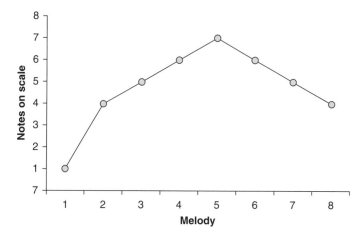

Figure 8.2　Building melody

exhilaration. The highest note is the minor 7th which is a 'blue' note associated with melancholy. This combination of notes, along with the sweeping longer articulation of notes, creates an outward positive burst of emotion over a wide pitch range that uses both building and hint of pain. Visually we see the landscape, high rugged mountain and the 4ths and the minor 7 bring a sense of awe, the sheer emotional wonder of such dangerous beauty, excitement and danger.

This theme is then repeated but played smoothly by a huge string section joined by the brass instruments. Here the masculine and feminine voices join together in their experiences of the landscape. We hear cymbals crashing open for further emotional bursts and bass instruments bring more weight, gravity and sheer might to the music. The smooth sweeping strings suggest continuity and ease. The introduction of larger numbers of instruments builds confidence and a sense of cohesion and common purpose. This also suggests certainty and community. Moments of threat often use singular or only several instruments.

The main theme is then played across the opening sequences in variations of arrangements. Sometimes we hear the whole orchestra to suggest unity and power, and at other times a single trumpet where we focus our attention on a moment of action such as where the characters wait for the helicopter to prepare the winch.

There is then a shift up eight notes to the phrases:

1 ↓ min7 ↑1 ↓　　　4 min7 ↑1↑ min3 ↓2 ↓1 ↑2

The first phrase begins by descending to the minor 7th immediately after the 1st note and then a return to the 1st note. Here there is a sense of pain, although it is emotionally contained and not an outgoing

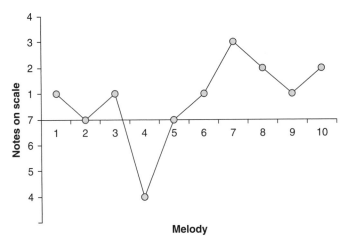

Figure 8.3 Threat melody

emotion as the pitch dips slightly. This is followed by descending to the 4th note. Again a move towards less optimism, an incoming emotion, but with the 4th suggesting something building that is negative. This phrase is typical of 'impending threat' music. Visually we see no such threat, but for a while tension and anticipation are increased.

In the second phrase is an ascending melody beginning with the minor 7 and moving through the 1st up to the minor 3rd. Here we have a painful emotional burst followed by the use of the 2nd to leave a sense of asking a question with something to follow. The message here is of the beauty, power and danger of the landscape where the characters are fragile. But the relatively short bursts of melody and the sweeps of the strings maintain a sense of energy and fluency. Also the 4th and 2nd notes keep a sense of direction and momentum to the melody. In sum we are told this is a grand moving landscape where something bad will happen.

It is important that this melody is delivered with great energy and flourish by a large orchestra who play in complete unison. Under the lead melody bass instruments pick out the chord notes giving weight and gravity. On top of this we hear much higher pitched strings giving a sense of brightness and optimism, even though notes of pain are used which bring in a hint of tension.

We then see wonderful views of mountains. At a moment where the hero is spotted on the cliff we hear a fast string riff to create excitement, a moment of action. This begins on the building 4th indicating movement forwards and uses the painful minor 7th. The rapid pace also brings a sense of urgency.

4 ↑min7 ↑ 1

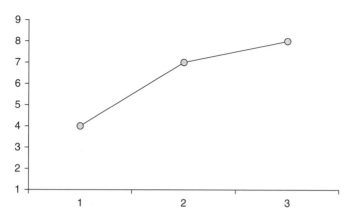

Figure 8.4 Urgency melody

There are also cymbal crashes and bass drum beat. This riff remains behind the main theme. We also hear harps play the same notes as this riff, although these are backgrounded. Harps have often been used to represent the openness and wonder of the ocean and for sunrises. Metaphorically they have been used to represent things that flow and therefore that are in motion.

We then see the man and woman the helicopter is going to rescue. The music changes with a repeated motif of three descending notes to indicate some drama or suspense. This quickly resolves as it turns out to be a joke and the main theme crashes back in with cymbals and bass. There is some joking banter amongst the smiling characters.

When the action starts, where the helicopter flies in, we hear the same orchestra sound but now playing 4ths and flat 4ths:

4 ↓ flat4 ↑ 6 ↓ 3

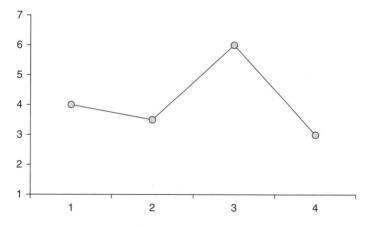

Figure 8.5 Troubled motif

The use of the flat 4th note here suggests something much less grounded to the music and therefore troubling or unsettled. The melody begins by descending, not quite reaching the 3rd note, then rising only to descend again. Danger is often represented by melodies that quickly change direction over a small pitch range.

When we get to the dramatic moment where the girlfriend falls we have a restricted melody using minor 7th, 6th, 1st and flattened 2nd. Cycling this pattern is typical of moments of intense drama in movies. Notes such as the flattened 2nd, unlike the 1st and 3rd notes, sit uneasily with the melody. In such sequences there is often rapid jumping between the notes to create an unsettled feeling.

Before the woman falls she loses her teddy bear from her pack and it falls. We have a descending chromatic scale. Such scales are made up of half notes and in this case are played in descending order. It would be like playing every note on the piano in descending sequence. Chromatic scales have often been used to suggest falling in this way. Ascending chromatic scales, in contrast, are used for climbing, although normally when this is something not under control by the person involved. Higher pitches suggest greater heights and levels of precariousness.

The use of high pitches and delicate instruments in this case, such as the flute, also give a sense of gently falling and weightlessness. As the woman begins to slip we hear a descending melody and some high-pitched rasping sounds. The horror of the event is augmented by the descending notes and the tension of the rasping sounds. This rises to deeper horns and screeching tension as Stallone tries to catch her. At this point we hear both low pitches to suggest danger and doom, and raspiness to suggest raw tension.

What is clear from this analysis of music in the introduction to *Cliffhanger* is the way that the music contributes to both setting and action. This is in terms of the instruments that are used, the notes they play and the manner in which they are played – fast, energetic or smooth and dwelling on the moment. We have expansive smooth melodies to suggest relaxation and openness, characteristic of landscape music. But we also find a hint of pain and of building to suggest excitement and wonder and thrilling danger. The sweeping strings and ascending melodies also help to create a sense of energy and ease about the context for the action, along with the promise that something is about to happen. The music is used to create suspense with faster repeated note sequences, which then resolves back to the main theme when this turns out to be a joke. Later, when the drama happens, we have a confined discordant melody played using lower notes indicating gravity and danger. As the protagonist attempts to catch the woman we have both deeper horns and screeching to convey their emotional state.

Character in movies

In this section we consider the way that character is represented by music using three case studies: *Pride and Prejudice*, *Taxi Driver* and *The Piano*. We find that music can represent types of character and also their relationship to others and to the wider society.

McClary's (1991) work on the representation of character in the music of certain classical composers helps us to focus on some salient features. She believes there is a long tradition of representing men and women, for example, in European music such as Beethoven's *Unfinished Symphony* where we are encouraged to identify with the feminine which is then tragically quashed. In Tchaikovsky's *Fourth Symphony* she says that the opening, played by the whole orchestra is military forceful and invincible (p. 71). The masculine theme is then played by horn and strings going down in small steps expressing fear and yearning. He is indecisive. The feminine part is then sultry and seductive, slinky and irrational. Later the masculine theme reappears yet trapped inside the feminine theme. The man escapes but only to be then quashed by the opening militaristic theme. McClary, noting Tchaikovsky's struggle with his homosexuality, explains that where the whole orchestra plays together at the start represents oppressive society. The second masculine theme represents the anguish of the protagonist and the third feminine theme a manipulative antagonist.

Reading from McClary, van Leeuwen (1999) lists therefore a number of associations in music that have been used to signify men and women:

Men

- Dotted rhythms
- Ascending melodies
- Disjunctive articulation (staccato)
- Wide pitch range
- Loud brass and percussion instruments

In other words, assertive, precise, forceful, thrusting, outward looking.

Women

- Soft connected articulation
- Descending melodies
- Narrow pitch range
- Suspension (delayed or lengthened notes for emotional effect)
- Softer instruments such as woodwind and strings.

In other words, gentle, delicate, seductive, emotionally contained, modest, inward looking.

In sonatas, McClary (1991) notes, we often find that the two melodies and sounds become intertwined as characters become involved. A third theme may be introduced to represent society as a whole or a third force that influences the main characters.

Within this basic framework, McClary explains, many different stories can be told:

> Many of Beethoven's symphonies exhibit considerable anxiety with respect to feminine moments and respond to them with extraordinary violence. Other pieces, such as many by Mozart and Schubert, tend to invest their second themes with extraordinary sympathy, and this leads one to regret the inevitable return to the tonic and the original materials. (1991: 69)

Drawing on McClary's observations we can now apply our observations on pitch, melody and sound quality to analyse several film characters.

Pride and Prejudice (1995)

We begin with the motifs used for some of the characters in the BBC adaptation of *Pride and Prejudice* (1995). All of these motifs are designed for stylised period authenticity. They also serve as emotional signifiers and provide continuity.

The first one is for the character of Mr Collins. He is a very stupid, socially inept man, who is physically unattractive and pompous.

Mr Collins

1 ↑ 4 →4 ↓1 ↓ min7 →min7 ↑ 5 ↓ 4 →4 ↓3 →3↓ 2

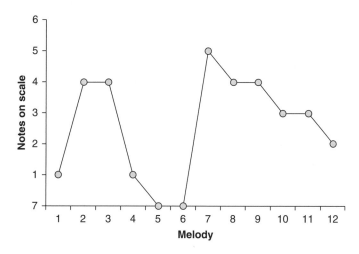

Figure 8.6 Mr Collins motif

The melody is played using cellos to create both high and low notes. Mera (2002) noted that extremes of tonal range are often associated with comedy characters. He observes also that instruments played at the limit of their range also tend to suggest comedy, as this adds awkwardness to the sound. In this motif we find cellos played in this manner. Of course lower pitched notes themselves can suggest weight and lack of agility. Also some of the notes are played using dotted rhythms. In other words, the notes are short and emphasised rather than drawn out. McClary (1991) has suggested that such notes are associated with masculinity. But in the case of Mr Collins's motif these notes played at deeper pitches suggest something lacking agility. And rather than staccato the notes bounce 'slightly', suggesting something playful or silly. We also find the motif played on strings rather than brass. This suggests a lack of masculine confidence. In the melody itself we can see that there is an initial falling away of energy followed by a peak which then gradually descends to end on the 'unfinished' 2nd note. We simply would not expect to find such a sequence of notes for a character that was more confident and stable.

At one point later in the film one of the Bennet girls, Kitty, alerts the other girls that Mr Collins is arriving, something they all find very tedious. The viewer cannot see him but his motif is heard, as if travelling over the landscape ahead of him. In this moment before he is seen it is possible to imagine that this music is non-diegetic and that,

in the manner of a Mel Brooks comedy, the other characters can hear this music and therefore avoid him before he arrives.

Lady Catherine de Bourgh

Lady Catherine de Bourgh is very different character. She is a rich, widowed member of the gentry who is unpleasant, yet powerful, and is filled with the sense of her own importance.

1 ↑2 ↑min3 ↑ 2 ↑min3 ↑5 5 ↑flat6 ↑ min7 ↓ flat6↑ min7 ↑1 1↑2 ↑ min3 ↓ 2 ↑ min3 ↑ 4 → 4 ↓min3→ min3↓ 2 →2 ↑min3

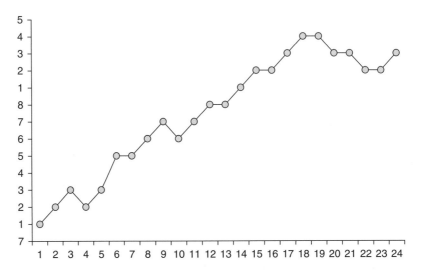

Figure 8.7 Lady Catherine de Bourgh motif

This motif is very expansive in terms of pitch moving from the 1st note to the 4th in the next octave. This therefore takes place over 12 notes. What is crucial about this particular melody is that is ascends in short bursts or statements. At the end of Chapter 5 we looked at the associations of shorter abrupt statements with assertiveness or formality, as in the fashion of newsreaders. While this motif is incredibly expressive and expansive it is also therefore very formal, making its progress in short steps. The extended increase in pitch gives the impression of excessive expression and even pompousness.

The motif also uses painful minor notes. We would expect this combination from a character who announces her presence proudly and sternly. There is also, importantly, high tension in the way the strings are played with tight vibrato. There is a combination of shorter dotted notes and longer articulated notes. This suggests some femininity, although also a more dominant, thrusting nature to the character.

Mr Bingley

The theme for Mr Bingley appears on the occasions when he arrives at his country manor. He is a kind, decent and simple man, and represents the wealthier gentry moving into the area. The melody is played on horns, as if a hunting call, using intervals of 4ths.

1 ↓ 5 ↑ 1→ 1 ↓5↑1→1 then 5 ↓ 2↑ 5→ 5↓ 2↑ 5→ 5

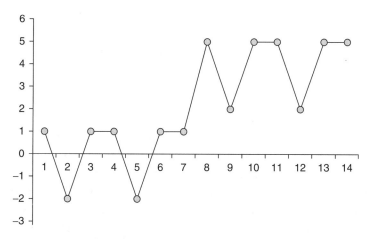

Figure 8.8 Mr Bingley motif

The main signification here is through the meaning of the country manor and associations with hunting. Yet the notes chosen and the large upward step of the melody over the two sections suggests bright optimism. There are both longer notes and also dotted notes on the 1st notes in the first section and the 5th in the second. This is in the fashion of military music. The use of the 1st and the 1st and 5th notes create a highly grounded melody. He is a stable and safe character.

In the second section the shift upwards of five notes of the same melody and the inclusion of the 2nd note suggests something positive is about to happen. Mr Bingley is literally someone exciting happening to the community and an important part in the plot. The motif also suggests his positive and bright character.

Taxi Driver (1976)

In this movie there are two motifs for Robert De Nero's character. The first theme involves two alternating chords, one major and one minor, played on a number of brass instruments, although not a whole orchestra. Each chord is sustained. They repeat, creating a sense of

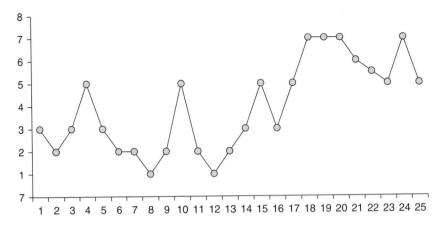

Figure 8.9 Jazzy melody

entrapment and also of discordance. Sometimes on each alternation there is a snare drum roll that gradually increases in speed or bass strings that pluck out repeating alternating notes monotonously. The drums have the effect of increasing drama ending in a shift to the next chord with a crash of cymbals. The use of the snare drum has a military connotation, although its lack of steadiness suggests instability. The strings simply add to the different levels of entrapment. The combination is whooshes of sound that suggest great drama and bleakness, with unstable military snares.

The second theme is a jazzy melody played on a saxophone backed by a jazz quartet of piano, bass and softly played drums.

3↓ 2 ↑ 3↑5↓ 3↓ 2↓ 2↓ 1↑ 2↑5↓ 2 ↓ 1↑2↑3↑5 3↑5 min7 →min7 → min7 ↓ 6↓ flat6↓ 5 ↑7 ↓ 5

This motif has a large pitch range from the 1st note to the 7th. It is therefore a large emotional expression. However, many of the phrases within this motif appear as shorter emotional outbursts. This is no confident outburst of emotion and optimism but smaller statements building and then descending. The smoothness of the articulation means that this suggests emotional wandering, rather than erratic, as would have been communicated with shorter staccato notes.

The melody begins by descending to the 2nd note. But by starting and returning to the 3rd note quickly this is joyful and bright. In fact the motif is dominated by 3rd and 5th and is therefore highly grounded in the chords beneath. The other dominant note is the 2nd, which is about something unresolved, a question. We should not be surprised to find this. The melody seems to represent De Niro's dreams to be somebody, to have some romance in his life, but it remains a huge question and therefore never quite feels safe. Later

in the motif there is an emphasis on the pain and blues of the flattened 6th second, although quickly after we also find the major 7th which is more longing. The use of the flat 6th works like the minor 3rd to create pain. Here the alternation of minor and major 6ths and 7ths gives the bluesy feel to the motif.

The motif is played with slur and seduction in jazzy fashion using the bright and optimistic sound of alto sax. It is stylish, seductive and romantic, although never leaving behinds the slightly sleazy feel of the jazz basement. The notes are not dotted but have a softer connected articulation which suggests femininity. Perhaps this also suggests the character's emotional side. Certainly his ambitions are of romance and seduction. This motif is of great contrast to the first motif of menace, entrapment and doom. Later in the film the motif is played on muted trumpets rather than the sax. There is also repeating timpani. This suggests more frustration and difficulty of expression and hollowness along with deep menace.

The Piano (1993)

The music in *The Piano* is interesting as it is partly diegetic and partly non-diegetic. Sometimes it is clear that the music is produced in the film world, by the piano, and at other times orchestral accompaniments are dubbed in. As with *Pride and Prejudice* the music uses stylised authenticity. And like *Pride and Prejudice* it also uses leitmotivs to tell a story and represent character. Both films contain both diegetic and non-diegetic music, although in *The Piano* the music is certainly obtrusive. It is used more forthrightly to tell the story as in some of the interactions between the two main characters Ada and Baines.

The first character we look at is Ada:

1 ↑ min3 ↑5 ↓min3 ↓ min7↑ 5 ↓ 6 ↑ min3 ↑ 6 ↓ 5 ↓4 ↓min3 ↓

6↑ 6 ↓ min7↑ min7 ↑ 1↑8 ↓ min3 ↓ min3 ↑ 4 ↑5 ↑6 ↑ min7

The motif is played on piano which is a very individualistic instrument and romantic. Playing piano has long been associated with feminine accomplishment; see, for example, the novels of Jane Austen. It is played 3/4 time, which is a less regimented and slightly skipping rhythm. The notes are softly and smoothly articulated. It is a melody with lots of ascending and descending bursts. We have discussed in previous chapters how such bursts are often used by folk singers to suggest frustration and anger. This melody shares that feature, although overall it expands over a large pitch range running over more than eight notes. On the second line there are leaps of whole

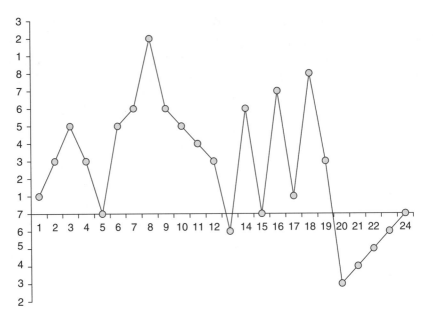

Figure 8.10 Ada's motif

eight notes only to return seven notes and then leap again. The melody jumps from the 6th note above to the 6th below and then the same with the minor 7th. This suggests a high level of emotional outburst, yet almost at a level of instability repeatedly returning to more or less the same point only to bounce up again. In the minor key with lots of minor 3 and minor7 notes these outbursts become cries of anguish. This gives a feeling of much resignation and yielding but also pushes against something with the upward surges. This line ends by descending lower than note 1 to rise only slightly, with some faint remnants of hope to end on the pain of the minor 7th.

Later, the same theme is played but much faster with the notes played much harder suggesting emotional outpouring and anger.

The second character is Baines:

7 ↑1 ↑ 6↓ 5 ↓ 1 ↓ 7

This motif uses longer notes that appear at first as short fragments and in the background. It appears to be pushing itself into Ada's thoughts, although at first without confidence and without subtlety. The melody gradually increases in force and confidence and plays a duet with the piano before taking over. The forcefulness of the melody is certainly highly masculine. Although the notes are longer their fragmented nature is not of smooth articulation. It uses major notes, although there is use of the longing of the major 7th and the 3rd note is avoided so the melody is only grounded by the 5th and

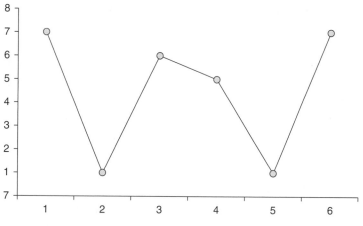

Figure 8.11 Baines' motif

the 1st notes. This suggests there is something unsettled in his character. Later in the film the melody is played with heavy vibrato, and therefore emotion, on a cello, with the switch to strings suggesting something much more emotional awaking in Baines.

Modality

In Chapter 2 we considered visual modality. We saw that the term modality has been used to describe the resources in language that we

have for expressing degrees of truth, for example, words like 'may', 'must', 'will' or 'perhaps', 'certain' and 'probable'. A high modality statement will be one which will reflect a high degree of certainty, a high degree of connection with naturalistic truth. Visual representations too can be thought of in terms of having modality cues, such as the levels of articulation of detail and tonal range. Some images are not presented as high modality or as true to everyday naturalistic truth as we would have seen had we been there to witness the scene ourselves. Some of the images we analysed in Chapter 2 had aspects exaggerated and were more than real or of a 'sensory' nature and others had details reduced making them less real or of low modality. Of course what is considered as naturalistic will depend very much on cultural values. But nevertheless we can judge against what those values are.

In this section we are interested in the modality of sounds. In films some sounds might be as we would hear them had we been there, but others have been changed, been reduced, exaggerated, had aspects modified, or been replaced by a sound that symbolises the original. In terms of visual modality having a set of tools with which to analyse what had been changed, made more or less real or symbolised, allowed us to observe much more closely how the visual world was being shaped for us. As in linguistic analysis of modality we can see this as part of the way that the author/producer wishes to manipulate how the world appears to us. For the same reason it is useful to have a set of tools that allow us to deal with modality in sound. On radio broadcasts we might be aware that sound effects are used to symbolise doors closing or people walking. On news broadcasts sounds of wind, traffic, people panicking, nature, are often added from sound archives to create atmosphere. The same kind of thing is done in movies although we may be less familiar with drawing our attention to these as we are distracted by the visuals and become immersed in the action.

Imagine we hear two film clips in a news item where a politician is speaking. It appears he is in an urban setting. In the first one we hear noisy traffic and road works. His voice has to be raised to be heard in the lofi soundscape. In the second clip these sounds have been pushed into the background. The sound of a bird singing has been added and he seems to speak in a much more relaxed manner. If we listen harder we find that the bird whistle has been positioned for us in the foreground. So literally it would have had to have been singing directly into our ears to create that effect. The sounds of the traffic and road works have been pushed into the background and softened. Clearly this has an effect on how we experience the politician and what he says.

In the case of movies we find much more complex manipulation of sounds. This in itself is of course no surprise. We all know that in real life there is no dramatic music to warn us of danger or string sections

to indicate a romantic opportunity. But we attend much less to the way sounds have been changed, made more than real or less than real, or replaced and symbolised, in terms of sounds. Going back to the movie *Cliffhanger*, this is what we deal with in this section. First there are a few things we need to think about in terms of what we regard as naturalistic sounds.

Music, naturalism and abstraction

Van Leeuwen (1999) suggests that from the 16th century onwards music developed the means to represent things in the world with different sound instruments. For example, the 1600s' *Fantasia* by John Mundy depicts lightning through ragged bursts of melody and good weather with a calmer music. It is important to remember that at the root of this is the metaphorical association (Arnhiem, 1969) that we discussed in Chapter 4. Qualities of one thing are used to express our experience of another. We express a clash of opinions by clapping our hands together. So we represent nice weather by melodies that do not contain bursts of activity and display evenness. They will be free of raspiness and tension.

Later in the 18th century, as did painters, composers represented landscapes such as in Vivaldi's *Four Seasons*. In the 19th century it also became more common to depict battle scenes again in painting as well as music. Sections in music would represent enemies, heroes and battle itself. It is from this tradition that we now take for granted that things in the world, events and actions can be represented through music.

Tagg (1982) has shown the way that the music played over early films drew on these traditions to connote landscapes, threats and joy, etc. Music mood catalogues were developed that are still available today. He shows how these collections drew almost exclusively on the pastoral stereotypes of the 19th-century bourgeois tradition. This, he explains, is a tradition that romanticises nature – a view that would not be shared by a person who worked in the fields at the time. These sounds then represented a division between the urban and the rural. So these sounds, with which we are now all so familiar, are a particular viewpoint of nature and the world of events.

Tagg suggests humans have always represented the world around them in accordance with their social and cultural situation. A Stone-Age hunter might use an animal horn to express a relationship to nature. In early village settlements the sounds of nature and of spirits would be made with sounds that resembled the movements

of the trees or of distant thunder. Then thunder, or such low sounds, could be used to represent other forms of menace of threat. This would be a society where human survival depended on nature, very different from the bourgeois tradition.

So we have a range of possibilities as regards the meaning of sounds. We can have actual sounds that are reproduced for us; we can have sounds that are somehow changed to shape our perceptions of a situation; and we can have metaphorical associations, where sounds symbolise things in the world. Of course music can never represent naturalistically as it cannot describe, although such is the nature of our established repertoire we might argue that certain melodies can signify romance in the manner of the word 'romance'.

Early film makers often saw sound as not being about naturalism but that it should be used to interpret, that it should convey the inner experiences of the characters (Weis and Belton, 1985). At first this would mean making sounds that corresponded to actions seen on film along with music to create mood. Of course it was developments in sound recording that allowed a whole new range of manipulation. Van Leeuwen (1999) suggests that the sound we hear on films is now not so much recorded but designed (p. 167).

When we wish to analyse the sounds in a film therefore we attend to how the soundscape has been designed for us. On the one hand, we can think about foregrounding and arrangement, as in the news footage of the politician speaking. On the other, we can draw our attention to how real, less than real, or more than real the sounds are. In other words, we can ask about the modality of the sound. Is thunder represented by an actual thunderclap? Has this been amplified or given greater resonance? Has it been brought forward in the soundscape? Have other sounds, say the banging of hollow metal, been added to make it more dramatic? Is it represented only by musical instruments? In turn we can ask what cultural values and messages, in other words discourses, these modalities help to communicate.

Modality in film sound

As with visual modality van Leeuwen (1999) argues that there are a number of modality cues for sound. We can use these to measure the degree and kind of truth of the sound. He begins by asking us to imagine four different locomotive sounds (p. 170). These are from four films:

1 *Honegger's Pacific 231*: here the whistle is played by abrupt upwards sliding on the strings and the engine chug by brass, strings and timpani playing faster and faster. We can also see

this in John Grearson's *Nightmail*, where the sound of the train on the track and the engine are represented by taut strings, kettle drums and snare drum rolls.

2 A naturalistic recording of a train: here you will hear the chugging of the train but also lots of other clanking, grinding and creaking sounds.

3 A film where a train is meant to frighten the viewer, say, where someone is in danger from the train; here the sound is exaggerated, possibly with deeper sounds exaggerated and heightened reverb. The whistle will sound like a scream. Here, naturalistic truth is not as important as is the sensory experience of fear. For example, in *Under Siege 2: Dark Territory* where the train roars are heavily flanged.

4 The locomotive from Disney's *Dumbo*: here the train is musical and abstract. The sound of the strings sounds unrealistic as if played on a synthesiser. Some of the sounds are exaggerated for comic effect. There is little in terms of naturalistic sound here.

In each case we could change the sound of the locomotive through adding more or less realistic sounds. We could add instruments to symbolise some of the sounds, instruments that were themselves more natural or synthesised.

Van Leeuwen (1999: 172) lists eight modality cues with which we can analyse the sounds in film:

Pitch range

This is the range from monotone to maximally wide pitch range. Where there are highly reduced pitch ranges this reduces the level of human emotion. It can represent monotone chanting and restraint or machine speech. We can hear this in the voice of the Daleks in the TV series *Dr Who*.

To represent naturalistic sounds wider pitch ranges are required, although after a point this will become more than real and can be used in high drama. In the case of locomotives in movies, for example, we can ask if the sound of the whistle is heightened in pitch to a scream and the chugging lowered to a menacing thunder sound. We can ask the same question of other machines in movies such as helicopters. In some films weapons can use exaggerated pitch ranges. A sword can make a high-pitched ringing sound as it is withdrawn. A bullet can make deep thumping sounds as it enters a body while the firing sound is very high pitched. This can be compared to the rattle sound of guns heard in naturalistic settings. Often in Hollywood movies cars make lots of screeching pitch sounds as they turn corners to add to the emotional drama of a chase.

Durational variation

This is the range where the duration of sounds are uniform or maximally varied. Newsreaders use a mechanical reading of the news to suggest restraint, authority and objectivity. When we are emotional we tend to increase the duration of words such as 'heeeeelp!'. Whether this is a natural or machine sound we can ask whether the duration has been increased or decreased. For example, the sound of water dripping might be extended as well as amplified. The sound of a sword being unsheathed can also be extended as well as raised in pitch.

Dynamic range

This is the range of loudness. Is there just one degree of loudness throughout a sound event or many? In the previous chapter we considered the meaning of variations in volume as indicating self-expression. It is only in Romantic music that the use of the **dynamic range** of volume began to be used as a mode of expression of the individual. Van Leeuwen (1999) suggests that it is instruments that do not allow for changes of volume that tend to be associated with the sacred as they prohibit human articulation. The synthesiser sounds of the 1980s and 1990s also suggested something alien or restricted of emotion such as the music of Gary Numan and Tubeway Army. If we wish to engage and influence people when we speak we need to use a range of loudness or we will be perceived as flat and uninterested. When we do things with expression we tend to make noise, such as shouting or slamming doors. So we can ask to what extent a film sound has range in volume or if it is highly regulated and controlled. Do the speakers use a range of loudness or is it even exaggerated?

Perspectival depth

This is the range from there being no background or foreground sound to maximum layers. We might find that all we can hear in a film sequence are the speakers. The background noises may be distinguishable but only remotely. This is very much like the way that articulation of background can reduce modality in visual images. Or the noises of the setting might themselves be amplified; for example, to create footstep noises on gravel, or of children playing in the distance as often happens in crime re-enactments. The sounds of footsteps being heard or horses' hooves can be used to indicate peacefulness as these are not drowned out by other modern era sounds. This can be used in period drama, or in any magazine-style programme reporting on rural life. The sound of running water might be foregrounded to connote tranquillity. In a movie footsteps over rocks might be amplified to emphasise the effort required to

walk. Such exaggerations and bringing to the foreground sounds that are normally in the background increases emotional effect.

Degrees of fluctuation

This is the range of vibrato, from a steady unwavering sound to one of a high degree of deep or rapid fluctuation. Van Leeuwen (1999: 175) relates this feature to expression of emotion. Lack of vibrato can mean restraint while high levels of vibrato suggest a strong expression of emotion. We are familiar with the way that kisses in movies, or moments of fear use vibrato, literally in both cases the sound shivers or trembles with anticipation. Lack of vibrato, in contrast, can mean relaxed although much meaning depends also on whether vibrato is increasing, decreasing, meaning relaxing, or of course whether it is constant and unchanging and therefore suggesting something mechanically produced and therefore artificial. In 1950s movies aliens often produced such constant vibratos through the use of the Theramin, a musical instrument that worked on modifying electrical currents with positioning of the hand.

Degrees of friction

As well as suggesting tension friction can suggest dirty or clean, pure sounds. These sounds can simply suggest natural sounds although these can be clean to the extent that they become sensory such as when we hear the sounds of hands on the frets of a guitar, or water running delicately over pebbles. To be more naturalistic there should be some degree of dirt or friction.

Absorption range

This is the degree to which sounds reverberate or are completely dry, suggesting varying degrees of space. If a film soundtrack is to appear as if we were there we should hear some resonance. Often in drama this is reduced to suggest intimacy which itself can connote dramatic tension. Like the removal of background in visual modality this can serve to decontextualise the foregrounded sounds. But where echo and reverb are increased this will create a sense of magnitude and even of dread of being exposed. In some films reverb can also be used to suggest that people are trapped in their own mind such as when they are concussed or drugged.

Degree of directionality

Here we ask to what extent we can establish the origins of a sound in a movie. Can we tell what the source is or does it seem to be coming from all around? Often this tells us which sounds are representational, those for which we can identify origins, and those that are sensory where we cannot.

We can use these cues to judge the way that a sound represents. We can use them to consider what kind of modality is being communicated. In each case this serves to tell us something about the reality and truth level of the film world created for us. Van Leeuwen (1999) describes three levels of modality for sound:

Naturalistic

Here the sound represents as we would find it in everyday life. Of course this will depend on cultural notions of naturalism.

Abstract modality

Here the sound represents the essence of something. It is a generalised sound. So, for example, a musical instrument can be used to represent the essence of a movement, such as a clumsy walk, or a locomotive.

Sensory modality

Here the sound does not represent a thing such as romance or horror or fun but tries to seduce, scare or make you feel happy. Here sounds are normally more than real.

Modality in a Hollywood movie sequence

Here we look at sound modality in the opening sequence of the movie *Cliffhanger* in order to complete the earlier analysis carried out on the music. We show that modality cues are a useful way to draw our attention to sound design in movies. Sound and image may communicate very different modalities. What we see may be naturalistic, while what we hear is abstract or sensory. In Chapter 3 we looked at the way that visual modality, according to Machin and Thornborrow (2003), was one way that departures from actual everyday reality rules can be signalled. These authors likened low modality images in women's magazines to elements of magic in fairy tales. Such markers indicate that normal rules do not apply. In the fairy tale this means that animals can perhaps talk, individual children have the power to save entire societies. In the women's magazine it allows women to have power simply through acts of seduction and other behaviours that would certainly not be indicative of power in everyday life. In movies likewise music and sound can indicate a reduced modality world and therefore one where possibly the protagonists are not affected by reality in the same way as everyday people. So in many movies people are not hurt very much by fighting and can easily punch in a car window in order to steal it and many unfeasible

coincidences can happen. Sound, along with other features such as colour that we examined in Chapter 3, can prepare us for this. It would be odd if a movie used a highly naturalistic soundtrack and then the characters began to act in a blockbuster manner.

Much of the opening sequence in *Cliffhanger* is dominated by the musical score, which we have examined above. But we can now think about the other sounds we hear in terms of modality. These have been listed in two columns. In the left-hand column the thing or action making the sound is described and in the right-hand column the modality is explained.

(1) Black screen – tinkling bells in minor key	Here snow and ice are represented through delicate bells, the minor key combining with high pitch and low volume to make it sound cold and fragile. On the one hand, this is abstract modality as it tries to represent coldness and delicacy. But we could say that it is also sensory as it attempts to communicate fragility. Here we have some naturalistic modality.
(2) Soaring loud chopper blades	This sound could have been made by an actual chopper. But if you have been in a chopper you hear the engine and whirring of the mechanism very loudly. Here the chopper sound becomes just the blades rotating. In this sense this sound represents abstract modality. The chopper is reduced to the rotation of its blades. The blade sounds are clear and highly foregrounded. It also appears that the lower pitch sound of the chopper blades have been amplified and foregrounded to make it sound more powerful or to add to the power of the landscape. In this sense the pitch here represents both the abstract essence of the hugeness of the landscape and the sensory effect of its menace. At times the sound of the helicopter appears to obey our point of view (in other words, obey directionality) increasing in pitch as it descends past the camera. At other times it does not. Sometimes we are therefore reminded of point of view. In this case we can say that sometimes the sounds are about representing naturalistically and, at others, where directionality diminishes that they have a sensory role.

(3) Sound inside cockpit	In the cockpit of the helicopter we hear no rattling sounds or movement sounds. Often aircraft rattles are included to emphasise the fragility of flight such as in war movies. We could say that this soft silence behind the chopper blades is complete freedom of dirt. This is an idealised reality.
(4) Hissing sound of flare	This is naturalistic but is exaggerated in terms of volume. We would not be able to hear it from the viewing position. The role of this also seems to be sensory and soothing. There is a mixture of communication of danger in this opening sequence but also comfort in the safeness of comradeship.
(5) Voices on radio – loud, clear and slightly raspy	The voices are all heard in absolute clarity without wind interference. We even hear slight breathiness, which suggests intimacy. This is important at this stage of the movie to communicate the friendship, intimacy and ease between the protagonists. Even when Stallone is hanging from a ledge by one hand hundreds of feet up there is no wind to be heard. Voices are relatively limited in pitch range compared to the soaring range of music. This suggests relaxation and comfort, even though they are high in the mountains. These people are clearly at home in this terrain – an important signpost for what happens later in the movie, where this belonging allows them to outwit the aggressors. Voices are heard with no echo or reverb as we might expect in such a large space.
(6) Clinking of climbing hooks as Stallone climbs over ledge and camera/helicopter looks down on him.	We hear this sound with exaggerated loudness, hearing it even with the noise of the helicopter. These sounds are naturalistic, although their loudness and duration are exaggerated. Here also, therefore, perspectival depth is not represented naturalistically. There is also little sense of absorption depth. The sounds are all flat. This is not so noticeable due to the role played by the musical score. It is of note that were we able to hear the clinking hooks in this manner; we would most likely also hear falling rock chips, which is the other salient sound of rock climbing.

(7) Talking/joking of actors on mountain	We hear these voices completely fore-grounded with no 'dirt' from wind. There is no sense of echo or weakened volume due to wind. This is a kind of talk, therefore, that is idealised and abstract and not in touch with the real world. A movie that wanted to emphasise realism might include the sound of the wind and the problems of chatting on top of a mountain. It is such cues that allow us to have certain expectations about the kind of movie that we are about to watch.
(8) Winch sound	The winch sound is naturalistic and representative. Although, as the winch lowers, the sound of horns begins with three descending notes involving a minor 7 note and a short pitch range suggesting momentary danger and some confinement. Therefore, the sound is sensory in that it communicates the feeling of threat or danger.
(9) Hammering hook into rock	This sounds more like scraping at rock rather than metal against metal. What is important here is the sensory experience of rockiness. The sound is also both amplified and has increased duration. In this way it is also represented in abstraction, the essence of rockiness.
(10) Connecting helicopter winch to hook in rock	This sounds like a whole bag of hooks being clinked about. Here duration of the sound is therefore increased and the degree of friction increased to more than real. In this case we have the abstract representation of 'metalness' and also the sensory experience of it.

In the earlier section on musical score we saw the way that action can be pre-empted and fairly ambiguous scenes given meaning by the flow of music. Here we can see that this music works with other sound effects, sometimes replacing and sometimes working along-side exaggerated or symbolised sounds. These sounds and their modalities, along with the music, are able to place connotations of things like friendship, relaxation and belonging. Just as sweeping strings with certain choices of notes can give the experience of open spaces and an impending threat, so modalities of sound can add sensory experiences of rocks and machinery.

In a short movie sequence study the sounds in terms of the levels of modality of:

- *Pitch ranges*: Are they naturalistic and wide ranging or are they reduced or exaggerated in order to create drama?
- *Duration of sounds*: Is the duration of sounds as we would expect naturalistically or have they been regulated or exaggerated, such as the sound of a water droplet or a sword being unsheathed?
- *Volume ranges*: To what extent has the film sound a range in volume or is it highly regulated and controlled? Do the speakers use a range of loudness or is it even exaggerated?
- *Perspective*: To what extent is perspectival depth as we would expect in a naturalistic setting? Have some sounds been foregrounded?
- *Vibrato*: Have the degrees of fluctuation or vibrato been reduced or exaggerated?
- *Friction*: Have degrees of friction been reduced or exaggerated in order to decrease or increase the sense of dirt or purity?
- *Reverb*: Has reverb been added or is there a reduced sense of space?
- *Directionality*: Is it possible to establish the origins of sounds?

Finally, we can ask which of the three modalities the sound communicates. Is a sound naturalistic, abstract or sensory?

9 Analysing Music in Video and Television

This chapter brings together the tools developed over the preceding chapters to analyse the use of music and sound in different genres of video. The aim, drawing on these tools, and on Halliday's (1978) work on clause relations in language, is to transcribe videos in a way that allows us to best describe and analyse the way that sound, image and word work together *multimodally*, to show how they interrelate to form a single communicative act. For example, over previous chapters it has been shown that we can consider the levels of modality found in the different communicative modes. We ask in the following analyses how these are the same or different in each mode. The same is done for the kinds of iconographic meanings carried by image, word and sound. Through these observations we can then consider how each mode helps to elaborate, extend or enhance meanings.

The first part of the chapter compares two music videos: 'The Scientist' by Coldplay and 'London Calling' by The Clash. The second compares the use of music and sound in two pieces of TV drama: *ER* and *Sex and the City*. In each case we look at how music, and particularly sound quality and modalities, can be used to communicate broader discourses not necessarily articulated visually. As we saw in our analysis of a Hollywood blockbuster in the previous chapter, sound can also be an important way of signalling something of the modality of the fictional world created for us. In other words, it allows us to anticipate what kind of rules apply, how much like our world, or aspects of our everyday lives, is this TV world? To what extent is it less than real or more than real?

For each of the film clips we describe the scenes and cuts in the left-hand column, the sounds and music in the middle and the actual spoken/sung words in the right-hand column. Each follows with a discussion of the way each mode communicates alone and with the other two modes where we consider both visual and sound modality, sound qualities, arrangements and melodies.

Coldplay: 'The Scientist'

Video	Melody and sound qualities	Lyrics
Begin in extreme close-up of singer's face with camera panning out to reveal he is lying on a torn mattress with his arm curled above him around his head in 'musing' pose. He is brightly yet softly lit.	We hear no diagetic sounds throughout the song. Arrangement piano with voice foregrounded. Hifi where singer almost speaks to give sense of intimacy. Voice has some raspiness but no tension. Piano is played slowly and thoughtfully with emphasised chords. There are minor and major chords.	Come up to meet ya, tell you I'm sorry You don't know how lovely you are
Cross-dissolve (gives sense of melting or dreamy, particularly of hot, warm air on a summer afternoon) cut continuing to pan out, we see mattress lies on paving slabs which contain graffiti.		I (on dissolve in) had to find you, tell you I need ya And tell you I set you apart
Cross-dissolve cut to close-up of singer. Camera is now at singer's side and is panning away from him swinging to his left. A graffiti-covered wall is revealed and he begins to move oddly (as if it is all filmed in reverse). As camera pans out we see it is an inner-city setting in a deprived area. A BMX cyclist rides past behind him (in reverse). It appears to be a recreation ground. He jumps to his feet and places his right hand on his left arm which hangs down straight. This gives a sense of musing and sensuality again.		Tell (on dissolve in) me your secrets, and nurse me your questions Oh let's go back to the start

Video	Melody and sound qualities	Lyrics
Cut to similar but slightly different angle to the front of him. We see the graffiti-covered building. It looks pleasant and sunny rather than bleak and dangerous. Camera pans back until he is in medium shot.		Running in circles, coming in tails
Cut to medium close shot of singer's upper body against bright summer sky. It is slightly washed out with sunlight. Camera circles him as he stands with his hand still on his arm. We see bright sky and tree tops behind him.	Gradual emerging of synthesiser playing sustained chords behind piano. Soft and warm sound.	Heads on a science apart
Cut to BMX cyclist spinning around in front of graffitied wall and barbed wire-topped railings.		
Cross-dissolve cut to singer's face and upper body in close shot. He walks backwards down a street lined with shops that appears to be typical of London. We see the backs of people as they pass him.	Voice increases in pitch, with some raspiness.	Nobody said it was easy It's such a shame for us to part (on dissolve)
Cross-dissolve to him jumping over a wall. Behind we see London council flats, trees and bright sky.		Nobody said
Cross-dissolve to him walking backwards down shopping street. He stops to stand next to a launderette where there is graffiti on the wall.		it was easy No one ever said it would be this hard (on dissolve)

(Continued)

Video	Melody and sound qualities	Lyrics
Cross-dissolve to a low angle shot of his feet walking through fallen leaves. Camera pans up and we see him jump another wall. In background we see a graffitied inner-city railway bridge.		Oh take me back to the
Cut to youths playing basketball, Bronx style, under railway bridge in slow motion in medium shot.	Light, thoughtful medium-pitched acoustic guitar strumming with mainly major but some minor chords starts alongside piano.	Start
Cut to longer shot if youth throwing at basket in normal motion.	Guitar and piano continues.	
Cut to similar view with ball bouncing off wall.		
Cut to closer shot of action, now again in slow motion with singer walking past behind them.	Guitar and piano continues – light beat begins.	

Video

Visually we find an iconography of inner-city London. There are rundown recreation areas, BMX culture and basketball under the railway bridge. Yet the modality of this is lowered with slightly increased tones and reduced colour modulations – simple manipulations with video-editing software. We see the singer's face at the start in high definition. In the vocabulary of Kress and van Leeuwen (1996) we would say that since details are enhanced, it is more than real and moves into the realm of sensory modality. We also find the use of slow motion and cross-dissolve cuts which offer a sense of melting and emotions and also of timelessness. The slow motion gives our eye extra time to dwell on the details of scenes which also therefore creates a sensory experience.

The initial poses of the singer also carry important iconographic meanings. He is found lying in a sensual musing pose with his arms curved around him. He then stands, holding his arm across his body,

still touching himself indicating sensitivity. We would not expect a tough guy in an action movie to strike such a pose.

Sound

The video footage of the cityscape, with its graffiti and street basketball, bring connotations of authenticity. Yet we hear no sounds of this urban setting such as dogs barking, police sirens or heavy traffic. In terms of diegetic sounds there is only the singer mouthing the words. We see no instruments being played. We could imagine that even if we did hear the sounds of children playing that in this video this would be highly idealised, rather than characteristic of actual urban sounds.

Music

A gentle but thoughtfully played piano with some slight weight on the way the notes are played dominates this piece. There is space between the chords suggesting musing and lack of hurry in the manner of the cross-dissolves represented by the edits. Behind the piano we hear a soft synthesiser bringing a white noise to the song, suggesting intimacy. Later an acoustic guitar is introduced played in the same manner as the piano: lightly yet with some emotional connection. The three instruments – piano, synth and guitar – almost merge playing in unison. This creates a sense of harmony and unity in the band and wholeness to the song. The vocals follow the rhythm created by the instruments completely. The lines of the verse also align with the cuts in the video, with each line being followed by a cut. The voice itself is soft and intimate with some breathiness, suggesting sensuality. There is no reverb, and therefore nothing lonely or magnificent being communicated. At times there is considerable raspiness in the singer's voice. On the one hand, this creates a sense of pure voice, with some contamination, but also suggests some tension through the closing of the throat. He is relaxed and intimate with some emotional power. But because volume remains low this remains a gentle outpouring of emotion.

The melody is as follows and is sung in a minor key:

Come up to meet ya, tell you I'm sor---ry
min ↑ 4 ↓ min3 ↑ min7 ↓ 5 ↓ min3 ↑ 4 ↓ min3 ↑ min7 ↓5 ↓

You don't know how lov-----ely you ar-----------e
min3 ↑ 4 ↓ min3 ↑ 5 → 5 → 5 →5 ↓ 5 ↓ 4 ↓ min3

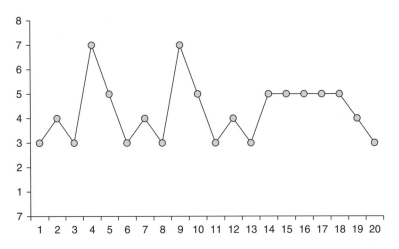

Figure 9.1 'The Scientist' melody

The song starts on the minor 3rd bringing slight pain to the melody, although it moves between this note and the building note the 4th. This creates a sense of moving forwards and of promise. The first three notes remain in a restricted pitch range here suggesting relaxation. After this it ascends dramatically to a mournful minor 7th note, expressing an outpouring of emotion. Also in fact the notes are from a major chord, F major, which is in the key of D minor. Therefore the intervals played have a major effect as well as being in the minor key. This helps to create a sense of warmth and an element of pain. As can be seen from the chart above, the melody is bursts of stasis and leaps of emotion. This creates the effect him bursting with contained emotional energy. But then at the end of the line this gradually relaxes down to the starting point. This communicates that he is quite easy going about all of this.

Lyrics

The lyrics of this song have a discourse schema where a relationship has ended and the narrator laments and reflects. We know nothing of what went wrong or anything of his partner. This is a love song characteristic of early love songs described by Carey (1969) and very much like his example of Johnny Cash's 'As Long as I Live' (1955) where the man simply remembers the wonderful woman, who we learn little about. It was only later that women began to take on more complex characters. The chorus of 'The Scientist', however, is more akin to that of 'Some Might Say', by Oasis. Here are three of the lines:

I was just guessing at numbers and figures
Pulling the puzzles apart
Questions of science, science and progress

We could interpret this as the singer/narrator considering their relationship as a series of puzzles which is a theme not unfamiliar in love songs. On the other hand, it allows what is basically a standard love song attain a sense of profundity.

The title of the song itself is 'The Scientist', which helps bring a greater sense of intrigue. We might imagine that a boy band would use a title such as 'Puzzle Over You' or 'Back to the Start' to such a song. For Coldplay it is important to maintain a sense of speaking to a more grown-up market. In fact a range of rock critics have expressed irritation as to the degree that Coldplay seem to be so carefully designed for a specific market.

In summary, the visuals connote discourses of urban credibility and authenticity yet are represented in lower modality, or sensory modality, through lighting, focus and edits. In this setting the singer is comfortable and dreamy, but this is also because he is brimming with emotion, as is indicated by the alternation of stasis and movement in the melody. The instruments play lightly yet firmly with lots of space, suggesting thoughtfulness and gentle emotion using some minor notes to suggest a hint of pain. The vocal melody uses painful notes and building notes and both restricted and expressive pitch ranges with some outpouring of emotion. Voice is soft with some tension. The music on the whole creates a hifi soundscape. The whole has a repetitive arrangement with vocal lines following repeating melodies following the rhythm and where instruments merge into the field. The use of minor notes with softness and voice tension seem to make the difference between this song and one a boy band might produce.

The relationship of sound and video

In the previous chapter we considered the way that music contributes to film action, setting, character and continuity. One fundamental rule was that the music should go largely unnoticed. In the case of pop video, of course, this will not be the case; the very point is that the video adds to the music. So what can we say about the relationship between the two modes in the case of 'The Scientist'?

In the case of *Cliffhanger*, discussed in the previous chapter, the music represented the mood we were to feel in the setting and towards the characters, one of adventure and wonder. In 'The Scientist' the music could be said to have the same relationship to the urban scene where we are to experience it through a mood of relaxed romance. The difference would be that, in *Cliffhanger*, in contrast to 'The Scientist', there were some naturalistic and abstract sounds, such as the sound of the flare, helicopter and climbing equipment. In 'The Scientist' we hear only the music. This of course changes our

experience of this urban setting from if we saw it with naturalistic sounds of people shouting and heavy traffic. So we are in the authentic urban setting, yet feeling relaxed rather than threatened. The same scenes could have been used in a rap video to create a very different mood of the menace of the inner city. Importantly, in this way the urban environment can in turn influence the meaning of the song itself.

Clearly we can see that meaning is spreading two ways here as the two modes work as a single communicative act. In fact we could argue that in movies too visuals can offer meaning to music that we hear. So we hear a particular song while we see images of a gritty urban setting populated by very attractive-looking actors. This can help to suggest that the song has cooler connotations. What we need is a way to break down this process of the exchange and building of meaning. We can find inspiration as to how this can be done in the work of clause relations in language (Halliday, 1985).

Baldry and Thibault (2006: 235) have drawn on Halliday's (1985: 202–19) account of the way that clauses follow on from each other to think about the way that video edits are related, that subsequent shots or edits in film can build those before them in different ways. This model can also be used to characterise the relationship of video and music. Halliday listed three ways in which clauses can expand on previous clauses: elaboration, extension and enhancement:

- *Elaboration* restates, providing equivalent information. So in a video we may see a scene of a man lying on a mattress then we see him from a different angle. We see the same thing slightly differently, learning no more about it.
- *Extension* adds or varies the meaning of the first clause by providing extra information. So we see a shot of a man lying on a mattress daydreaming and in the next shot we see that it is in front of a wall covered in graffiti. The meaning of lying down and daydreaming is modified.
- *Enhancement* is where circumstantial information that is relevant to the first clause is given in the following clause. So this is to do with time, place, condition etc. So we have a clip of a man lying on a mattress, we find it is a mild summer's day and in a city.

These concepts are useful for helping us to draw out the relationship between music/sound and video. In *Cliffhanger*, when we hear the noise of the helicopter, this can be described as elaboration. There is no new information; only a different perspective provided by the visuals.

In *Cliffhanger* the music that sets the mood for the mountain scenes can be seen rather as extension. We see the mountains and

people, but then are given additional information by the music that informs us that something is about to happen. The music also provides enhancement as it tells us about the place they are in and the condition and mood of the characters.

In the case of 'The Scientist' video the relationship of music to setting is not one of restating as it changes how we perceive the city, as does the modality of the style of shooting. There is some extension as it provides extra information about the setting, that it is pleasant. And there is enhancement as we are told about the mood of the place: inner-city London is a pleasant place to daydream on a summer's day.

But this analysis assumes that music brings meaning to the setting and action. In pop, video is normally a support to the music.

In 'The Scientist' we first hear the piano and the singer, seeing only his face in close up. Here meaning is created mainly through the sounds, style of voice, and the soft focus and high definition. We then see he is on a torn mattress and then in an urban setting. This provides extension to the meaning of the artist. As the camera pans out to show further scenes the meaning is elaborated. We find it is a torn mattress, it is in an inner-city park, etc. This is developed enhancing the identity of the artist. He is in a cool urban setting with youths playing basketball. This is not simply another love song but one performed by an artist with inner-city chic. The meaning of this is elaborated as the edits develop. The images also provide extension of meaning to the music as it becomes something that has its identity through this kind of urban chic. We could imagine the change in meaning were the music played over a typical boy band video where the artists perform a simple choreographed dance in a studio setting. This extension of meaning continues as the singer walks epically in slow motion touching himself gently.

From this analysis we can draw out the way that the two modes work together to create meaning. As we will see later in the chapter we find different kinds of relationships in different genres of video.

The Clash: 'London Calling'

Video	Music, sound	Lyrics
Shot of Big Ben clock tower on Houses of Parliament in London looking up at twilight sky.	Silence.	

Video	Music, sound	Lyrics
Cut to shot of band members walking towards and past the camera carrying guitars. It is twilight but there is a bright light coming from the right casting deep shadows. We see railings to the left.	Guitar riff between two chords, one major and one minor. This is a riff that moves only one half note, and therefore is contained. The strumming is sharp, tense and assertive yet controlled. Strings do not ring. The sound is at a fairly high pitch with raspiness. There is a snare drum being hit on the 2nd and 4th beat to sharpen and drive the riff.	
Cut to close shot of foot tapping. We see instrument/ amp cable in the background on the floor. Again a bright light creates contrasts of dark and bright. We see no colour.		
Cut to band member running away from camera against railings with bright lights and deep shadows.	Bass guitar bursts into the foreground playing a riff over the guitar riff.	
Cut to two sets of feet tapping to the music, again with bright backlighting creating lots of shadows.		
Cut to band member walking away from camera cradling guitar against his shoulder.	Some open cymbal crashes to emphasise guitar riff.	
Cut to three band members in medium close shot facing each other playing guitars and swinging about to rhythm. Behind them is darkness. They are all dressed in black.		
Cut to feet tapping and them moving to the left.	High pitched snare drum roll.	
Cut to same view of band but slightly higher to see their bodies move left towards microphones to begin singing.	Drum beat joins in to create momentum of slow hesitant movement forwards.	London calling

Video	Music, sound	Lyrics
Cut to longer shot of band from their left face on performing. They are performing on a boat and play facing off its deck. The bright lights belong to the boat. The camera pans in.		to the faraway towns
Cut back to close shot of band facing left although we are now slightly in front of them and see their faces for the first time. A light shines into the camera slightly blinding it.		Now war is declared – and battle come down

Video

This video is a simple one where we see the band arrive at a scene and then perform. Beginning with a shot of Big Ben at the Houses of Parliament we see a number of scenes cast in dark shadows, or washed out with light, of the band setting up and performing on a boat at night. In theatrical fashion anticipation is set up as we do not actually see the band at the start of the video, only dark figures moving past the camera and feet tapping out a rhythm. There are fast edits with short sequences.

The scenes are of high modality in terms of seeing visual details. It is how we would have seen it had we been there. But as a composition its uses of extremes of tone of dark and shadow heavily stylise the film into a noir piece. In our earlier analysis of colour we established that the lack of colour in a composition itself suggests a sense of reserve as opposed to the use of a full colour palette that would suggest liveliness or fun. Here there is certainly no fun. We also found that bright tones can suggest truth and optimism while darker tones express obscurity, the hidden, or darker moods. Here we find extreme darkness and shadows along with painful brightness. While the music of London calling is certainly lively, it is tempered by the dark moods and blinding unkind lights.

While the song is about London, we do not find an inner-city iconography as in the previous example of Coldplay's 'The Scientist'. This video is filmed by the River Thames on a boat. The setting is slightly sleazy and certainly unglamorous, with its lighting and the dark waters. The boat is not a yacht but an everyday working boat connoting something ordinary and everyday about London.

In fact it would be hard to imagine The Clash using an iconography of the clichés of the gritty inner city with them wandering though them, lost in their own thoughts in the manner of Coldplay. Nor would it seem likely to find The Clash in a video shot in bright soft tones with cross-dissolve edits. Clearly a different kind of identity is being communicated by both the iconography and the style of the film.

While commercially successful, The Clash maintained a punk ethos. They were gritty and direct. Punk had no room for gentle emotional musings, and certainly no romanticisation of the inner city. In punk the artists and the fans *were* the inner city. As Hebdige (1979) argued, this music came at a time of a certain kind of disillusionment with what was viewed as a stifling and conservative society. The single shot of Big Ben at the start, at the time, would have signified conservative mainstream society. What is the mainstream, as discussed in Chapter 1, is in many ways a matter of constructing something to stand against and is never really clearly described. Does the mainstream include the society that produces and maintains hospitals, that provides housing benefits and other social welfare, for example? But at the time of punk, out of which The Clash arose, there was a growing questioning of the nature of an unequal society where many young people experienced long periods of unemployment.

The grittiness of the Clash is also reflected in the poses and attitude of the band in the video. They are absorbed by the music, performing for themselves. Punk music had to be seen to have this lack of design or manufacture in its performance and music. Of course this itself is a discourse and does not in itself indicate any greater level of artistic ability or real integrity. But this allows the viewer to put certain meanings into the music. Many of this range of punk connotations have since been drawn upon by other artists. We might find a boy band such as McFly performing physically in the manner of The Clash, although we might find that they combine this with a greater colour palette in their videos to introduce some connotations of playfulnesss and fun.

Sound

As in the Coldplay example we hear no diegetic sounds of the river or of the band setting up. We hear no footsteps when they walk past the camera. We hear no water lapping against the boat. Here the setting is there to give meaning to the sound and needs not provide additional diagetic cues. As with Coldplay such sounds would serve to distract from the song world. The music must control the visuals. The sounds of a boat engine and running water would change the meaning of the setting towards a naturalistic modality. This would distract from its symbolic role.

Music

This piece is dominated by a guitar chord riff that involves a half tone move from minor to major: F minor to E at a relatively high pitch. While it has volume and takes up space it is also very restrained. This is in terms of the short pitch movement and the way that it is played choppily, precisely and assertively with the strings controlled and restricted. There is therefore a strong sense of tension. The bodily movements of the band reflect this as they move jerkily from side to side. The guitar sound is distorted and raspy, suggesting dirt and realism. The riff is repetitive and relentless, suggesting some kind of entrapment.

The piece uses a strong bass line. As Tagg (1994) would say, for a while the ground comes to the fore. The strength of the bass brings a sense of gravity and danger. Drums play a bright bouncing side-to-side beat. This serves to lift the restriction of the guitar riff to something slightly lighter.

The vocal melody line is as follows:

```
London    cal—ling    to     the    far---a--way towns
1 →    1 ↓ min6 ↓ 4 → 4   → 4 ↑ 2→ 2↑ min3 ↓ 2
```

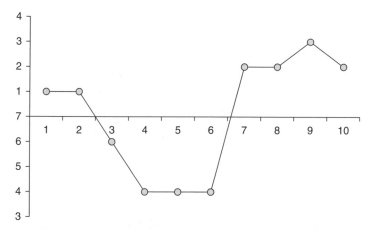

Figure 9.2 'London Calling' melody

This melody covers a wide pitch range of over an octave. It is therefore very emotionally expressive. It begins with descending notes moving through the minor to the building 4th notes. The notes therefore move downwards to gravity and to danger. We could imagine the difference were the words 'LONDON CALLING' to use an ascending melody. In such a case, still using the minor note it would appear more chilling rather than dark. The 4th notes bring a sense of promise of building.

So the call is dark yet exciting. The melody then leaps to the 2nd and minor 3 notes to a phrase with little breadth in pitch. So there is still some pain of the minor 3, although this is mixed with use of the 2nd note that gives a sense of something about to happen. That the line ends on this note promises more to come. It is a story to be told.

The voice is raspy and uses both low volumes and breathiness to suggest confiding and higher volumes of shouting to express emotion. The phrasing of the lines involves abrupt endings. So the word 'towns' covers only one beat, with rapid decay. These shorter abrupt phrasings are associated by linguists with certainty and with authority, as used by newsreaders. We could imagine the opposite where a jazz singer might linger on the word 'towns' to suggest emotional expression. In contrast here with The Clash there is a lack of emotional indulgence and a sense of urgency.

As for arrangement the voice is in the figure, although the bass comes out at the start playing notes of the minor chord to give a sense of weight to the pain. There is vocal backing although voices remain distinct. There is a mixture of lofi and hifi soundscapes. Instruments can be heard distinctly along with the almost spoken lyrics, but then this shifts towards lofi in moments of emotion. Unlike some of the punk acts that used complete lofi, the dirty sounds of the modern urban world, The Clash draw also on the communicative style of folk protest songs.

The vocal melody sits strongly with the rhythm. There is therefore a sense of unison and certainty in the song. In jazz music, for example, instruments might play very different parts, each playing with the main melody and rhythm in different ways. In the case of The Clash there is a strong sense of cohesion. But this is not to the extent where the band members are absorbed by it, as is the case in a boy band. We still hear distinct vocals and at different times instruments do step forwards in the arrangement, as does the bass early in the song.

Lyrics

The lyrics of 'London Calling' have no specific discourse schema but comprise a set of connotations about chaos, anarchy and challenging the mainstream. They mention words like 'underworld'. What this means exactly is not specified. As in the fashion of punk they declare themselves to be set apart from regular pop music as in The Beatles. Here is the first verse:

London calling to the faraway towns
Now war is declared – and battle come down
London calling to the underworld
Come out of the cupboard, you boys and girls
London calling, now don't look to us

Phoney Beatlemania has bitten the dust
London calling, see we ain't got no swing
'Cept for the ring of that truncheon thing

The reference to 'that truncheon thing' points to police brutality. And, along with the strikes in the 1980s for many British people there was a strong feeling that the police were indeed simply an arm of the government and unconnected to actual law enforcement.

Later verses of the lyrics point to 'zombies of death' and a 'nuclear era'. Certainly the threat of the use of nuclear weapons up to the end of the Cold War was an important topic at the time. But overall this is a mixture of connotations of irreverence, social criticism and hinting at political issues. But rather than conveying any clear set of ideas this simply allows the artists to suggest that they are indeed political and topical. A fan from a Web blog puts it like this:

> The clash stood for something and played and sang about it. if you don't like them, fine, but you gotta respect them. The fact that they are one of the greatest punk bands ever is just dessert. (http://www.songmeanings.net/songs/view/52876/)

But what exactly did they stand for? As a teenager I was a Clash fan and was certain himself that The Clash somehow represented him. They had other songs like 'I Fought the Law', which suggested rebellion and anarchy. This fitted with my experience of schooling that was extremely alienating and of having watched the government crush local communities through the start of economic policies by Margaret Thatcher and Ronald Reagan that we now know as the shift to the global economy. But what The Clash stood for is not clear. Lyrically they hint at rebellion, although they don't say against what. Musically their music is tense and lively, with stern singing, sometimes confiding and at others yelling angrily. In videos, such as for 'London Calling', we find them cool and slightly mysterious, inhabiting sleazy environments. So the video, sounds and words are littered with connotations of certain discourses.

Another fan states on the same blog;

> The song was written in the late 70's during a heavy depression and hence is very negative London was rebelling in fashion and in music, the clash were in the middle and were echoing the fears of the nation's youth.

Perhaps on the one hand this is the case. The fears of the youth were as unarticulated as those of The Clash. Of course this also raises the issue of 'subcultures' we dealt with in Chapter 1. Was there in fact a collective youth spirit voiced by such punk bands? Or did many of the people who bought Clash albums just like a little dabbling in rebellion by wearing certain clothing and dancing in a particular way?

Nevertheless what we find are all these discourses realised across the different communicative modes even though closer inspection reveals nothing we can really pin down as clearly formed ideas.

Music and video

As in the Coldplay example above we can consider the relationship of the video to the music in terms of Halliday's three categories of clause relation. In other words, how they build up a sense of communication of ideas, moods and overall coherence in relation to each other.

First we see Big Ben. This provides an immediate enhancement on the meaning of the band, as we locate them and the song in the political heart of Britain. We then see a dark night-time river setting with band members setting up in the dark. This provides extension of meaning as we find we are in the sleazy underbelly of the city rather than its tourist sites. This also provides enhancement in terms of the look of the place and the lighting. This is a particular place in London that has particular qualities. This is elaborated throughout the video.

As we see the first riverside scene we hear the guitar riff. This provides extension of meaning as it adds tension and drive. When the riff begins it does not restate any information about Big Ben but communicates a set of ideas and moods through its qualities and therefore provides some extension in terms, of the slightly threatening but lively mood. Different music would have added different meaning to the setting. The appearance of the bass riff both elaborates on this theme, as well as providing some tension but also extends the meaning to bring in greater weight and menace. Since the setting is then given extension of meaning, continually elaborated by the music, this is able to provide enhancement for the meaning of the band.

Summary

The music communicates a slightly dirty and tense mood with the drums raising this up with bouncy rhythm. The bass that appears towards the foreground of the composition creates a sense of weight and importance. The whole is a mixture of hifi as we hear all of the instruments but also lofi with levels of distortion in instruments and voice. The combination creates a sense of more intimate communication and outlet of urban emotion. The setting is London, we are shown only from the sight of Big Ben at the start, presumably by the Thames. The band are presented as direct, slightly mysterious and dedicated to the music. Lyrics are vague but give a sense of political engagement and general disenchantment with society. All this combines to create a kind of punk cool that still engages in the manner of protest songs.

Compare the way that the music, video and lyrics in two pop videos interrelate. Consider:

- Iconography of settings in the video and the lyrics – are they the same?
- Modality of the setting.
- The meaning of the sound qualities in relation to the setting and the lyrics.
- How does the video provide enhancement to the artist?

Sound in TV drama

We now move on to our two examples of sound in TV series: *ER* and *Sex and the City*. Here we are interested primarily in the modalities of the sounds. But we also link these to continuity, mood, action and character, again looking for the way the different modes work together.

ER, episode 1

This clip is from the opening scene of the *ER* series. We simply see a doctor being awoken from sleep in a hospital treatment room to attend to an emergency case where a child has stopped breathing. What is interesting here is the way that sound works through both abstract and sensory modalities to provide elaboration of meaning.

Video	Music and sound quality	Speech
In darkness we see vague outline of someone sleeping. Camera looks obliquely down on her. Door opens, throwing light on woman doctor asleep lying on hospital bed.	Echoing sounds of people rushing about in corridors – abstract and sensory modality as all amplified and also communicate mood of energy and urgency. It also provides enhancement of meaning where we learn about the nature of the setting.	*Woman's voice*: Susan. Susan. Susan. You have to get up. *Susan*: What time is it?
Camera angle lowers so we see past Susan to the nurse who calls and the bright light of the corridor behind her.	Door opens loudly. Noises of voices and telephone ringing abstract and sensory.	*Nurse*: It's a baby. *Susan*: A baby? *Nurse*: In respiratory arrest.

(Continued)

Video	Music and sound quality	Speech
We see people moving behind the nurse in the corridor and she glances around at them. Sarah gets up and leaves the room.	Loud siren sound from ambulance naturalistic but amplified, brought into foreground and therefore abstracted. Modality is reduced as we cannot pinpoint where it comes from. The sounds restate the mood of the pace of life in the hospital. We hear Susan move on sheets – again amplified. High articulation of these sounds, the enhanced friction, increases modality to more than real. This elaborates the level of modality which is highly sensory. Snare drum strikes once and we hear a low pitch menacing synth sound/roar that swirls/flanges. Then a slightly higher pitched synth. Sensory modality as music communicates drama. The music elaborates further on the mood of urgency but also extends by adding meaning by increasing tension.	
Cut to scene of patient on trolley being wheeled along corridor towards camera, through swinging doors by ambulance team, doctors and parents of baby. The camera watches as the trolley weaves through corridors and then turns to our left into the treatment room.	Deep synth sounds, some rasping with a sense of roaring, some light high-pitched clicking percussion creating a tense uneven creeping forward rhythm, pulsing bass notes, deep yet sharp echoing bass drums and some almost explosion-type sounds to signal drama. Sensory modality. Further elaboration. During this music we hear footsteps on corridor floor. There is abstraction here as we hear them louder than we would in real life and we cannot pinpoint origins. But this restates sensory level. Music grows in intensity, as in the fashion where in movies a section of violins would increase tension with a repeated taut high-pitch note. Here it is with sounds of rapid piano notes and higher pitched minor synthesiser chords that come to the fore drowning out much noise except voice of ambulance team giving information. The music grows until we hear nothing else.	*Susan shouts*: Has she been sick? *Voice of father of baby*: No. *Susan*: Any medication? *Voice of father of baby*: No!

Video	Music and sound quality	Speech
	Music stops. Sensory level communicated by the music takes over from the abstract experience of the diagetic sounds.	*Susan*: Any recent trauma? *Voice of father of baby*: No. Nothing!
Cut to medium close shot of parents looking terrified. Out of focus, nurses move busily in and out of shot in close shot.	Sounds of rustling and clicking of equipment and voices. Here there is abstract modality as the essence of hospital sounds are represented. There are stylised sounds in the manner of the medical jargon often spoken by the actors. The pitch of these sounds is heightened to foreground them and their origins are not clear. They connote activity in an abstract sense and also in the sensory manner of 'businesss'. We hear heavy nasal bass notes, played in twos, an abstract representation of a heartbeat, and lighter percussion that begin a rhythmical sequence with uneven cycling rhythm. This suggests uneven momentum along with the passing of time. Percussion uses congas suggesting hypnotic rhythm and a cow bell for tension (sensory) and some glass clinking sounds to represent hospitalness (abstract).	
Cut to shot down treatment table where we see a baby and nurse and doctors looking on.	Music continues and we continue to hear clattering, clicking of medical implements and indistinct voices. All these are foregrounded and are both abstract and highly sensory in modality.	*Voice of mother of baby*: [sobs]. *Nurse*: I think we can't find a vein here.
Close shot of Susan leaning over treatment table. We see parents in background.	Music and sounds continue.	*Susan*: Shh!
Cut to side shot where we watch from behind as Susan examines baby. Camera circles the scene past hospital equipment.	Medium pitch soft synthesiser sound starts up over bass and percussion.	*Susan*: Come on. *Susan*: [grunting with effort].

(Continued)

| Medium close-up of baby that is obscured by out-of-focus figure in close shot. Camera pans up to see concerned faces of busy nurses. | Deep kettle drums strike. Synth sound continues in minor notes as bass and percussion fade into background. Enhancement as circumstances change to a different level of mood, concentration, and graver suspense. We hears sounds of heart rate monitor brought to foreground. | We hear nurse making comments using medical jargon. |

Video

On the one hand, *ER* uses *cinéma vérité* or Direct Cinema camera techniques pioneered in the movies of Edgar Morin, Jean Rouch and Derek Wiseman, respectively. These film makers were interested in representing reality as it was rather than setting up shots that were engineered for later preplanned edited sequences. So, for example, Wiseman filmed in a hospital to show the real goings on. The idea was simply to hang around and film what happened to create a real record of everyday life in the institution. In his footage there were a lot of shaky camera shots and speakers would move in and out of focus as they moved around. There would be long scenes where a person would sit in silence as Wiseman wanted to show everyday boredom and emotional strain. Since this time such techniques have been drawn upon by fiction film makers to signify liveness and immediacy. For example, a director of a Hollywood movie can shoot a scene with a shaking camera following a person who is running away from a pursuer. This has the effect of putting the view there in the scene. They can film conversations in rooms where people move awkwardly out of shot at times to suggest spontaneity and liveness. Such techniques are used with moderation in *ER*, along with other more usual filming techniques. Visually this technique serves to increase a sense of being there, of immediacy and of the viewing position having to react rapidly to changing circumstances, as do the doctors. The sequence transcribed above is all about pace, rapid response and chaos – in the context of which the doctors generally triumph.

However, there are other aspects to the visual that move away from the signified high modality of the Direct Cinema filming style. The footage appears slightly softened yet also sharp at the same time. We were unable to establish exactly how the *ER* production team achieve this but such techniques can easily be achieved in basic film-editing software. One way to do this manually would be to run two copies of the footage simultaneously in synch but to one of them

add a slight gauzian blur and to the other the reduced opacity. By playing around with brightness, contrast and colour it is very simple to create both a look of softness yet also sharp clarity along with a slightly over-exposed feel which is often used in advertising to create a cleaner environment where colours appear less modulated and more saturated.

Of course these techniques move away from the naturalistic modality of Direct Cinema. Modality is reduced in terms of articulation of detail. And the softening effect increases sensory modality.

The scenes in the *ER* clip are all in hospital rooms and we see hospital staff and equipment. But everything is clean, shining and appears to work well. There are no signs of ageing or highly dated equipment or buildings. The drama is clearly not to be based around naturalistic socio-economic issues. Throughout the series there are scenes in car parks and garbage rooms, none of which appear particularly unpleasant.

Sound and music

First we do not hear what we would have heard had we been there as witness. While there is use of filming techniques to create a sense of liveness the sound does not. The foregrounded voices of the actors are naturalistic. But objective reality has receded in terms of sound to the subjective reality of hurry and urgency created by the other sounds. This is done, on the one hand, through the highly textured sounds of hospital implements and machines and noises of people in corridors, telephones ringing and ambulance sirens. We hear amplified, high-pitched footsteps in the corridor to represent fast movement. The duration ranges of the sounds of hospital instruments has been increased. The heightened textures of these creates an abstract modality where sounds are represented in their essence rather than how we would hear them had we been there. Also since they communicate the feeling of hurry and busyness this increases the sensory experiences in the manner of the modality of the footage.

The music uses mainly clicking percussion, high pitched and tense, low nasal bass notes and smooth medium-pitched synthesiser notes. Higher pitches and volumes are used to create moments of tension. They also provide extension of meaning in that the two scenes of the baby in the treatment room are given different meanings. One is ominous and the other making progress, although this progress is by no means certain and may involve further obstacles, as is indicated by the uneven rhythm. Deep nasal bass notes work in twos to abstractly represent heartbeat and to symbolise the gravity and bleakness of the situation. Minor synthesiser notes connote threat and menace using a technological sound to communicate the scientific environment.

Summary

ER uses a combination of film techniques to create a mixture of cues for high modality and liveness, but also lower modalities with softened images. Sound is for the most part abstract in modality, representing the essence of 'hospitalness' and sensory in the way that it represents hurry and activity. These sounds are used for elaboration of the business shown in the visuals, whereas music is used for extension of meaning of the mood of situations and enhancement to communicate about circumstance. Later in the scene above, for example, before we are given any visual, cues the music begins to indicate some success in the procedure.

Sex and the City: Samantha's orgasm 2

This is one scene taken from the series *Sex and the City* which represents a sex scene typical of the programme. Notable here is the limited use of naturalistic sounds.

Video	Music and sound quality	Speech
Close shot of head and shoulders of Samantha. She appears to be in her bedroom in front of a doorway. She takes a deep breath looking slightly frustrated and then wondering what to do. She is making a phone call. She then looks seductive and 'naughty', speaks and then turns to walk out of the room. Camera pans to follow her and our view disappears in the wall.	Rustle of paper. Beeps to indicate telephone call being made. These are naturalistic but abstract in that they have been added to the footage and amplified to suggest telephone 'beepishness'. We hear slight sound of movement as she turns. Music begins with percussion. Bright 4/4 beat with light high-hat cymbal and rim taps accompanied by some kind of twist/shaker percussion.	*VO*: In times of sorrow some people have trouble reaching out. Samantha wasn't one of those people. *Samantha*: Wanna rustle?

Video	Music and sound quality	Speech
Camera pans across from edge of room from right to left – view emerges as if from out of the wall. We see couple having sex in stylised room of the manner of a furnishing catalogue or advertisement. Bright tones, colour-coordinated. This does not appear to be a living space. Camera stops with them in medium shot. There appears to be no emotion.	Percussion continues. No other sounds.	*Samantha*: groans and says 'Keep doing that'. We hear her breathing. We do not hear her partner.
Cut to close-up of her immaculately made-up face as she lies on the pillow. She is smiling but this gradually fades to frustration.	Percussion is joined by riff on saxophones. Not slurs or longer articulation but jumpy. Sound of saxophones is fairly smooth but bouncy and light.	*VO*: But today something was just out of reach.
Cut to camera panning downwards. In foreground (slightly out of focus) are sparkling champagne glasses stored on shelving. Between shelves we see Samantha and partner in medium shot having sex in a different position.	Percussion and riff continue but additional horns play higher pitch. Rapid high-pitch rolls on percussion, on high-pitch congas to suggest some tautness – almost clicking.	*VO*: So they tried another position 299 followed immediately by Samantha's gasps. *Partner, breathily*: Yeah I'm almost there. Samantha and partner both gasp softly.
Cut to Samantha in close shot, upper torso and face. She appears to be on top of her partner.	Xylophone melody. Spaced-out notes at medium pitch, descending. More rapid conga rolls.	*Samantha, breathily*: Just hang on one more second … just one more second …

Video

This is a highly stylised sex scene in a stylised room. In women's lifestyle magazines such as *Cosmopolitan* we find the same kinds of scenes in photographs. Couples are shown in bed sitting on

brilliant-white sheets in their own white undergarments. There will possibly be one other exciting saturated colour which will be used to coordinate a number of carefully placed items. Tones are bright and colours are of slightly low modulation and higher saturation. Machin and Thornborrow (2003, 2006) have discussed the meaning of this lowering of modality. Through this technique sex becomes part of a fantasy world and is more easily connected to the world of lifestyle consumerism and women's agency. This scene from *Sex and the City* is of the same order and uses the same kinds of film-editing techniques to provide softer focus and sharper details described above for *ER*.

We find an iconography of opulent lifestyle. On the shelves we see only champagne glasses. There is little evidence of being in a living space. This is the kind of space we often find in furniture advertisements. The sex between the two characters is itself highly sanitised.

Sound and Music

There is very little diegetic sound apart from the voices of the two actors. Unlike *ER* we do not hear sirens in the street. It is not therefore naturalistic reality. The sex itself is sanitised with no squelches or creaking bed, and the gasps of pleasure are highly dignified and reserved. We hear a few naturalistic sounds such as the telephone keypad, which has been added to the scene so that we are sure what she is doing is providing abstract modality.

The scene is dominated by the music which is in the style of the series' theme tune, which is salsa, connoting fun, energy, sensuality and abandon. There are three main parts to the music. First, we have a section of percussion which begins as we first see the couple having sex. This is a simple 4/4 drum beat with snare at a medium-fast tempo. It suggests a fairly rapid forwards, side-to-side, motion. This is given some added tension by high-pitch clicking rim shots. The beat is clinical as if from a drum machine. Earlier in the book in Chapter 6 we looked at the drum beats used in Britpop. In the case of Blur's 'Parklife' we found a drum beat played with open crashing high-hat. This was much more expressive, untidy and less constrained. Here, in contrast, the beat is synthetic and without depth or resonance. So, like the setting it is tidy and of lowered modality. It is idealised. Nevertheless it brings enhancement to the scene as it gives pace.

Second, we have the saxophone riff. A section of this is as follows:

M3 ↓1 ↑M3 ↓ 2 ↓7 ↑ 1 ↑2

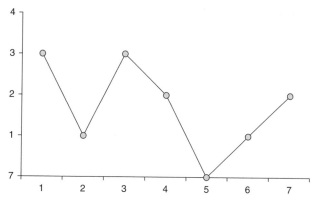

Figure 9.3 Sex and the City saxophone riff

It uses happy major 3rds, 2nd notes which suggest something about to happen and the 7th for some longing. It is played using tight, short, rapid notes in a confined space with repetition. There is much rapid ascending and descending giving a complete back of stasis or measure as can be seen in the chart above. The sax notes have some slight rasp in them as opposed to smoother, softer tonguing as is associated with romantic saxophone style. The rasp creates tension that combines with the urgency of the pace of the motif. In terms of the kinds of instruments and articulation of notes that we discussed in the film chapter, brass instruments are associated with masculinity. The notes are for the most part staccato which is also customary for masculine motifs. Of course, this is appropriate in this scene which is not about emotions or feelings but practical, strategic sex.

The other motif is played on a vibraphone. Here we hear notes played over a wide range but descending:

Sharp 4 ↓ 1 ↓sharp 5th ↓2

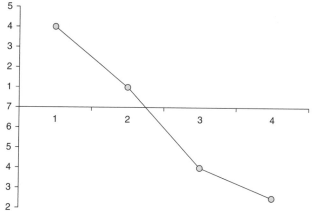

Figure 9.4 Sex and the City descending melody

The vibraphone, in contrast to the sax, creates a light, smooth, delicate tone. Its metal bell-type ringing timbre is much more technological or modernist than the natural sound, for example, of the wooden glockenspiel. The notes move away from the basic scale to create a sense of trouble, although the lightness and pleasantness of the vibraphone sound prevents this from being depressing. It expresses a wide emotional range, falling away extensively. Here we have sensory modality as the enduring nature of the wait for the orgasm is reflected over the faster percussion. The feeling of frustration or waiting is expressed through the music on top of the speed and playfulness of the sex itself as represented visually.

Summary

The scene from *Sex and the City* is shot in low modality. Visually this is the equivalent of a sex version of a furniture advert in terms of tones, colours, and the layout and contents of the room. Sound is used for extension and enhancement. It gives information about mood through pace, tension and unsettled notes rather than smoother articulation. It also communicates idea of modernity through the vibraphone and the synthetic drum beat.

Activity

Listen to two clips of television drama of no more than around 5-10 seconds. Transcribe these as above. Compare the two in terms of:

- Modality of sounds – what is real, exaggerated, removed or symbolised?
- The way that sounds and music are used for elaboration, extension and enhancement.
- The way that the music contains iconic instruments as *ER* used synthesiser sound for technology and bass sounds for drama, whereas *Sex and the City* used saxophone and vibraphone to suggest fun and modernity.
- In what way is sound used to depict place?

Conclusion

An interviewer once asked Michael Jackson about the secret of writing successful hit records such as 'Billie Jean'. Just after his death in summer 2009, the media, after years of vilifying him, were filling their pages and airtime by celebrating the contribution made to music by the 'King of Pop', and sections of this interview were aired to illustrate his 'fragile, troubled genius'. Jackson replied that writing great songs is something you can't do consciously. Rather you have to let the music come by itself. The job of the musician, he said, is to 'Get out of the way of the music'. Only then can truly great music be made.

Jackson's explanation of how to write a hit record goes against all that has been covered in the chapters of this book. He was, of course, drawing on the discourse of authenticity, in the romantic tradition, where creativity comes from some divine source where the composer, the musician, is simply the tool through which the music becomes realised, through which it is born into this world. After Jackson's death many radio stations played his songs between discussions with experts, and phone-ins where callers lamented his passing. Many of his songs sounded very typically '1980s'. Are we to assume then that the divine force, the vibrations of the cosmos, that finds its realisation through these genius composers, changes every decade or so?

From writers in the sociology of music such as Simon Frith, Richard Middleton, Keith Negus and Robert Walser, along with musicologists such as Nick Cook and Lydia Goehr, to name just a few, we now have a clear set of resources that allow us to understand the way that Jackson's talk about his own talent has specific origins in the way our culture has come to think about sounds. We can also understand much of the way these sounds have emerged as part of a multinational industry yet at the same time have allowed us to feel like music and sound say something about us, about who we are. In film studies we have learned much about the uses of music and sound to create narrative, setting and character. But what we know much less about are the precise semiotic resources that underlie particular kinds of music and sounds – that allow them to have such meanings for us; that allow them to communicate particular ideas, values and identities.

Michael Jackson's *Thriller* album was originally reviewed using words such as 'slick', 'harrowing', 'dark messages', 'tense and obsessive

sound'. Connolly, writing in *Rolling Stone* (1983), commented that the record has 'a deeper, if less visceral, emotional urgency than any of his previous work'. Our talk about sound is mostly limited to these vague adjectives. This book has argued that music and sound can be subject to systematic description. We can say exactly what semiotic resources have been used in the music, lyrically and visually. Do we in fact find anything 'harrowing' or 'visceral' in the music of Michael Jackson? In other words, what sounds, sound qualities and arrangements, communicate pain and the more basic emotions and what are the origins and associations of the sound qualities that allow these meanings to realised?

This book follows from the likes of Nick Cook and Simon Frith in the principle that meanings are not so much in the sounds themselves but that we put them there. But it suggests we take this observation one step further to attempt to create an inventory, a code-book or phrase-book, of these meanings as they are found in the semiotic choices made throughout the music, lyrics and look of the artist and in the soundscapes we find in video sequences. All semiotic resources have powers invested in them by us and not in their own right. This book would therefore recommend that we do indeed think carefully about the explanations given by Michael Jackson or any other musician, about why and how they do what they do, and that we do consider the social origins of the kinds of adjectives we use to describe music. But it would urge that we then look for the ways that these ideas are realised in the music and other semiotic modes used by artists. Each individual chapter in this book has shown how we can look for the specific semiotic means by which discourses are expressed. Complex cultural ideas about things like 'freedom', 'togetherness', 'femininity' can be expressed through spoken language, but they can also be realised, communicated, through other semiotic modes, visually, and through sound.

Deryck Cooke, in his book on *The Language of Music,* was committed to the idea of studying the code-book that underlies classical music. He believed strongly that our lack of understanding of music in this way impoverishes our culture, since we deny ourselves the possibility of understanding particular human experiences. He certainly saw music as a kind of language. Of his own book he says:

> It attempts to show that the conception of music as a language capable of expressing certain very definite things is not a romantic aberration, but has been the common unconscious assumption of composers for the past five-and-a-half centuries. It attempts to isolate the various means of expression available to the composer. (1959: xi)

In this book it has been argued that we can take Cooke's project also to the study of popular music and the soundscapes that we find in

video. It has shown that we can study the patterns and rules in the different semiotic modes, creating a picture of how they work together to communicate the ideas, values and identities that comprise broader discourses that constitute the ways we understand the world.

We must understand that all processes of communication are to some extent rule-based, although the nature of these rules can vary immensely. We more readily accept that we can only communicate through language once we have mastered its rules. In traditional semiotics the idea of there being rules or a kind of 'code-book' was important. De Saussure called *langue* the rule-book for language and *parole* its use. The same principle can be applied to music and sound. When we listen to music and sound what we hear is the *parole*, its use in context. What we can do is study instances of *parole* in music and sound – i.e., what we hear on records and soundtracks – in order to be able to describe the *langue*, the system that lies behind it. As was stated right at the start of this book this is not the same as describing the musical notation or chords but rather the sound qualities and their place in soundscapes at the simplest level. We can ask therefore, what is the *langue* of sounds for particular kinds of musical genre? How are these combined and modified? Genius artists are often credited with having their own sound or with pushing the boundaries of music. But how is this so in terms of what we hear? What are the semiotic resources used by Michael Jackson in terms of arrangement, pitch and sound qualities? If indeed, as reviewers suggested, that there was something in the *Thriller* album that pointed to his sense of lack of fit in society, is this indeed reflected in the way that sounds are foregrounded and backgrounded, the unity/disunity of sounds and the relationship of the vocal and instruments to underlying rhythms as was described as being relevant to social belonging in Chapter 6?

We can put all this a different way. The idea of seeking a semiotic rule-book of music may sound like music is nothing more than following rules. But we do not think this of language. Just because we can describe its rules and structures we do not feel oppressed by them when we sit around joking with friends. Our knowledge of grammar does not stop us from appreciating a novel, nor would we think that studying the way it is put together should somehow diminish or deny our enjoyment of it. This approach to music and sound should not therefore so much be seen in the first place as being about the rule-book but rather as a study of what can be expressed by the semiotic value of sounds. All the combinations of cultural associations and metaphorical association that the sounds, visuals and words we have looked at in this chapter all create a rich potential for meaning-making. It is this potential and how it is harnessed that we are studying.

Of course how sounds have been analysed in this book, how images and lyrics have been discussed, is to some extent artificial. While there is no neutral way to hear a sound it is true that we generally hear them in specific 'natural' contexts. We rarely sit and study lyrics but rather maybe hear one or two words that catch our attention while we are in a club or round at a friend's place sharing a few drinks. We like to listen to a song that contains a favourite guitar riff while we are getting ready to go out in the morning. It is a combination of place and setting and accumulated associations that give the lyrics or riff their meaning. I personally recall feeling that the lyrics of the British group The Jam were incredibly profound such that I would always listen slightly pained by the sheer weight of the truth that was entering my ears. On leaving school I worked labouring in an engineering plant. It was at that time that I listened to The Jam feeling that they spoke of working-class disillusionment. Years later when I listen again I really wasn't at all so sure what they were talking about. This kind of level of interpretation of music, that is contextual, and can be individual, is of course important, and in Cultural Studies many interesting works have looked at the reception of music (Willis, 1978; Breen, 1991; Straw, 1991; Grossberg, 1992; DeNora, 2000; Harris, 2000; Weinstein, 2000; Bennett and Peterson, 2004). But as with language the use of semiotic resources can be described and it should be clear from this book that there are patterns and conventions in sound and music. And the kinds of semiotic rules described in this book should certainly be used as one component in projects where reception and uses of sounds and visuals are also important. But above all, this book should be used to open our ears and eyes to the wonderful profusion of semiotic production that is this thing we call music. It should be used to show precisely that musicians do not 'get out of the way of the music' but that they are skilful users of semiotic resources with a keen sense of how to use them in specific social contexts. Studying this process is to create an inventory of how these resources have been used historically, how they are now used and how they may become future resources. As societies change, new semiotic resources, and new ways of using the old ones, are needed. The use of every semiotic resource was once fresh and innovative and a phrase-book of popular music should be able to celebrate this rather than being seen as simply a way to reduce music to its nuts and bolts.

Glossary

Arrangement This is the way that instruments, vocals and sounds are organised into one 'soundscape'. They can be foregrounded or backgrounded to construct our 'point of view'. In a soundscape the most foregrounded sound can be thought of as the *'figure'*, which is the 'focus of interest'; those sounds that are placed in the *'ground'* for the 'setting or context'; and *'field'* for the place where observation takes place. These different sounds will be ranked for us at different levels of importance and we identify primarily with the 'figure' sound. The way that voices and instruments are positioned as closer or more distant from us in a sound mix has important associations with social distance.

Authenticity This is the idea that some music is somehow tied to the soul and comes from the heart as opposed to music that is contrived or of the intellect. This distinction has its origins in the Romantic tradition where creativity came from God. Those musicians who can most draw on certain signifiers of authenticity, however predictable they in fact are, and however contrived, will be thought of as sincere and as producing music from the heart.

Breathiness In singing this can suggest moments of intimacy and sensuality. When we hear a person's breath when they speak this may be a moment of confidentiality as they whisper in our ear, or share their thoughts with us when they are in a moment of emotional strain or euphoria. These kinds of associations can be used in music.

Codal system of music This is the system of music that is understood by people in Western societies. This is why certain kinds of melodies, instruments and sound qualities have come to have quite specific meanings for the people in that culture.

Creativity Creativity is often contrasted to that which is contrived and particularly that which is manufactured. This means that in terms of music the act of creativity is seen to sit uncomfortably with the activities of the corporate record label. In fact it has been argued that what we know as popular music simply would not have developed

without the record companies. The relationship between the two is therefore more complex than the simple opposition held in popular culture.

Diegetic music This is music which can be seen produced in the world represented in a film. Non-diegetic music has been added to the film afterwards and is not part of the represented film world. There are often points where the two merge.

Directionality Here we ask to what extent we can establish the origins of a sound in a movie. Can we tell what the source is or does it seem to be coming from all around? Often this tells us which sounds are representational, those for which we can identify origins, and those that are symbolic or sensory where we cannot.

Discourse Discourses are models of the world that are shared within societies through which people think about and understand events, actions and identities. Discourses need not represent truthfully but simply be versions of how we can understand these things. Importantly these discourses can be signified by their parts. So a whole set of events, actions and identities can be signified by elements associated by any of these. Pop artists can connote particular identities and actions through the clothes they wear and the poses they strike, for example.

Discourse schema This is the 'activity schema' that underlies song lyrics; in other words, what happens in the song at the simplest level. When we break down a song so that we can observe the basis schema we are able to reveal the basic cultural values underlying the song.

Distortion Raspiness in sounds can suggest contamination of the actual tone, or 'worn' and 'dirty'. This raspiness and grittiness can be associated with excitement and aggression as opposed to the well-oiled warm, soft sounds of an acoustic guitar on a folk record. Of course, distortion and raspiness can also mean pure emotion where excitement and tension are not suppressed. Distortion can mean a representation of the modern world as it really is, with dirt, lack of order, chaos.

Dynamic range This is the range of loudness. Is there just one degree of loudness throughout a sound event or many? This can relate to self-expression versus control.

Experiential meaning potential The meaning of sound quality may derive from associations of things in the real world. Our physical environment produces noises all the time. These may be due to

certain qualities of the element that makes the sound or the meaning of that thing in our everyday lives.

Genre We often speak of genres of music. While there does on the surface appear to be kinds of music that share characteristics, that have sounds and look in common, that allow us to speak of musical genre such as rap, it is in reality not possible to find any fixed boundaries that allow us to make any concrete distinctions. For the most part classification is arbitrary. And the role of record companies has been important in defining genres for the purposes of marketing and radio play. Nevertheless it is possible to explore what commonalities we can find across the work and look of artists.

Hifi soundscape This is where all sounds can be heard distinctly. It is like being in a forest where you hear a branch snap somewhere nearby and a rustle of leaves slightly further away. Sounds are not competing. The hifi soundscape is typical of ambient music, or of some kinds of folk music that wish to increase sensual effect. In this kind of soundscape there is no overwhelming background hum. Rather there is a space and calmness that can connote pre-industrial settings.

Iconography This is simply an analysis of the content of images or soundscapes, or the landscape depicted in a text. We often find that certain artists will draw on a particular iconography both in terms of look and sound in order to communicate about their identity.

Lofi soundscape This is typical of our modern cities. There is such a jumble of sounds that we do not really hear any of them distinctly. Heavy rock and any music where sounds of instruments tend to merge can be characterised as lofi. This kind of music is often used to connote industrial or post-industrial settings.

Loudness Loudness relates to power. In society those who have more power are allowed to have themselves heard and make more noise. With existing amplification and recording technology it is not really necessary to shout to be heard, yet many musicians still do so. We can ask what the social meaning of this is.

Mainstream This is often used by people in order to differentiate themselves from an imagined other. Our sense of shared identity is often formed out of oppositional stances towards others. However, the very idea of a mainstream is itself problematic. It is often something proposed by people in order to authenticate their own likes and styles. But what is actually meant by 'the mainstream' is never specified.

Metaphorical association Both images and sounds can have much meaning for us through metaphorical association. A thick, heavy typeface found on an advert suggests something durable and stable through association with thicker objects in the real world. A deeper-sounding guitar will sound more ominous than a bright high-pitched one due to our association with deeper sounds in the natural world. Much of the meaning potential in sounds we examine in this book derive from metaphorical association.

Modality This term has been used to describe the resources in language that we have for expressing degrees of truth; for example, words like 'may', 'must', 'will' or 'perhaps', 'certain' and 'probable'. A high modality statement will be one which will reflect a high degree of certainty, a high degree of connection with naturalistic truth. The same principle can be applied to both visual representations and to sound. In images we can ask if the scene is depicted how we would have seen it had we been there in terms of things like articulation of detail and tonal range. In terms of sound we can also ask if the sound in a movie or on the radio is heard as it would have been had we been there; for example, in terms of reverb, volume, distortion.

Multimodality We can think of some forms of communication, such as a piece of text, as being 'monomodal'. There is only one mode of communication employed: language. In contrast an advertisement that comprises both image and text communicates its message *multimodally* as more than one mode of communication is used: both language and images. In multimodal analysis we can examine the way that different modes of communication work together. In this book we are interested in the workings of three modes: image, sound and word.

Nasality In vocals this can give the impression of reluctance and lack of enthusiasm, and a whining feel. Alternatively, a jazz singer may use soft, warmer open vocals.

Notes on the scale There are eight notes in a scale ranging from 1 to 8, where note 8 is the same as note 1 but a octave higher. These have all been shown to have meaning potentials and uses:

- 1 – anchoring, stable
- 2 – something in between, the promise of something else
- 3 – stable and happy
- Minor 3 – stable but sad or painful
- 4 – building, creating space
- 5 – stable, like the 1st note

- 6 – generally happy like the 3rd
- 7 – slightly thoughtful and longing
- Minor 7 – pain, sadness

There are notes in between some of these notes that are not part of the scale. When used along with the above notes these can create a sense of trouble and unease. They are most commonly found in use in jazz.

Perspectival depth This is the range from there being no background or foregrounded sound to maximum layers. In a movie soundtrack or any soundscape we can listen for the way that certain sounds have been unnaturally foregrounded.

Phrasing Linguists have shown that shorter, sharper phrasing in speech is associated with truth and confidence. We find the same meanings in music, in vocal lines and melodies. Longer lingering phrases are associated with emotional openness.

Pitch This has metaphorical associations of high pitches with optimism and brightness and lower pitches with menace, gloom and foreboding.

Pitch range Melodies with large pitch ranges are associated with emotional expression. Small pitch ranges are associated with emotional restriction or stasis.

Provenance This is simply when a sound comes to have a particular meaning in a particular culture. Pan pipes suggest nature or simple, ancient cultures, especially from Latin America. Such associations may have no actual connection to any real time or place. The point is that associations have become established and whose origins could be discovered. Yet in our own usage these associations will have been forgotten.

Resonance/reverb Echo can be used to suggest space as they are normally experienced in large spaces or massive landscapes. They can therefore be used to suggest something ominous, grand or epic.

Rhythm This is the way that sound is ordered into structured patterns. We can relate different kinds of rhythm to different kinds of physical movement, particularly walking: jerky, smooth, stamping, skipping.

Semiotics of sound This is the study of the meanings of sound types, qualities and arrangements. Sounds in this approach are

treated not unlike words as having arbitrary meanings that have been established in a particular culture.

Sensory modality sounds Here the sound does not represent a thing such as romance or horror or fun but rather is produced in order to seduce, scare or make you feel happy.

Soundscape This refers the entirety of the qualities that comprise what we hear, the kinds of sounds, how they are arranged. When we sit in a room we are positioned in a soundscape and able to hear sounds that are closer and further away. If we live in a busy city these sounds will create a different kind of soundscape than if we live in the countryside. A piece of music and a film soundtrack also create soundscapes.

Subcultures This is the idea that those who follow a particular kind of music form a subculture, for example 'punks'. However, it seems to be more often the case that simply some people like to have a particular haircut or wear a particular jacket as it is 'cool' or has 'cultural capital' rather than being part of an identifiable subculture. Music and clothes can be seen as markers of distinction and status. Of course, this can involve an extremely conformist seeking of acceptance and status, realised in the first place though acts of consumption.

Tension in sound This ranges from the very tense to the more relaxed sound of the wide open throat, but the same can be suggested by the manner in which an instrument is played. Are guitar strings allowed to ring out or tightly restricted, for example?

Unison Where instruments and voices work in *unison,* where they have the same volume and play the same notes, metaphorically, this can indicate social cohesion. Where instruments all work together, where voices sing in complete harmony, they represent themselves as one unit. Alternatively there can be foregrounding, or voices can be individualised to some degree, through volume or sound quality.

Vibrato This is when a sound wavers in pitch. Metaphorically it relates to our physical experience of trembling. The meaning of vibrato will depend on its speed, depth and regularity. High regularity might suggest something mechanical or alien. Increasing and decreasing vibrato is common in movies to create romantic moods, indicating increasing and decreasing levels of emotion. Absence of vibrato can suggest constancy, forward moving and steady or free of emotion.

References

Adorno, T. and Horkheimer, M. (1979) *Dialectic of Enlightenment*. London: Verso.

Arnhiem, R. (1969) *Visual Thinking*. Berkeley, CA: University of California Press.

Bakhtin, M.M. ([1930]1981) *The Dialogic Imagination: Four Essays*, ed. M. Holquist, trans. C. Emerson and M. Holquist. Austin, TX and London: University of Texas University.

Baldry, A. and Thibault, P.J. (2006) *Multimodal Transcription and Text Analysis*. London: Equinox.

Barthes, R. (1973) *Mythologies*. London: Paladin.

Barthes, R. (1977) *Image/Music/Text*, trans. S. Heath. New York: Noonday.

Becker, H. (1974) 'Art as collective action', *American Sociological Review*, 39 (16): 767–76.

Becker, H. (1976) 'Art worlds and social types', in R. Peterson (ed.), *The Production of Culture*. London: Sage. pp. 41–56.

Bennett, A. and Peterson, R.A. (eds) (2004) *Music Scenes: Local, Trans-Local and the Virtual*. Nashville, TN: Vanderbilt University Press.

Bourdieu, P. (1986) *Distinction: A Social Critique of the Judgement of Taste*. London: Routledge.

Brazil, D., Coulthard, M. and Johns, C. (1980) *Discourse Intonation and Language Teaching*. London: Longman Higher Education.

Breen, M. (1991) 'A stairway to heaven or a highway to hell? Heavy metal rock music in the 1990s', *Cultural Studies*, 5 (2): 191–203.

Brown, R.S. (1994) *Overtones and Undertones – Reading Film Music*. Berkeley, CA: University of California Press.

Bruner, J. (1990) *Acts of Meaning*. Cambridge, MA: Harvard University Press.

Buhler, J. (2001) 'Analytical and interpretive approaches to film music (II): interpreting interactions of music and film' in K.J. Donnelly (ed.), *Film Music: An Anthology of Critical Essays*. Edinburgh: Edinburgh University Press. p. 39–61.

Burke, K. (1969) *Rhetoric of Motives*. Berkeley, CA: University of California Press.

Carey, J.T. (1969) 'Changing courtship patterns in the popular song', *American Journal of Sociology*, 74 (6): 720–31.

Chaney, D. (1996) *Lifestyles*. London: Routledge.

Chapman, M. (1996) 'Thoughts on Celtic music', in M. Stokes (ed.), *Ethnicity, Identity and Music: The Musical Construction of Space*. Oxford: Berg. pp. 29–44.

Chapple, S. and Garofalo, R. (1977) *Rock n Roll is Here to Pay: The History and Politics of the Music Industry*. Chicago: Nelson Hall.

Clarke, G. (1990) 'Defending ski jumpers: a critique of theories of youth subcultures', in S. Frith and A. Goodwin (eds), *On Record: Rock, Pop and the Written Word*. London: Routledge. pp. 81–96.

Connelly, C. (1983) Review of Thriller, Rolling Stone magazine (http://www.rollingstone.com/artists/michaeljackson/albums/album/303823/review/6067536/thriller).

Cook, N. (1990) *Music, Imagination and Culture*. Oxford: Clarendon Press.

Cook, N. (1998) *Music: A Very Short Introduction*. Oxford: Oxford University Press.

Cooke, D. (1959) *The Language of Music*. Oxford: Clarendon Paperbacks.

Cooper , G.W. and Meyer, L.B. (1960) *The Rhythmic Structure of Music*. Chicago. University of Chicago Press.

Cutler, C. (2000) "Chanter en yaourt": pop music and language choice in france', *Popular Music and Society*, 24 (3): 117–34.

DeNora, T. (2000) *Music in Everyday Life*. Cambridge: Cambridge University Press.

Doyle, P. (2006) *Echo and Reverb: Fabricating Space in Popular Music Recording, 1900–1960*. Middletown, CT: Wesleyan University Press.

Fabb, N. (1997) *Linguistics and Literature: Language in the Verbal Arts of the World*. Oxford: Blackwell.

Fairclough, N. (2000) *Analysing Discourse*. London: Routledge.

Foucault, M. (1978) *Discipline and Punish: The Birth of the Prison,* trans. A. Sheridan. New York: Pantheon.

Frith, S. (1983) *Sound Effects: Youth, Leisure and the Politics of Rock 'n' Roll*. London: Constable.

Frith, S. (1984) 'Mood music', *Screen*, 25 (3): 78–89.

Frith, S. (1987) 'The industrialization of Popular Music', in J. Lull (ed.), *Popular Music and Communication*. London: Sage. p. 53–79.

Frith, S. (1996) *Performing Rites: On the Value of Popular Music.* Cambridge, MA: Harvard University Press.

Gage, J. (1993) *Color and Culture: Practice and Meaning from Antiquity to Abstraction*. Boston, MA: Little, Brown.

George, N. (1988) *The Death of Rhythm and Blues*. New York: Pantheon.

Gilroy, P. (1994) *Small Acts: Thoughts on the Politics of Black Cultures*. London: Serpent's Tail.

Goehr, L. (2007) The Imaginary Museum of Musical Works: An Essay in the Philosophy of Music. Oxford: Oxford University Press.

Gorbman, C. (1987) *Unheard Melodies – Narrative Film Music*. London: BFI.

Grossberg, L. (1992) *We Gotta Get Out of This Place: Popular Conservatism and Postmodern Culture*. London: Routledge.

Hagen, E. (1971) *Scoring for Films*. New York: Criterion Books.

Halliday, M.A.K. (1978) *Language as Social Semiotic: The Social Interpretation of Language and Meaning*. Baltimore, MA: University Park Press.

Halliday, M.A.K. (1985) *An Introduction to Functional Grammar*. London: Arnold.

Hanslick, E. (1957) *The Beautiful in Music,* trans. G. Cohen, edited, with an introduction, by M. Weitz. New York: Liberal Arts Press.

Harker, D. (1980) *One for the Money: Politics and Popular Song.* London: Hutchinson.

Harris, K. (2000) '"Roots?" The relationship between the global and the local within the extreme metal scene', *Popular Music,* 19 (1): 13–30.

Hebdige, D. (1979) *Subculture: The Meaning of Style.* London: Routledge.

Hesmondhalgh, D. (1995) 'Is this what you call change? Post-Fordism, flexibility and the cultural industries', in W. Straw, R. Johnson and P. Friedlander (eds), *Popular Music: Identity and Style.* Montreal: Centre for Research into Canadian Cultural Industries. pp. 141–7.

Hibbett, R. (2005) 'What is indie rock?', *Popular Music and Society,* 28 (1): 55–77.

Hodge, R. and Kress, G. (1988) *Social Semiotics.* London: Polity Press.

Hodge, R. and Kress, G. (1989) *Language as Ideology.* London: Routledge.

Horton, D. (1957) 'The dialogue of courtship in popular songs', *American Journal of Sociology,* 62 (6): 569–78.

Hsu, H. (2005) 'Look back in anger', *The Village Voice* (http://villagevoice.com).

Hutnyk, J. (2000) *Critique of Exotica: Music, Politics and the Culture Industry.* London: Pluto Press.

Iedema, R. (2001) 'Analysing film and television: a social semiotic account of Hospital: an unhealthy business', in T. van Leeuwen and C. Jewitt Carey (eds), *Handbook of Visual Analysis.* London: Sage. pp. 183–206.

Iedema, R.A. (2003) 'Multimodality, resemiotization: Extending the analysis of discourse as multi-semiotic practice', *Visual Communication,* 2 (1): 29–57.

Itten, J. (1974) *The Art of Color: The Subjective Experience and Objective Rationale of Color.* New York: Van Nostrand Reinhold.

Jewitt, C. and Oyama, R. (2001) 'Visual meaning: a social semiotic approach', in T. van Leeuwen and C. Jewitt (eds), *Handbook of Visual Analysis.* London: Sage. pp. 134–56.

Kandinsky, W. (1977) *Concerning the Spiritual in Art.* New York: Dover Publications.

Kassabian, A. (2001) *Hearing Film: Tracking Identification in Contemporary Hollywood Film Music.* London: Routledge.

Kofsky, J. (1970) *John Coltrane and the Jazz Revolution of the 1960s.* New York: Pathfinder Press.

Kress, G. and van Leeuwen, T. (1996) *Reading Images: The Grammar of Visual Design.* London: Routledge.

Kress, G. and van Leeuwen, T. (2001) *Multimodal Discourse.* London: Arnold.

Kress, G. and van Leeuwen, T. (2002) 'Colour as a semiotic mode: notes for a grammar of colour', *Visual Communication,* 1 (3): 343–68.

Kruse, H. (1993) 'Subcultural identity in Alternative Music Culture', *Popular Music,* 12 (1): 33–42.

Laing, D. (1985) *One Chord Wonders: Power and Meaning in Punk Rock.* Milton Keynes: Open University Press.

Lakoff, M. and Johnson, M. (1980) *Metaphors We Live By.* Chicago: University of Chicago Press.

Lang, P.H. (1972) `Musical thought of the Baroque: The doctrine of temperaments and affections', in William Hays, (ed) *Twentieth-Century Views of Musical History*, New York: Scribner. p. 195. Citing from Athanasius Kircher (1602–1680) *Musurgia Universalis*, ex typographia Haeredum Francisci. Corbelletti, 1650. Item held in the Henley Parish Collection, University of Reading Library Special Collections.

Lee, S. (1995) 'Re-examining the concept of the 'independent record company: the case of Wax Trax! records', *Popular Music,* 14 (1): 13–31.

Lévi-Strauss, C. (1966) *The Savage Mind.* Chicago: University of Chicago Press.

Lévi-Strauss, C. (1967) 'The story of Asdiwal', in E. Leach (ed.), *The Structural Study of Myth and Totemism.* London: Tavistock. pp. 1–47.

Levitin, D.J. (2006) *Your Brain on Music.* London: Atlantic Books.

Liberman, M. and Prince, A. (1977) 'On stress and linguistic rhythm', *Linguistic Inquiry*, 8 249–336.

Lomax, A. (1968) *Folk Song Style and Culture.* New Brunswick, NJ: Transaction Books.

Low, S.M. and Lawrence-Zúñiga, D. (2003) *The Anthropology of Space and Place: Locating Culture.* Oxford: Blackwell.

Machin, D. and Thornborrow, J. (2003) 'Branding and discourse: the case of *Cosmopolitan*', *Discourse and Society*, 14 (4): 453–506.

Machin, D. and Thornborrow, J. (2006) 'Lifestyle and the depoliticisation of agency: sex as power in women's magazines', *Social Semiotics,* 16 (1): 173–88.

Machin, D. and van Leeuwen, T. (2007) *Global Media Discourse.* London: Routledge.

Manvell, R. and Huntley, J. (1957) *The Technique of Film Music.* London: Focal Press.

McClary, S. (1991) *Feminine Endings – Music, Gender and Sexuality.* Minneapolis, MN: University of Minnesota Press.

McClary, S. and Walser, R. (1990) 'Start making sense' in S. Frith and A. Goodwin (eds), *On Record: Rock, Pop and the Written Word.* London: Pantheon. pp. 277–92.

McConnell-Ginet, S. (1988) 'Language and gender', in F. Newmeyer (ed.), *Linguistics: The Cambridge Survey. Vol. IV, Language: The Sociocultural Context.* New York: Cambridge University Press. pp. 75–99.

Mera, M. (2002) 'Is funny music funny? Contexts and case studies in film music humor', *Journal of Popular Music Studies*, 14: 91–113.

Middleton, R. (1984) *Music and Markets.* Cambridge: Cambridge University Press.

Middleton, R. (1990) *Studying Popular Music.* Milton Keynes: Open University Press.

Murphey, T. (1992) *Music and Song. Resource Books for Teachers.* Oxford: Oxford University Press.

Negus, K. (1992) *Producing Pop: Culture and Conflict in the Music Industry.* London: Arnold.

Negus, K. (1996) *Popular Music in Theory*. London: Polity Press.

Panofsky, E. (1970) *Studies in Iconology*. Oxford: Oxford University Press.

Panofsky, E. (1972) *Perspectives as Symbolic Form*. New York: Zone Books.

Pinker, S. (1997) *How the Mind Works*. New York: W.W. Norton.

Propp, V. (1968) *Morphology of the Folk Tale*. Austin, TX: University of Texas Press.

Richardson, J. (2007) *Analysing Newspapers*. Basingstoke: Palgrave Macmillan.

Saussure, F. de ([1916] 1974) *Course in General Linguistics*, trans. W. Baskin. London: Fontana/Collins.

Schafer, R.M. (1977) *The Tuning of the World*. Toronto: McClelland & Stewart.

Schenker, H. (1979) *Free Composition*, trans. and ed. E. Oster. New York: Longman.

Seeger, C. (1977) *Studies in Musicology, 1935–1975*. Berkeley, CA: University of California Press.

Shepherd, J. (1991) *Music as Social Text*. Cambridge: Polity press.

Shepherd, J., Virden, P., Vulliamy, G. and Wishart, T. (1977) *Whose Music – A Sociology of Musical Languages*. New Brunswick, NJ: Transaction Books.

Simpson, P. (2004) *Stylistics: A Resource Book for Students*. London: Routledge.

Straw, W. (1991) 'Systems of articulation, logics of change: communities and scenes in popular music', *Cultural Studies*, 53: 368–88.

Tagg, P. (1982) 'Nature as a Musical mood category', Norden's working paper series (http://www.tagg.org/articles/xpdfs/nature.pdf).

Tagg, P. (1984) 'Understanding musical time Sense', in *Tvarspel – Festskrift for Jan Ling (50 år)*. Göteborg: Skriften fran Musikvetenskapliga Institutionen (http://www.tagg.org/articles/xpdfs/timesens.pdf).

Tagg, P. (1989) 'Open letter about "black music", "Afro American music" and "European Music" Popular Music, 8 (3): 285–9.

Tagg, P. (1990) 'Reading sounds: An essay on sounds, music, knowledge, rock and society', *Records Quarterly*, 3 (2): 4–11 (http://www.tagg.org/articles/readsound.html).

Tagg, P. (1994) 'From refrain to rave: the decline of the figure and the rise of the ground', *Popular Music*, 13 (2): 209–22.

Tagg, P. and Collins, E.K. (2001) 'The sonic aesthetics of the industrial: reconstructing yesterday's soundscape', paper for Soundscape Studies Conference, Dartington College (http://www.tagg.org/articles/xpdfs/dartington2001.pdf).

Taruskin, R. (1995) *Text and Act: Essays on Music and Performance*. Oxford: Oxford University Press.

Thornton, S. (1995) *Club Cultures: Music, Media and Subcultural Capital*. Cambridge: Polity Press.

Todorov, T. (1990) *Genres in Discourse*. Oxford: Blackwell.

Toynbee, J. (2003). 'Music, culture, and creativity', in M. Clayton, T. Herbert and R. Middleton (eds), *The Cultural Study of Music: A Critical Introduction*. London: Routledge. pp. 102–12.

Trevor Roper, H. (1983) 'The invention of tradition: the highlander tradition of Scotland', in E. Hobsbawm and T. Ranger (eds), *The Invention of Tradition*. Cambridge: Cambridge University Press. p. 15–41.

Trudgill, P. (1983) 'Acts of Conflicting Indentity', in *On Dialect: Social and Geographical Perspectives.* Oxford: Blackwell. p. 141–4.

van Dijk, T.A. (1991) *Racism and the Press*. London: Routledge.

van Leeuwen, T.J. (1996) 'The representation of social actors', in C. Rosa Caldas-Coulthard and M. Coulthard (eds), *Texts and Practices*. London: Routledge. pp. 32–70.

van Leeuwen, T. (1999) *Speech, Music, Sound*. London: Macmillan.

van Leeuwen, T. (2001) 'Semiotics and iconography', in T. van Leeuwen and C. Jewitt (eds), *Handbook of Visual Analysis.* London: Sage. pp. 92–118.

van Leeuwen, T. (2005) *Introducing Social Semiotics*. London: Routledge.

van Leeuwen, T. and Wodak, R. (1999) 'Legitimizing immigration control: a discourse historical analysis', *Discourse Studies,* 1 (1): 83–118.

Wall, T. (2003) *Studying Popular Music Culture*. London: Arnold.

Walser, R. (1993) *Running with the Devil: Power, Gender and Madness in Heavy Metal Music*. Hanover, NH: University Press of New England.

Warell, K.L. (2005) 'Fight the power', Salon.com (http://archive.salon.com/ent/masterpiece/2002/06/03/fight_the_power/index.html).

Weinstein, D. (2000) *Heavy Metal: The Music and its Culture*, 2nd edn. New York: Da Capo Press.

Weis, E. and Belton, W. (1985) *Film Sound: Theory and Practice*. New York: Columbia University Press.

Whitehead, N.L. and Wright, R. (eds) (2004) *In Darkness and Secrecy.* Durham, NL: Duke University Press.

Wilkinson, M. (1976) 'Romantic love: the great equalizer? Sexism in popular music', *The Family Coordinator*, 25 (2): 161–6 (www.jstor.org/stable/582795).

Williams, R. (1961) *The Long Revolution*. London: Chatto and Windus.

Willis, P. (1978) *Profane Culture*. London: Routledge & Kegan Paul.

Wright, W. (1975) *Six Guns and Society*. Berkeley, CA: University of California Press.

Index

SAGE Student Reference Guides
Our bestselling books for undergraduates!

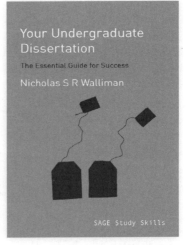

Providing no nonsense guidance to studying more effectively

Good Essay Writing
Third Edition Peter Redman

Your Undergraduate Dissertation
The Essential Guide for Success
Nicholas S R Walliman

SAGE Study Skills

Essential Study Skills
The Complete Guide to Success at University
Second Edition
Tom Burns and Sandra Sinfield

Study Skills

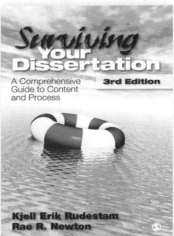

Surviving **Your Dissertation**
A Comprehensive Guide to Content and Process **3rd Edition**

Kjell Erik Rudestam
Rae R. Newton

...ls.sp

SAGE